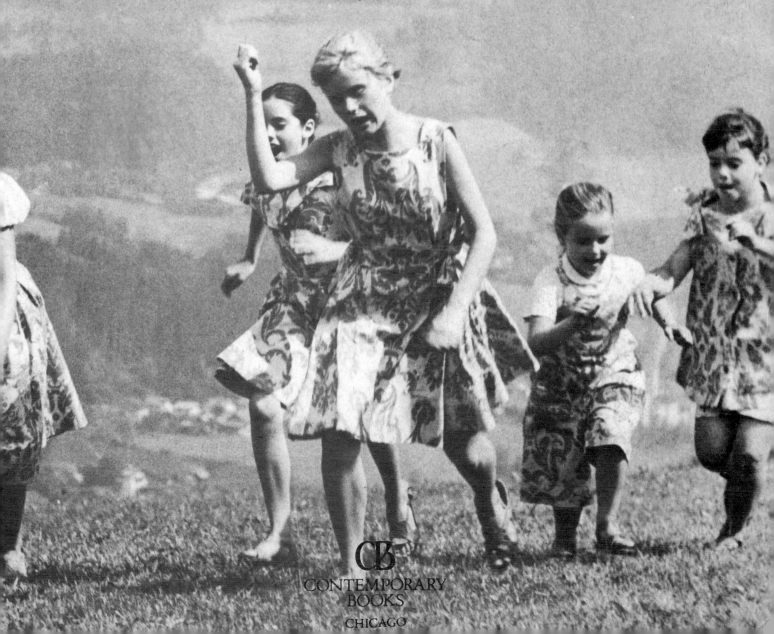

THE SOUND OF MUSIC

The Making of America's Favorite Movie

JULIA ANTOPOL HIRSCH
Foreword by Robert Wise

CB
CONTEMPORARY
BOOKS
CHICAGO

Library of Congress Cataloging-in-Publication Data

Hirsch, Julia Antopol.
 The sound of music : the making of America's favorite movie /
Julia Antopol Hirsch : foreword by Robert Wise.
 p. cm.
 Includes bibliographical references and index.
 ISBN 0-8092-3837-3
 1. Sound of music (Motion picture) I. Title.
PN1997.S63373H57 1993
791.43'72—dc20 93-28378
 CIP

Published by Contemporary Books, Inc.
Two Prudential Plaza, Chicago, Illinois 60601-6790
Manufactured in the United States of America
International Standard Book Number: 0-8092-3837-3
10 9 8 7 6 5 4 3 2 1

*This book is dedicated to
the love of my life,
my husband, Lonnie Hirsch;
to
my children, Adam and Lili;
and to
Robert Wise,
whose patience, generosity, and support
made this book possible.*

CONTENTS

FOREWORD

WHAT MAKES A MOTION picture a hit around the world? Specifically, what made *The Sound of Music* the most beloved film of its time?

It has been almost three decades since the film was released, and I am still being asked that question on an average of twice a week. Frequently I am also asked to explain the continuing heavy sales of the videocassette version. The answer to all these questions is simple: I don't know. I wish I did, because then I could repeat that success.

But to give that simple answer would be to ignore the hard work, the talent, the years of creative effort that were involved—years that stretch back almost four decades to when Mary Martin and Richard Halliday convinced Richard Rodgers and Oscar Hammerstein II that some German films based on the exploits of the Trapp Family Singers could form the basis of a Broadway musical. The show turned out to be the most successful of all Rodgers and Hammerstein musicals.

That's why I am delighted that Julia Hirsch has invested the time and effort to interview countless people, dig through the archives of three universities, and go through thousands of photographs at Fox seeking answers to the questions that are always asked of me. Ms. Hirsch has done a marvelous job of capturing the joys and frustrations of putting together a successful film. She has also managed, through her use of anecdotes and photographs, to convey some of the wonder the film evokes in audiences of all ages. Looking at the movie from the distance of three decades and through Ms. Hirsch's journalistic eyes, I am reminded that some things simply defy explanation—they just are.

Nevertheless, I can tell you what *The Sound of Music* has meant to me, apart, of course, from the satisfaction that comes from having a big hit. When the project was first proposed, my immediate reaction was one of pleasure mixed with caution. It was an opportunity to do another musical, which I knew I would enjoy. But more than that, a definite challenge was involved— to make a musical so radically different in form and tone from my previous film, *West Side Story*. That perhaps was one of the first things that drew me to *Music*.

Another was the chance for a reunion with Saul Chaplin and Ernest Lehman, my associate producer and screenwriter, respectively, on *West Side Story*. Later I discovered still another

plus—the joy of working with Julie Andrews, a great talent and a delightful human being who found, as you will discover in the book, ways to make an adventure out of even the most trying circumstances.

But nowhere in this book will you find any mention of the one important element for which none of us connected with *The Sound of Music* could take credit—timing. It isn't mentioned because it was the *X* factor, the one thing that no one could depend on and on which no one even wanted to make a guess.

The Sound of Music was released in the spring of 1965. The date was not picked arbitrarily, nor was it selected on the basis of some arcane chart. It was released then because, after all the work and the previews, that is simply when it was deemed ready to be shown to the public.

And that, of course, was when the question of timing first came to the fore. Nineteen sixty-five was a volatile year in the United States and throughout the world. Newspapers carried headlines of the war in Vietnam, a cultural revolution was beginning to spread throughout the country, and people needed old-fashioned ideals to hold on to. The moviegoing public was ready, possibly even eager, for a film like this. Besides an outstanding score and an excellent cast, it had a heartwarming story, good humor, someone to love and someone to hate, and seven adorable children.

There was no question, from the very first week of its release, that the movie was going to be successful although even those of us closest to the project never dreamed exactly how popular it would be. And ever since then experts have been dissecting all the elements that Julia Hirsch describes here in an effort to learn if there is a formula for success.

I have often been told that if the film had been released two years earlier, or two years later, the public taste would have been different and we would not have been so successful. I am not prepared to argue the point, though I am pleased to note that the film's ongoing popularity— even with young audiences— suggests at least a certain timelessness. I am just pleased and proud that we were able to create an entertaining movie that touched so many lives.

Robert Wise

Robert Wise
October 28, 1992
Beverly Hills, California

PROLOGUE

ACCORDING TO HER BOOK, *The Story of the Trapp Family Singers*, it was in 1933 that 28-year-old Maria von Trapp, visiting a friend in Tirol, made a fateful wish. The friend, a famous writer, began discussing her profession. "Isn't it funny," her friend confessed, "I never wrote a word in my life until after I was forty!"

The next day, as they were hiking in the Alps, the travelers came upon a quaint little chapel that looked down upon an enchanting green valley. Inside the church, Maria, seeing a rope dangling from the opening that led up to the steeple bell, mischievously took hold of the rope and jokingly proclaimed, "I wish I could become a writer, too, after *I'm* forty!" Maria then pulled the rope, and the sound of the bell echoed throughout the glen.

Her friend stared at her incredulously. "Did you know the story?"

"Which story?" asked Maria.

"Well, the people say that once in a hundred years, it happens that if someone rings this bell while pronouncing a wish, that wish, whatever it may be, will come true. . . . The people of this valley call it the 'wishing bell.' "

Fifteen years later, Maria von Trapp wrote her first book, *The Story of the Trapp Family Singers*. Seventeen years after that, a musical film based on that book changed movie history.

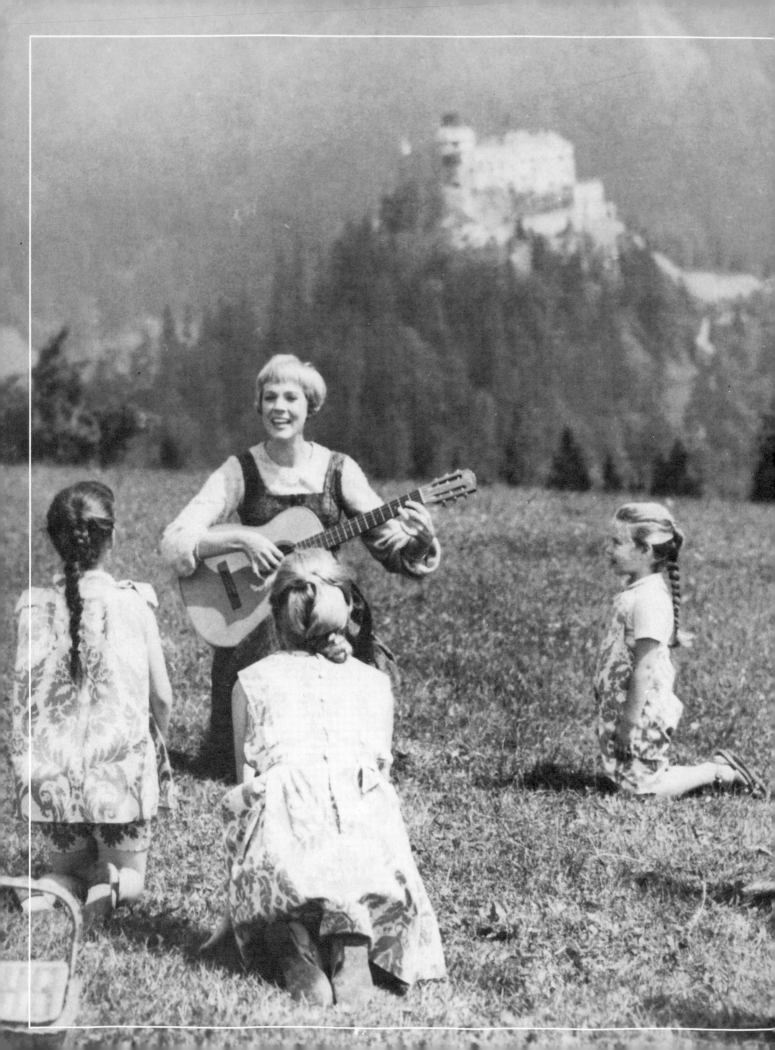

"Let's start at the very beginning . . ."

From Vienna to Hollywood

MARIA AUGUSTA KUTSCHERA made her grand entrance into the world in a fashion that would later typify her character: in motion. She was born on January 26, 1905, on a train racing toward Vienna. Already displaying signs of a restless nature, she was just too impatient to wait until the train reached the city, where a staff of doctors would surely be waiting at the hospital. Instead, her mother, Augusta, was forced to recruit a train conductor to act as midwife and, just before the stroke of midnight, he helped deliver Augusta's baby daughter.

Augusta died of pneumonia when Maria was two years old, and her father left the youngster with an elderly cousin's family so that he could be free to travel throughout Europe. (This seemed to be her father's pattern; when his first wife died, he had left Maria's older brother to be raised by the same relatives.) Maria was reared in a family of adults, and she became a lonely and unhappy child. The household she lived in was also so strict and her uncle, who became her legal guardian after her father died, so physically abusive that she developed a rebellious nature as well.

Maria's guardians had

1

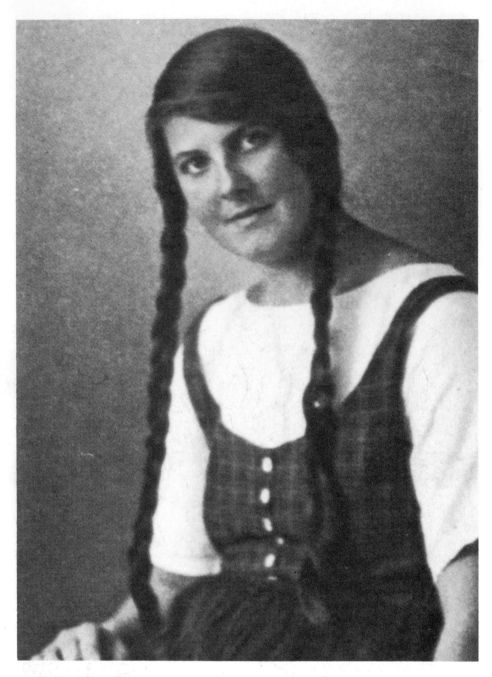

brought her up as a socialist and raised her to be cynical toward all religion, but a visiting Jesuit priest who lectured at her college changed her life. His speech had a powerful impact on the vulnerable young student, though Maria still felt compelled to meet the priest a few days later to "enlighten" him as to all the reasons his beliefs were wrong. But at that meeting the priest's composure and quiet confidence impressed the romantic young woman, and all her arguments were forgotten. Instead she found his unwavering faith and utter tranquility the perfect medicine to heal her troubled heart. Maria's newfound religious beliefs became so strong, in fact, that after graduating from college with a degree in education, the once-devout atheist traveled to Salzburg, Austria, and joined the Nonnberg Abbey as a postulant.

Maria was intensely devoted to the convent, but her dedication did not prevent the former tomboy from getting into mischief. The sudden change from her free-spirited college days of mountain climbing to the more sedate life at the abbey also seemed to adversely affect her health. One day, the Reverend Mother called Maria to her office. Maria's headaches had worried the abbey's doctor; he thought she

needed exercise and fresh air. So the Mother Abbess had decided to send Maria to the home of retired naval captain Georg von Trapp, to be governess to one of his young daughters. The child, also named Maria, had developed rheumatic fever and was forced to spend much of her time in bed. The young postulant accepted her new post only after she received the Reverend Mother's promise that in nine months she could return to the abbey for good.

But, as we all know, Maria never did come back to stay. She married the Captain on November 26, 1927, and had three children to add to the seven from his first marriage. The family, whose members seemed to have a natural talent for music, and whose voices blended beautifully, began to perform professionally—at the Salzburg Festivals, on the radio, and even touring Europe. When Hitler invaded Austria and the Captain was called back into service, for the Navy of the Third Reich, the family, violently opposed to the Nazi regime, decided to escape. They climbed over the mountains to Italy; from there they traveled to England, then crossed the ocean to America, where they continued to perform as the famous Trapp Family Singers.

When the young Maria rang that steeple bell, she had had no inkling that her innocent wish to become a writer would come true or that her life would eventually be the subject of two German motion pictures, a Broadway play,

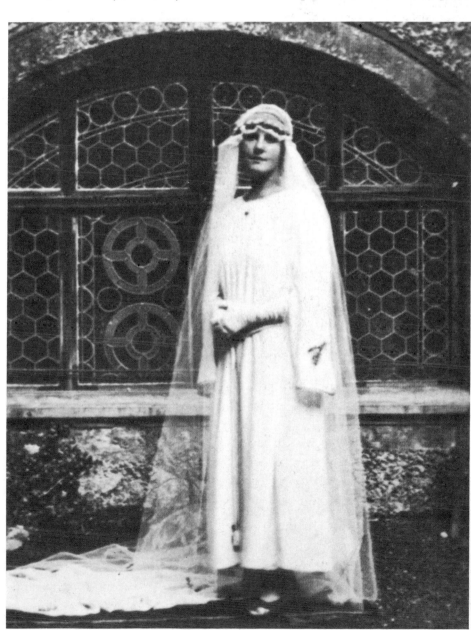

Maria on her wedding day.

and the most successful American musical film of all time. But had she known, Maria would not have been surprised. She was a strong personality and a powerful promoter of her family. Mary Martin, who starred as Maria in the Broadway musical, wrote in her autobiography, *My Heart Belongs*, ". . . I came to the conclusion that perhaps the family didn't just climb that mountain to escape. She pushed them, all the way up."

Promoting her family was one of the reasons Maria wrote *The Story of the Trapp Family Singers* in 1948. Soon after the book was published, Hollywood beckoned. But the producers wanted to buy only the title of her book, and Maria turned them down flat. They'd have to buy the whole story or nothing.

According to Maria's autobiography, *Maria*, in 1956, German producer Wolfgang Reinhardt, son of the famous film director Max Reinhardt, approached Maria with a contract for $10,000 to buy the rights to her entire story. That was a tidy sum to a widow with ten children (the Captain had died in 1947), but Maria's lawyer suggested that she also ask for royalties. Heeding his advice, Maria met again with the producer's agent and asked for a share of the movie's profits. The agent hesitated and said he'd have to call Germany and ask Reinhardt's permission. He came back shortly and said, "I am sorry, I have to inform you that there is a law in existence which forbids a German film company

from paying royalties to foreigners." (Maria was now an American citizen.)

Maria took the man at his word and didn't even verify his story with her lawyer. She signed the contract and, at the same time, unknowingly signed away all film rights, including all profit participation, to her story. Not only had the agent misled her (no such law existed), but he actually called her a few weeks later and suggested that if she would agree to take $9,000 instead of the full $10,000, he could give the entire amount to her immediately. She needed the cash and made the deal.

Die Trapp Familie was produced in Germany in 1956 and became a big hit. It did so well that Reinhardt followed it up in 1958 with a sequel entitled *Die Trapp Familie in Amerika*. Both movies starred Ruth Leuwerik as Maria and Hans Holt as the Captain and were directed by Wolfgang Liebeneiner. They soon became the most successful films produced in Germany since World War II and subsequently became hits in Europe and South America as well.

Paramount Pictures in Hollywood purchased the U.S. film rights to the two movies, hoping to produce an English-language version as a vehicle for its young star Audrey Hepburn. At the time, Paramount had just signed Broadway and television director Vincent Donehue to a contract, with no specific project in mind. One of the first things

they showed him was the film *Die Trapp Familie*. Donehue sat watching the picture in Paramount's projection room, and when the lights went up, he turned to John Mock, story editor at Paramount, and said, "I think this would make a great vehicle for Mary Martin!"

Donehue had directed Mary Martin in the national tour of *Annie Get Your Gun* along with the television version of the musical. He'd also worked with Martin in the stage and television versions of *The Skin of Our Teeth* and two other television specials. Donehue, Martin, and Martin's husband, producer Richard Halliday, had been looking for another project to work on together for the Broadway stage. Donehue flew the film back to New York and screened it for Martin and her husband. They fell in love with the idea and began working on the project. By the time they went to buy the rights, however, Paramount had dropped its option and no longer owned the rights to the German films. So Halliday, unaware of Maria's deal with the German producers, thought he had to go through Maria to get permission. Maria, who was involved in missionary work in New Guinea at the time, soon began receiving strange notes from an American producer saying he wanted to turn her story into a Broadway play starring Mary Martin. Maria received three of these notes, and each time she got one she tore it up. She didn't know who Mary Martin was, and she thought the

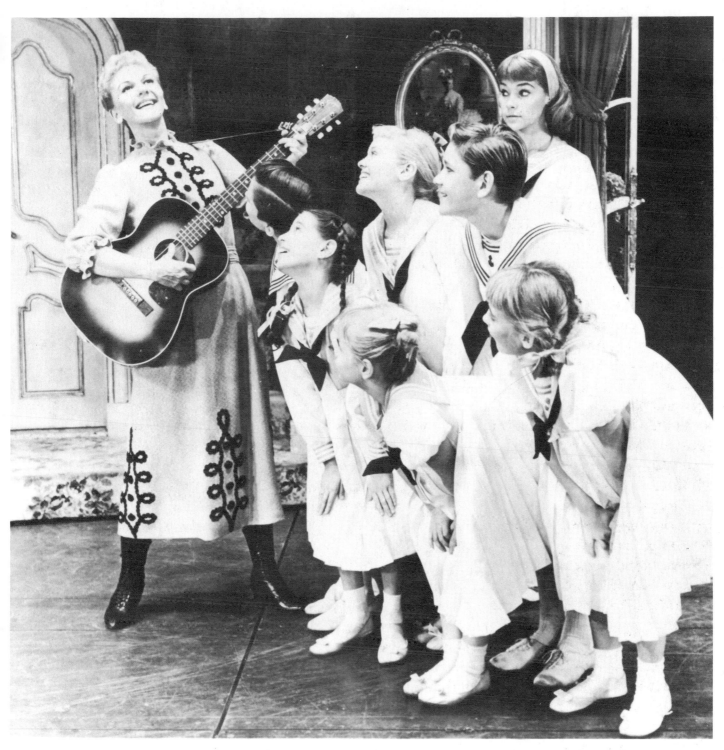

Mary Martin and the children from the stage version of The Sound of Music.

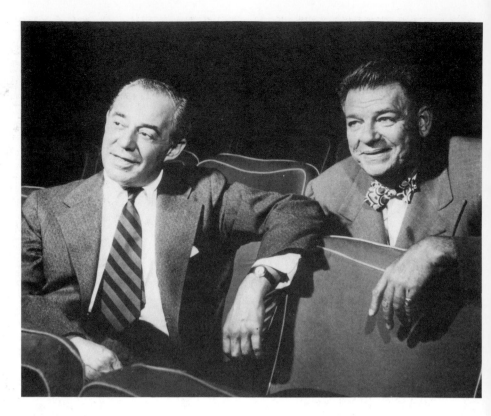

Richard Rodgers and Oscar Hammerstein II.

whole idea of a play based on her book was preposterous!

When Maria returned from New Guinea, an undaunted Richard Halliday was waiting to meet her ship in San Francisco. He invited her to see his wife's performance in *Annie Get Your Gun* that evening. Maria loved the show and afterward went backstage to meet Mary Martin. From the first minute they met, Maria and the future "Maria" felt they were kindred souls.

But unfortunately, the real Maria von Trapp had no say in whether or not Halliday could buy the rights to the book. Reinhardt's company in Germany had seen to that. So Halliday and his partner, Leland Hayward, made a deal with the German producer. And although legally the American producers didn't owe Maria a penny, they voluntarily gave her three-eighths

of 1 percent in royalties on the Broadway show. It was more than Maria expected, and she was grateful.

Initially Martin and Halliday conceived of their version of *Die Trapp Familie* as a straight dramatic play, using the actual folk songs and religious numbers the Trapp family sang on tour. So they hired playwrights Howard Lindsay and Russel Crouse— whose previous successes had included *Life with Father* and *State of the Union*, for which they had won the Pulitzer—to write the stage play. The writing team had also produced many shows on Broadway, including *Arsenic and Old Lace*.

After securing Lindsay and Crouse, Halliday and Martin approached the legendary composing team of Richard Rodgers and Oscar Hammerstein II and asked them to write one

original song for Martin to sing in the play. But Rodgers and Hammerstein thought that mixing the two styles of music, theirs with authentic Austrian folk songs, would be like mixing oil and water. They did, however, offer to write an entirely fresh new score and to act as coproducers of the show. The one stipulation they had was that Halliday and company wait until Rodgers and Hammerstein completed work on their current project, *Flower Drum Song*. Halliday and Martin decided it was worth the wait to get the talented duo on board.

The Sound of Music opened at the Lunt-Fontanne Theater in New York on November 16, 1959.

Mary Martin as Maria von Trapp (right).

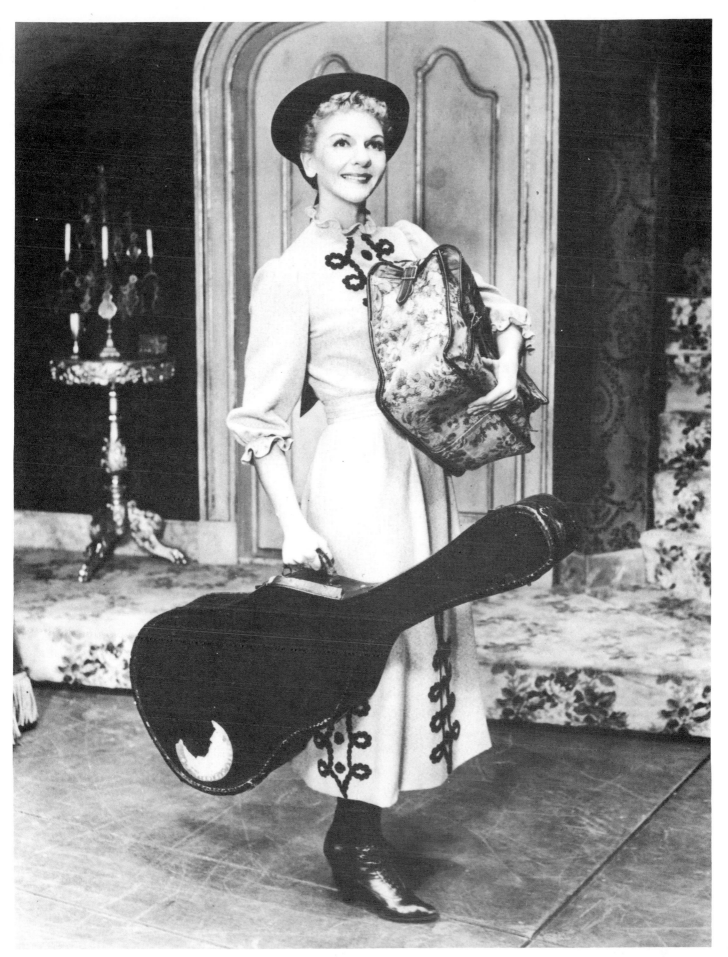

The reviews ranged from indifference to loathing. The critics found it too "sweet" and "saccharine" (terms that would later haunt the film version), but the audience must have had a sweet tooth, because they ate it up. As Richard Rodgers wrote years later, "It's my conviction that anyone who can't, on occasion, be sentimental about children, home or nature is sadly maladjusted."

The show ran on Broadway for 1,443 performances, won six Tony Awards including Best Musical, and sold more than 3 million cast albums. Martin's popularity was a big contribution to the show's success; even before the play opened the box office had garnered $2 million in advance ticket sales. For 1959, when theater ticket prices hovered around $5, a $2 million advance was a notable beginning.

On opening night, legendary motion picture agent Irving "Swifty" Lazar, who represented the show's writers, Rodgers, Hammerstein, Lindsay, and Crouse, was sitting in the audience with the president of Twentieth Century Fox, Spyros Skouras. Skouras was there because his studio had "right of first refusal" on any new Rodgers and Hammerstein musical. (Twentieth Century Fox had adapted three Rodgers and Hammerstein shows as motion pictures: *South Pacific*, *Carousel*, and *The King and I*. When Fox purchased *The King and I*, it also acquired the right to option any subsequent Rodgers and

Hammerstein properties before the other studios had a chance to do so.) As Skouras sat watching the play, Swifty Lazar watched his client, wanting to gauge the studio chief's reaction to the show. By the middle of the play, Lazar had no doubts. "He was crying like a baby," the agent recalled, "and I knew I had a customer."

But Lazar and Skouras were not the only Hollywood visitors to realize the musical's film potential. Two weeks after it opened, screenwriter Ernest Lehman went to see the show. Lehman had begun his career working in the office of a theatrical press agent in New York, where he learned the ins and outs of show business. He turned this knowledge into numerous magazine articles, short stories, and novelettes, including a novelette that he later adapted as a movie, *Sweet Smell of Success*.

A novelette, *The Comedian*, which followed *Success*, brought him to the attention of Hollywood, and he was summoned to the West Coast. His first screenplay was *Executive Suite* at MGM. The director of the film was a man with whom Lehman would establish strong ties as both a friend and collaborator on four films— Robert Wise.

Following his successful Hollywood debut, Lehman went on to write the screenplays of such classics as *North by Northwest* and *Somebody Up There Likes Me*. In addition, he penned the screen adaptations of *Sabrina*,

The King and I, *West Side Story*, and *Who's Afraid of Virginia Woolf?*

During the intermission of *The Sound of Music*, Lehman and his wife rushed to a nearby Howard Johnson's Restaurant for a quick bowl of soup. Over a cup of steaming clam chowder, Lehman turned to his wife and said, "I don't care what anyone says about this show; someday it's going to make a very successful movie." When he returned to California, he repeated this statement to David Brown, story editor at Twentieth Century Fox.

In June 1960, seven months after the show had opened, Twentieth Century Fox exercised its option and bought the rights to *The Sound of Music* for $1.25 million, against 10 percent of the gross. Lazar had certainly found a willing customer: at that time, this was the largest sum a studio had ever spent on a literary property.

Fox also protected its investment by purchasing a six-year option on the U.S. release of the two German films *Die Trapp Familie* and *Die Trapp Familie in Amerika*. Fox combined these two movies into one, hired Lee Kresel to dub the film in English, retitled it *The Trapp Family*, and released it in the United States in March 1961. Once again, the critics found the story as light as Wonder bread. A reviewer from *Daily Variety* wrote that its "uncompromisingly sentimental nature has a tendency to slop over into naivete." Shades of reviews to come.

20th To Film R&H's 'Sound of Music'; Pays Million For 15-Year Lease On Hit

Twentieth-Fox has purchased film rights to the Richard Rodgers-Oscar Hammerstein musical, "The Sound of Music," plunking down over $1,000,000 for a 15-year lease on the property.

Pic, with book by Howard Lindsay and Russel Crouse, cannot be released until 1963, according to terms of the contract agented by Irving Lazar and New York attorney Howard Reinheimer. It's presumed "Music" will be considered as a 20th entry in Todd-AO.

Property is based on Maria Augusta Trapp's "The Trapp Family Singers," telling the story of a novice from a convent who tutors seven singing children of an Austrian widower. She marries the father and saves the family from the Nazi invasion of Austria.

Interestingly, the Trapp family already has been the subject of one film—"The Trapp Family In America," a German pic produced by Divina Productions and released by Gloria Films.

"Sound of Music" is the fourth Rodgers-Hammerstein musical purchased for filming by 20th, with the $1,000,000 outlay marking the greatest sum ever paid by studio for a literary property. Twentieth already has filmed "South Pacific," "Carousel" and "The King and I."

Fox's contract with Rodgers et al. stipulated that the film of its musical could not "be released in the United States or Canada until all first-class stage presentations of the musical have closed in such countries or December 31, 1964, whichever is earlier." So even though Fox paid a handsome price for *The Sound of Music*, the property was put on hold. And while it lingered on the shelf, the studio's finances, which had begun tumbling in the mid-fifties, took a nosedive.

In fact, the only reason Fox had been able to purchase the property in the first place was the standard industry practice of paying in installments. The contract, dated May 31, 1961 (although the deal was made a year earlier), called for the payment to be made as follows: $125,000 paid in December 1961; $100,000 payable June 30, 1962; $823,850 after worldwide release; and $201,150 to be paid in nine installments of $22,350 each, on each anniversary of the release date. If 10 percent of the gross exceeded $1.25 million, then the additional payments would be made quarterly. The rights would expire on December 31, 1977.

Fox's financial troubles began in 1956, when Darryl Zanuck left for Paris to start his own independent production company. Zanuck, who had founded the film company Twentieth Century and had then merged with Fox Films to create Twentieth Century Fox, had once been the guiding light of the studio. But after his departure, a succession of studio heads came and went—all supervised by Fox president Spyros Skouras.

Unstable leadership however, was not the studio's only problem. By the late fifties, the studio had had a series of failures at the box office. To make matters worse, television had by then become the most popular form of entertainment, which spelled poison for the entire motion picture business. At the same time, location shooting was becoming the most cost-effective way to make pictures, and the old studio system was becoming obsolete. Things finally got so bad for Fox that in 1957 Skouras even flirted with the notion of giving up the Fox lot completely and simply renting studio space at

MGM over in Culver City. This would have meant giving up both its status as a major studio and its industry muscle.

But instead of shutting down the *entire* studio, Skouras began drawing up plans to sell off 260 acres of the studio's backlot property (which eventually became the master-planned business and shopping community Century City). If Skouras hesitated at all to go ahead with the Century City deal, explained Richard Tyler Jordan in a 1989 *Los Angeles Magazine* article, one out-of-control project convinced him to push the deal through. Skouras told Edmond Herrscher, his director of property development, "I need $48 million. . . . that damn *Cleopatra* has put me in such a fix!"

His *Cleopatra* problems began in September 1960, just three months after the studio paid its phenomenal price for *The Sound of Music*. Skouras announced the beginning of principal photography on what he thought would be a $2 million quickie to star Joan Collins as the Egyptian queen. But what he got instead was an all-star boondoggle that turned into one of the highest-priced movie failures of all time. It was a film destined to become more famous for bringing together Elizabeth Taylor and Richard Burton than for its dubious contribution to the annals of motion picture history.

Every calamity that could befall a motion picture struck *Cleopatra*. Taylor contracted pneumonia, forcing production to close down for six months; two major roles had to be recast; directors quit; the producer was fired; and, while the affair between new lovers Taylor and Burton sizzled onscreen and off, their escapades proved costly to a production already way over budget. The movie wasn't even completed, and it had already cost the studio nearly $40 million, in 1963 dollars. As the costs spiraled out of control, Fox's board of directors forced Skouras out of his position as president and gave him the nominal title chairman of the board.

Then, like a knight in shining armor, Darryl Zanuck returned to reclaim his castle. He was a major stockholder in the company and so had a lot to lose if the studio went bankrupt. He also wanted to protect the distribution of his new movie, *The Longest Day*, which Fox was releasing. But even though the gallant knight had returned to save the kingdom, he didn't want to live there. Or he couldn't. There was a rumor circulating around town that the separation agreement he'd made with his wife, Virginia, had stipulated that Darryl could not enter California unless Virginia gave him permission. Whether or not this was true, Darryl ran the studio from either the George V Hotel in Paris or, if he had to be in the country for a board meeting, the St. Regis Hotel in New York. As for the studio in Los Angeles, he appointed his son, Richard "Dick" Zanuck, vice president in charge of production at the California location.

Dick Zanuck had grown up on the Fox lot and was already a seasoned Hollywood veteran at the ripe old age of 27, having produced two motion pictures: *Compulsion*, the classic film adaptation about the Leopold and Loeb murder case, and *The Chapman Report*, a George Cukor film, starring a very young Jane Fonda, about the sexual mores of suburban women. After this notable beginning, Zanuck became his father's West Coast liaison to the independent film company Darryl had started in France.

When Dick Zanuck returned to Fox after his father regained control of the studio in 1963, it seemed like a different company. Instead of the productive, vital studio he had known in his youth, Zanuck soon discovered he had inherited a chaotic studio on the brink of bankruptcy. The new head of production blamed many of the studio's troubles on bad management. "When I came back to Fox, they had all these projects and people, and nothing was happening. I read thirty scripts the first few days I was there, and there wasn't one thing that was any good."

Zanuck's first step was to shut down the studio. Only a handful of projects were left in production, 1,000 employees were laid off, and even the commissary closed down. He then corralled everyone onto one floor of one building, to "gather momentum." By all accounts, Twentieth Century Fox became a ghost

town. "Tumbleweeds were rolling down the streets," Zanuck recalled.

"It was a haunted studio," concurred Ernest Lehman.

But while the studio *looked* as if it was about to declare Chapter 11, Dick Zanuck knew he would somehow find a way to bring it back around. "I know there was a big concern at the time as to whether or not we would ever open up the studio again," related Zanuck. "But by the film community, not by us. We still had some money for production, and we had every intention of opening up again. We knew that we would." Zanuck had a few projects in various stages of development, among them *What a Way to Go!* to star Shirley MacLaine and an all-star cast; and *Something's Got to Give*, which was to have starred Marilyn Monroe before she died and was now retitled *Move Over, Darling* for Doris Day and James Garner. *The Sand Pebbles* was in the early stages of development, with Robert Wise as director. Two other films, *The Agony and the Ecstasy* and *Those Magnificent Men in Their Flying Machines*, were in development and would eventually be shot in Europe at the same time as *Music*. Zanuck also knew that he needed a *major* project to put the studio back on the map.

The solution was there all along. *The Sound of Music* had been collecting dust since its purchase by Fox, yet it was still a tremendous hit on Broadway. Zanuck couldn't understand why

no one had put the project into development. "I just thought it was such a wonderful piece of family entertainment. And it had been so hugely successful that it was just an obvious thing to do." Once again, Zanuck questioned the studio's former management. "Even though the studio couldn't release the picture until the play closed, they could have put a writer on it. What you want to do is have your movie ready for release when your date comes."

There wasn't much overhead involved in putting a property into development. It just meant hiring a writer. Ernest Lehman had made it known around town that he was very optimistic about

the possibility of a movie based on *Music* and that he was anxious to do the adaptation. His big successes with adaptations of *The King and I* and *West Side Story* convinced Zanuck to let Lehman work his magic again on *Music*. *This* would be the film to herald the new regime at Twentieth Century Fox!

When *The Hollywood Reporter* and *Daily Variety* announced on December 10, 1962, that Fox had hired Ernest Lehman to work on *The Sound of Music*, the news reverberated throughout Hollywood. Not only had Fox eluded bankruptcy; it actually intended to make an *expensive, major* film.

'SOUND' OF 20TH PROD'N HEARD; LEHMAN INKED

Ernest Lehman has signed to script "Sound of Music." Deal completed Friday by studio chief Richard Zanuck is first of a number with top personalities designed to get 20th-Fox back into full-scale production this summer.

Choice of Lehman to adapt the Rodgers-Hammerstein music drama was signaled by prexy Darryl F. Zanuck, who hired writer in 1955 to transfer another R&H stage music hit, "The King and I." Lehman, who last year took home an Academy Award for his scripting of "West Side Story," will tackle the "Sound of Music" screenplay on Jan. 14.

Show opened on Broadway in 1959 with Mary Martin and still is running. It was bought by 20th the next year for $1,250,000. Filming is slated to start this summer with location work in the Austrian Alps and interiors at the studio here.

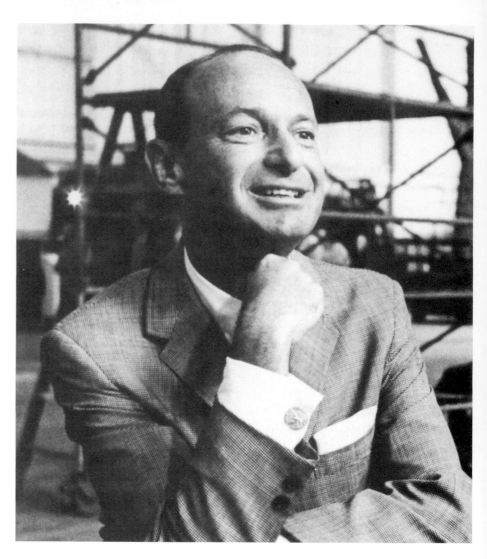

Screenwriter Ernest Lehman.

Hollywood was skeptical. First of all, no one thought that Fox had the money. In fact Lehman was getting warnings from friends. "Fox is using you," they said. "They're not going to pay you. They're reneging on their contracts!" Even the board of directors at Fox didn't have confidence in its own project, fearing the movie would be too costly. Then something happened that changed the directors' minds.

Lehman and Zanuck had a lunch date at Romanoff's. "It was our first meeting," Lehman remembered. "I got to the table first, and I saw Irving Lazar approach Dick at the top of the stairs. They were huddled in conversation for a while, and then Zanuck came to the table."

"Swifty just offered me $2 million to buy back the rights to *Music*," Zanuck told Lehman. "I told him to go to hell."

Lazar wouldn't mention the name of his client, but Lehman and Zanuck were convinced it was Jack Warner. It seems the rumors about Fox were so bad that Warner thought the studio couldn't possibly afford to make the picture, and he thought his studio might do well with the project. His offer of $2 million to buy out the Rodgers and Hammerstein contract would have provided Twentieth Century Fox with a $750,000 profit. Warner thought the studio was hungry enough to bite. Instead Fox's board of directors gave Zanuck the OK to begin production.

But it wasn't just Fox's financial troubles that made the film community question Lehman's sanity in taking on the project; it was the project itself. Reputations die hard, and *The Sound of Music* was still known for its schmaltz. Lehman recalled sitting in the newly reopened commissary one day when Burt Lancaster, who had starred in Lehman's critically acclaimed *Sweet Smell of Success*, walked up

and asked what he was working on. When Lehman replied, "*The Sound of Music*," Lancaster retorted, "Jesus, you must need the money!"

Another example of the community's distaste for the play came from director Billy Wilder. Wilder and Lehman, guests at Jack Lemmon's home one night, began discussing Lehman's upcoming projects. When Lehman told Wilder that he had just started working on *Music*, Wilder announced to his friend, "No musical with swastikas in it will ever be a success!" (This is precisely the reason Lehman wrote the scene in which Captain von Trapp rips up the swastika.)

As Lehman began developing the screenplay, he and Zanuck decided they'd better start looking for a director/producer. They immediately thought of Robert Wise. Wise was known as a gritty, realistic director, and they felt that his style of filmmaking would help compensate for the more sugary aspects of the story. Wise had also just directed and produced the highly acclaimed film adaptation of *West Side Story*, for which he had won double Oscars for Best Picture and Best Director (the latter Oscar he shared with co-director Jerome Robbins). But Wise was already on the Fox lot preparing *The Sand Pebbles*, a sprawling adventure about the lives of a U.S. Navy gunboat crew in 1926 China. The picture was only in the early stages of development, and Wise could have left to do Fox's *Music*, but he wanted to stay

with *The Sand Pebbles*. Besides, Wise wasn't particularly interested in *Music*. He'd also heard the rumors. "It's not his cup of tea," his agent said.

Lehman's second choice was director Stanley Donen. Donen had directed such classic musicals as *Singin' in the Rain* (codirected with Gene Kelly), *Funny Face*, and *Damn Yankees*. But when Lehman called him at his home in Switzerland to ask if he'd be interested in directing *Music*, Donen declined. Though he had been an investor in the Broadway show, he had no interest in directing the film. Lehman then approached Gene Kelly. In addition to dancing and acting in more than 30 films, Kelly was an accomplished director. He'd directed *On the Town* and *Singin' in the Rain* (with Donen), as well as *Invitation to the Dance*. He seemed an excellent choice for *Music*, and Lehman was excited as he drove to Kelly's Beverly Hills home on Rodeo Drive. "As soon as I walked inside the house," Lehman remembered, "I announced, 'Gene, I came over to ask if you'd like to be our director on *The Sound of Music*.'" Kelly walked Lehman back out the door and said, "Ernie, go find somebody else to direct this kind of shit!"

Lehman was undaunted. He knew he and Zanuck would find the perfect director. On January 17, 1963, the two men met with Zanuck's father, Darryl, in New York. When the talk turned to directors, Lehman mentioned that, in his opinion, one of the

best directors in the world was William Wyler. And, indeed, Wyler was a master. Not only did his credits include the haunting *Wuthering Heights* and the delightful *Roman Holiday*, but he had also directed three films that went on to win the Academy Award for Best Picture: *Mrs. Miniver*, *Ben Hur*, and *The Best Years of Our Lives*. Darryl Zanuck agreed that Wyler would be an outstanding director on *Music* and immediately phoned him in California.

Wyler flew to New York the next day to see the show with Lehman. This was Lehman's third visit; he had seen the play a second time with Dick Zanuck just a few nights before. Lehman's reaction to the show the second night wasn't particularly enthusiastic, and as he sat for a third time watching the play with Wyler, he began to panic and thought to himself, "My God, what have I done?"

It had been two years since Mary Martin had left the show and a new actress, Nancy Dussault, had taken over the role of Maria. Lehman wasn't too crazy about her or the original production. In fact, as Lehman sat watching the show as if through Willy Wyler's eyes, he wondered what had come over him that night two years before when he had proclaimed that this would make such a popular picture. Still, he was so anxious for Wyler to like the play and see its potential that he sat on the edge of his seat, almost *willing* the show to be better.

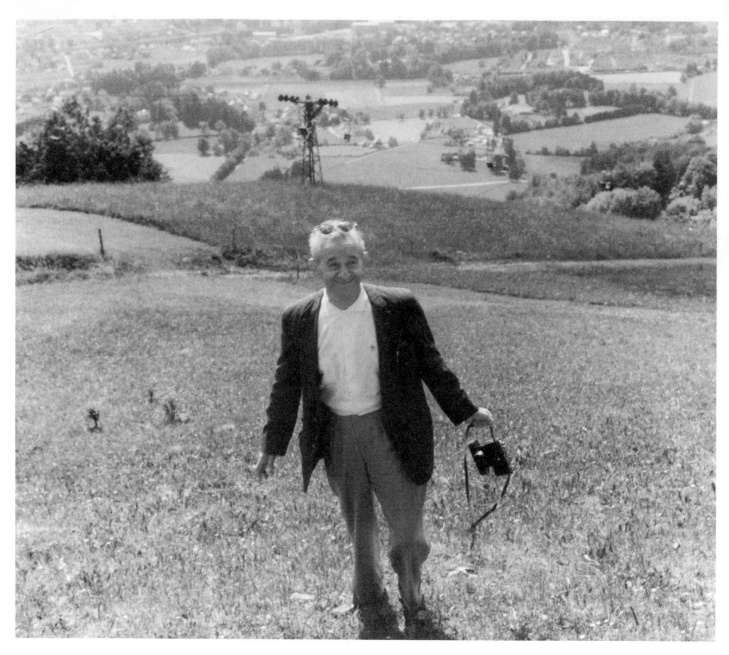

William Wyler scouting locations in Austria.

While Lehman sat nervously watching Wyler's reactions to the play, Darryl Zanuck waited anxiously at The "21" Club, where he was to meet the two men after the show. As Wyler wandered out of the theater, he turned to Lehman and said, "Ernie, this is terrible. I can't meet Darryl. I hated the show, and I'm not going to do this. But keep talking to me anyway."

Lehman and Wyler went for a walk, and Lehman explained all of his ideas for the show, all the changes he'd make, all the strong moments he planned to underscore. Throughout the evening Wyler just kept repeating, "I hate the show, Ernie. But keep talking."

Finally, at 2:00 in the morning, utterly frustrated and talked out, Lehman stopped and said, "Willy, I know you hated the show, but just tell me one thing. What did you feel at that moment when Captain von Trapp started singing 'The Sound of Music' with his children?"

Wyler took Lehman's hand and said, "Funny you should bring up that moment. I almost cried." Lehman smiled and said, "Willy, that's it! That's what it's all about!"

Darryl Zanuck, meanwhile, was fuming because he thought he'd been stood up. But when Lehman filled him in the next morning, Zanuck cried, "Stop working on the script! Forget everything you're doing! Your job is to get Willy Wyler to do this movie!"

On the plane back to California, Lehman explained to Wyler how enormously successful the play had been and what a loyal following it had generated. Every day, in Wyler's office, Lehman elaborated on his ideas for the film and how Wyler's contributions were essential to make this not just an entertaining musical but a film of substance. At Wyler's home every night, Lehman talked about the energy and spirit of the story. This exhausting routine went on for two weeks. Finally, when Lehman was beginning to run out of ideas, Wyler at last capitulated and agreed to direct and produce the picture. Everything was ready to go. There was just one minor problem. . . .

Willy Wyler hated *The Sound of Music*!

Wyler hired Roger Edens, a well-respected musical supervisor who had done numerous musicals with Arthur Freed at MGM, including *Meet Me in St. Louis*, *Easter Parade*, and *Annie Get Your Gun*, as his associate

producer. Edens, Wyler, and Lehman then flew to Salzburg, Austria, to scout locations for the film.

Though Wyler was going through the motions of being the "director" on the film, Lehman was having trouble keeping him interested. "I was very wary of Willy because I'd been through many experiences with him, and I knew you had to watch him very carefully," recalled Lehman. "You can't accept what he says as gospel. The fact that he had signed to do the picture didn't mean all that much to me. I was still very leery."

And rightly so. Wyler spent much of his time in Austria taking long-distance phone calls from other studios and discussing other projects, sometimes, because his hearing was so poor, asking Lehman to act as "interpreter." One of the projects he was discussing was an MGM script, *The Americanization of Emily*, which was at the same stage of preproduction as *Music*. To add insult to injury, Wyler wouldn't heed Lehman's pleas to hire Julie Andrews for the role of Maria in *Music*, but he did mention that Julie would be a perfect choice for *Emily*.

Another irritant for Lehman was the presence of Wolfgang Reinhardt, who had directed the German films on the von Trapps and was a close friend of Wyler's. "He followed Wyler all over," remembered Lehman. "I felt that he was an interloper. Wyler was consulting with him instead of me, the writer!"

At one point, Wyler and Lehman had a heated argument. "Wyler wanted me to go up in the small plane with him when we were looking for the opening shots," Lehman said, "and I refused to go up. He demanded that I go along, but I was very stubborn. It wasn't just the ride. I don't know why I didn't want to go. I guess it was my mistrust of Willy."

"Well, when they got back, I got a report from Roger Edens, and he told me that the pilot turned out to be an ex-Nazi. When Wyler found out, they got into a terrible fight. There they were, flying over the Alps, screaming at each other about Nazism! I was lucky I wasn't there."

In all fairness to Wyler, he did see this movie as a way to make a personal statement. Wyler was an Alsatian Jew. Although he had left Europe before the Holocaust, unscathed, some of his family members had perished during the war. "I knew [the movie] wasn't really a political thing," said Wyler in his biography, *William Wyler—The Authorized Biography*, written by Wyler and Axel Madsen. But "I had a tendency to want to make it, if not an anti-Nazi movie, at least say a few things."

But turning a Rodgers and Hammerstein musical into a political platform was not what Lehman and Zanuck had in mind. "Willy was going to make it very heavy-handed at the end," said Zanuck. "He wanted tanks. He wanted a real invasion, blowing

up the town and everything. I didn't see any need for all this right in the middle of a musical."

After the group returned to California, Lehman and Dick Zanuck decided that the only way to ferret out Wyler's true intentions was for Lehman to quickly complete a first draft of the screenplay so the two of them could carefully observe Wyler's reactions to it. Wyler had a reputation for being tough on writers and their scripts. "He ate writers alive," said Lehman. But it was this tenacity that indicated his commitment to a film. The tougher he was, the more he liked a project.

Lehman finished the first draft of the screenplay on September 10, 1963, and immediately sent if off to Wyler. A few days later Wyler came over to Lehman's office. "Ernie, I'm embarrassed," Wyler began. "I've never read such a perfect first draft. I can't think of a single thing I can improve. I ought to have a lot of suggestions for you, but I can't think of anything. Well, I gotta go now. I'm playing gin rummy over at Hillcrest."

Lehman immediately went to Dick Zanuck's office and told him to start worrying.

One Saturday afternoon a few days later, Wyler was having a small party at his home in Malibu and invited Lehman to join him. Rex Harrison was going to be there with his wife, Rachel Roberts, and Wyler wanted Lehman to convince Harrison to play the part of Captain von Trapp. As Lehman began his pitch to Harrison, he noticed Wyler huddled in a corner of the room with another party guest, Mike Frankovich, the head of Columbia Pictures.

An hour later Lehman was passing Wyler's study on his way out when he noticed that, among the many scripts in Wyler's office, one was lying facedown, the title hidden from view. His curiosity aroused, Lehman turned the script over and read the title. The screenplay was *The Collector*,

Wise Helms 'Sound' at 20th

Hollywood, Nov. 5
Robert Wise succeeds William Wyler as producer-director of "The Sound of Music" at 20th-Fox, film now to be a joint venture by Wise's Argyle Enterprises and 20th-Fox. Lensing is now slated to go before Todd-AO cameras March 15 instead of previously-set May 15, and will be 20th Christmas 1964, release.

Wise, who previously was prepping "The Sand Pebbles" for 20th under his own banner as a joint production, has set start of this back to Oct. 15 from Sept. 1.

currently in preproduction *at Columbia Pictures*.

The next day, Lehman went to see Dick Zanuck. "Dick, Willy is going to direct *The Collector*."

Zanuck nodded grimly. "I'm ready."

Then Lehman had an idea. He went back to his office and arranged to surreptitiously slip a copy of the *Music* screenplay to Phil Gersh, agent for director Robert Wise.

Soon after Wyler's Malibu beach party, Paul Kohner, Willy Wyler's agent, visited Dick Zanuck. Zanuck was prepared. "Wyler would like to do *The Collector* before he does *Sound of Music*," Kohner told Zanuck. "And he'd like you to postpone *Music* until *The Collector* is finished."

Zanuck paused for only a moment. "Tell Willy to go make *The Collector*. We are not postponing *The Sound of Music* for five seconds!"

And that concluded Willy Wyler's association with *The Sound of Music*.

"I loved Willy, and he was a genius and everything," conceded Zanuck years later, "but he was a guy that would get cold feet. I think he got scared. Maybe he thought the movie was too saccharine. Maybe that's why he needed to insert this whole military aspect into it that I thought was unnecessary. So, when we finally had to let Willy go, I didn't think that it was that great a loss. Oh, we ranted and raved about how awful it was, but down deep inside I was a bit relieved."

"I know it was very perverse of me," explained Lehman when asked why he had put up with Wyler's antics for so long, "but it's like I was willing to endure what I had to endure in order to get one of the best directors in the world. It's kind of like figuring out who your executioner is going to be. As it turned out, I guess I was pretty stupid, because Willy wouldn't have been the best

director for the movie."

At the time Robert Wise was suddenly handed Lehman's screenplay, he was well into preproduction on Fox's *The Sand Pebbles*, but the picture had run into a number of problems, including trouble with the Taiwanese government about shooting the film in their country. The movie was postponed for a year, and Lehman knew that Wise was looking for another film to direct until he could start working on *The Sand Pebbles*. The timing was perfect.

The first thing Wise did, even before he read the script, was call Saul Chaplin, his associate producer on *West Side Story*. He asked Chaplin for his opinion of the project, for Wise had never seen the stage show.

Chaplin not only had been Wise's associate producer on *West Side Story* but was also a well-known musical supervisor. He'd won three Academy Awards for Best Scoring of a Musical: *An American in Paris* (with Johnny Green), *Seven Brides for Seven Brothers* (with Adolf Deutsch), and *West Side Story* (with Johnny Green, Irwin Kostal, and Sid Ramin). A few of the famous songs he has written are "Bei Mir Bist Du Schoen" (with longtime collaborator Sammy Cahn, recorded by the popular forties singing group the Andrews Sisters); "Anniversary Song"; and "You Wonderful You" (with Harry Warren and Jack Brooks).

When Wise called Chaplin to ask for his opinion of the project, he unknowingly put Chaplin in an awkward position. Chaplin had disliked the stage version of *Music* but was a good friend of Lehman's, so he wasn't sure if he could give Wise an unbiased opinion. He told Wise how he felt about the Broadway show but did mention that it had been the most successful of all the Rodgers and Hammerstein musicals and, in his opinion, contained their very best score.

This was enough to pique Wise's interest, so he read the script and thought Lehman had done an excellent job on the material. Then he bought the cast album and was very impressed with the music. Next he sent the screenplay to Chaplin and, this time, asked for his opinion of the actual script. Fortunately Chaplin was pleasantly surprised with Lehman's first draft and told Wise so. After reading through the script a second time and playing the score once more, Wise decided to take on the assignment.

Immediately after Wise told Zanuck of his decision to direct the film, Zanuck called Lehman into his office. His eyes gleamed. "Ernie, I've got a big surprise for you. Guess who would like to direct *Music*?"

"Who?" Lehman asked.

"Bob Wise!"

"No kidding!" Lehman exclaimed.

Zanuck stared at him a moment, then grinned. "You son of a bitch! *You* gave him the script, didn't you?"

"Who, me?" Lehman replied innocently.

And to this day Lehman has never officially admitted that it was he who smuggled that script out to Robert Wise.

DID YOU KNOW . . . ?

Three scenes that were filmed for the movie never made it into the final cut of *The Sound of Music*:

Scene 8
Maria is kneeling in prayer by her bed at the abbey when Sister Margaretta comes in to tell her that the Mother Abbess wants a word with her. Sister Margaretta escorts Maria to the hallway outside the mother's office. Maria waits there until the sister, who has gone in to announce Maria, comes back out to tell her she may go inside.

Wise and his editor, William Reynolds, elected to begin the scene with Maria waiting out in the hall; the sister then comes out and tells her that the mother is waiting for her, and Maria goes in.

Scene 20
In the middle of the "Do-Re-Mi" sequence, at the horse fountain, Liesl spots Rolf delivering telegrams. She invites him over to meet Maria. They cut out this scene because it interrupted the flow of the montage.

Scene 42
The night the Captain sings "Edelweiss," he walks out onto the terrace, and it is clear his thoughts are about Maria. The camera moves up to Maria's room, where she is gazing out the window, thinking about the Captain. Again, Wise felt this scene broke the flow and was unnecessary.

Liesl introduces Rolf to Maria. This scene was cut from the film.

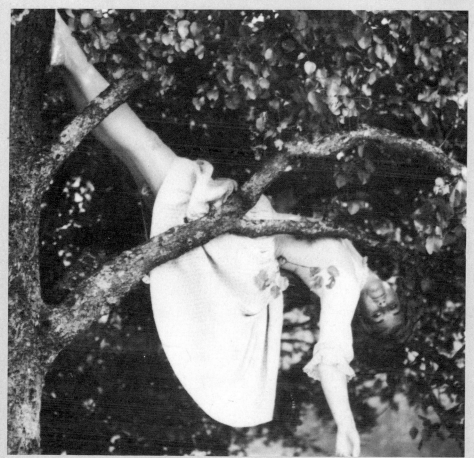

That's Larri Thomas, not Julie Andrews, hanging from that tree! This is one of the few scenes in which Larri, Julie's stand-in, is actually shown onscreen. It is, of course, the scene in which the Captain drives by and sees the "street urchins" dangling like monkeys from the trees, only to realize they are his children! No doubles were used for the "urchins"—the kids gladly cooperated.

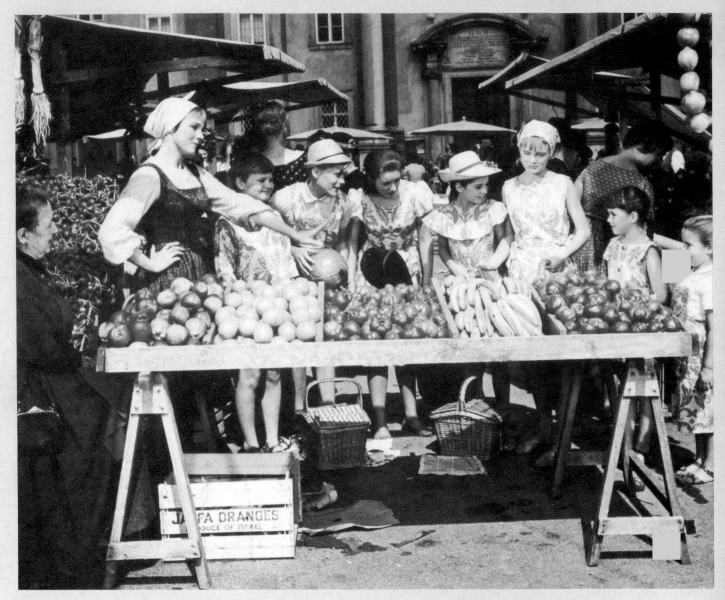

What's wrong with this picture? When the crew built the "marketplace," they made one mistake. If you look closely, you can see a crate of oranges marked "Produce of Israel." At the time this story took place, Israel was not yet a country!

PROCEED WITH CAUTION -- WATCH OUT FOR CHILDREN.

While Wise was conducting his talent search for the seven von Trapp children, he had so many youngsters coming in and out of his office that his associates put this sign on his door.

When Heather Menzies (who played Louisa) appeared in the movie SSSSSSS, she wanted to publicize the fact that she was finally breaking away from her Music image and accepting more adult roles. And break away she did. In August 1973, she posed nude for Playboy.

Florence Henderson toured in many Mary Martin shows. From 1961–1963, she appeared as Maria in The Sound of Music and performed in 35 North American cities. She and her agent met with Ernest Lehman soon after Lehman signed on to write the screenplay of the musical, but she was never considered for the film.

"When you read you begin with ABC . . ."

SCRIPT AND MUSIC

THE FIRST THING ERNEST
Lehman did after he was hired to
write the screenplay of *The Sound
of Music* was to read the original
play script. As he went through it
for the first time, he immediately
began rearranging and
eliminating songs. The play
started with the nuns chanting
"Dixit Dominus." Then, in the
following scene, Maria is seen
sitting high up on a tree branch,
looking over the meadow and
singing "The Sound of Music."
Lehman switched these two
numbers, wisely selecting the
more upbeat *Music* to open the
film.

In the stage version the
Mother Abbess and Maria sing
"My Favorite Things" together: it
is a song they both remember
from childhood. Lehman thought
the song might work better as a
vehicle to calm the children
during the thunderstorm. In the
play Maria and the children sang
"The Lonely Goatherd" in the
storm scene. Lehman decided to
use "Goatherd" later in the movie.

He deleted two of the play's
songs right away, both of which
are sung by Elsa and Max,
secondary characters in the story.
Elsa is the Captain's initial love
interest; Max is a family friend.

23

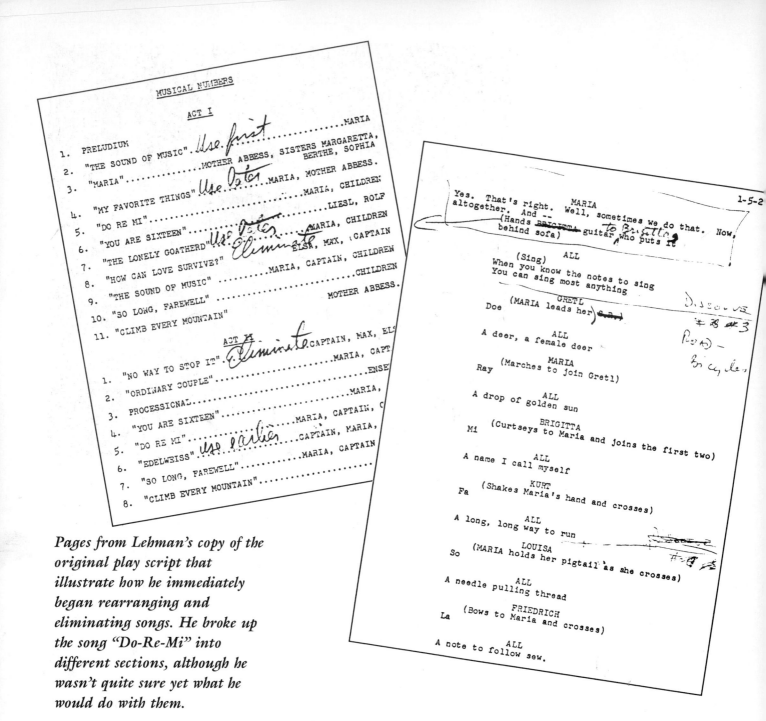

MUSICAL NUMBERS

ACT I

1. PRELUDIUM .. MARIA
2. "THE SOUND OF MUSIC" *Use first* MOTHER ABBESS, SISTERS MARGARETTA, BERTHE, SOPHIA
3. "MARIA" *Use later* MARIA, MOTHER ABBESS.
4. "MY FAVORITE THINGS" MARIA, CHILDREN
5. "DO RE MI" LIESL, ROLF
6. "YOU ARE SIXTEEN" MARIA, CHILDREN
7. "THE LONELY GOATHERD" *Use later* *Eliminate* .. ELSA, MAX, CAPTAIN
8. "HOW CAN LOVE SURVIVE?" MARIA, CAPTAIN, CHILDREN
9. "THE SOUND OF MUSIC" CHILDREN
10. "SO LONG, FAREWELL" MOTHER ABBESS.
11. "CLIMB EVERY MOUNTAIN"

ACT II *Eliminate*

1. "NO WAY TO STOP IT" CAPTAIN, MAX, ELS
2. "ORDINARY COUPLE" MARIA, CAPT
3. PROCESSIONAL ENSE
4. "YOU ARE SIXTEEN" MARIA,
5. "DO RE MI" MARIA, CAPTAIN, (
6. "EDELWEISS" *Use earlier* CAPTAIN, MARIA,
7. "SO LONG, FAREWELL" MARIA, CAPTAIN
8. "CLIMB EVERY MOUNTAIN"

Pages from Lehman's copy of the original play script that illustrate how he immediately began rearranging and eliminating songs. He broke up the song "Do-Re-Mi" into different sections, although he wasn't quite sure yet what he would do with them.

1-5-2

MARIA
Yes. That's right. Well, sometimes we do that. Now, altogether. And --
(Hands ~~Brigitta~~ guitar to ~~Brigitta~~ who puts it behind sofa)

(Sing) ALL
When you know the notes to sing
You can sing most anything

GRETL
Doe (MARIA leads her)

ALL
A deer, a female deer

MARIA
Ray (Marches to join Gretl)

ALL
A drop of golden sun

BRIGITTA
Mi (Curtseys to Maria and joins the first two)

ALL
A name I call myself

KURT
Fa (Shakes Maria's hand and crosses)

ALL
A long, long way to run

LOUISA
So (MARIA holds her pigtail as she crosses)

ALL
A needle pulling thread

FRIEDRICH
La (Bows to Maria and crosses)

ALL
A note to follow sew.

"How Can Love Survive?" is a number the two sing together to describe how Elsa and the Captain's love could never survive because, being rich, the couple wouldn't have the chance to struggle together like other, younger, poorer lovers. They sing "No Way to Stop It" to the Captain in an effort to convince him that what is happening in Germany is inevitable, so he

might as well go along with the political developments. Lehman thought these two songs were weak compared to the other songs in the show. He also wanted to scale down the roles of the secondary characters to streamline the story.

Lehman knew right away that he had to do something with "Do-Re-Mi." In the play it was a stagnant, 12-minute number sung

in the hallway when Maria first meets the children. He wanted to break the song up into different sections, but he wasn't quite sure yet how that could be accomplished.

It wasn't that the placement of these songs didn't work in the play. Obviously, considering the play's success, it did. But in adapting the play as a film, Lehman was given an opportunity

24

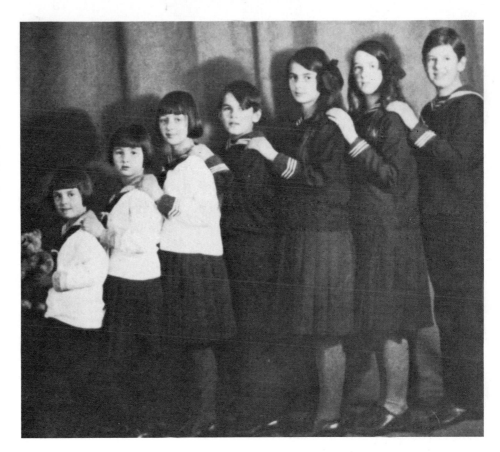

Maria's new family—
the real-life
von Trapp children.

to "open up" the story to the lavish beauty of the Austrian Alps. In a 1965 article Robert Wise wrote for the *Los Angeles Times* called "Why 'The Sound of Music' Sounds Differently," Wise described "opening up" a play as "taking some of the action out into the world in order to utilize the flexibility of the camera to emphasize mood and action that, on stage, can only be referred to or implied." For example, Maria didn't have to sit in one spot for the entire length of the title song. She could run up a hill, cross over a brook, dance through the trees. Likewise, with the magic of movie-making, "Do-Re-Mi" was not restricted to one single indoor setting. There could be quick cuts and dissolves to show other locations.

Lehman did not make these changes lightly. In fact, he had a

reputation for being unusually faithful to original material. "I remember one time someone criticized Ernie for changing only nineteen words from one of the shows he was adapting," recalled Dick Zanuck. "But I thought that was a compliment. Most writers try to put their handprints on the script, but he is smart enough to recognize when something works. That's one of the reasons I hired him to adapt *The Sound of Music.*"

Robert Wise agreed. "I've done a lot of films with Ernie, and one thing I know is he has a lot of respect for the original material."

Certainly Maria's story went through many changes as it evolved into an American musical film. The original story, from her book *The Story of the Trapp*

Family Singers went like this:

As a young postulant, Maria leaves Nonnberg Abbey to take a post as teacher to Captain von Trapp's bedridden daughter. After Maria meets the Captain, he proceeds to call the children in with his boatswain's whistle. The children—Rupert, Agathe, Maria, Werner, Hedwig, Johanna, and Martina—are just a little too perfect. However, Maria thinks the whistle is a great idea.

Maria teaches the children how to sing, and when the Captain comes in and hears them for the first time, he is overjoyed. He even joins in, playing along on his violin.

As times goes on, the Captain falls in love with Maria, much to the dismay of his fiancée, Princess Yvonne. One night the princess comes into Maria's bedroom and tells her

that the Captain is in love with her. Maria wants to go back to the convent right away, but the princess stops her. The princess knows that if Maria left now, the Captain would only fall more in love with her. The princess goes so far as to have a priest come in and speak to Maria to encourage her to stay. The priest tells Maria it is "the will of God" that she remain with the family.

Maria stays at the von Trapps', but she begins to ignore the Captain, which intrigues him even more. He finally breaks off his romance with the princess, but Maria continues to ignore him. Now that their father is unattached, the children ask him why he won't marry Maria, but he tells them that Maria doesn't even like him. The children then run to Maria and ask her if she likes the Captain. When the children relay to their father that Maria does indeed care for him, the Captain misunderstands, approaches Maria, and says, "The children say that you'll marry me."

Frightened by the prospect of marriage, Maria runs to the Reverend Mother and asks her if she should marry. The mother says it is God's will. Maria and the Captain marry in 1927, and in 1929 Rosmarie is born. Then, in May of 1931, Maria gives birth to Eleonore.

As Hitler begins his rampage through Europe, the Captain makes the mistake of taking his money out of a safe bank in England and depositing it all in an Austrian bank owned by a close friend. The Austrian bank folds, and the Captain loses his fortune. Now desperate for money, the von Trapps build a chapel on their property and begin renting out rooms to students of the Catholic university.

One of their guests is Father Wasner, who, with his vast musical knowledge, becomes their vocal director. One day the singer Lotte Lehmann overhears the family singing and insists they perform in the Salzburg Festival. The Captain is aghast at the thought of his family performing in public, but the group, along with Father Wasner, enters the festival and wins first prize. The von Trapps begin singing on Austrian radio and then

The real Maria might have approved of the Captain calling his children using a boatswain's whistle, but her fictitious counterpart found the practice appalling!

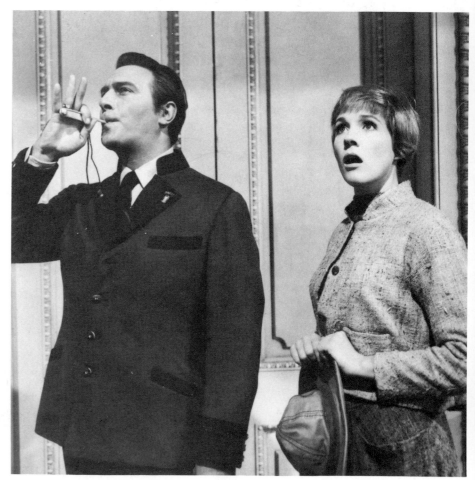

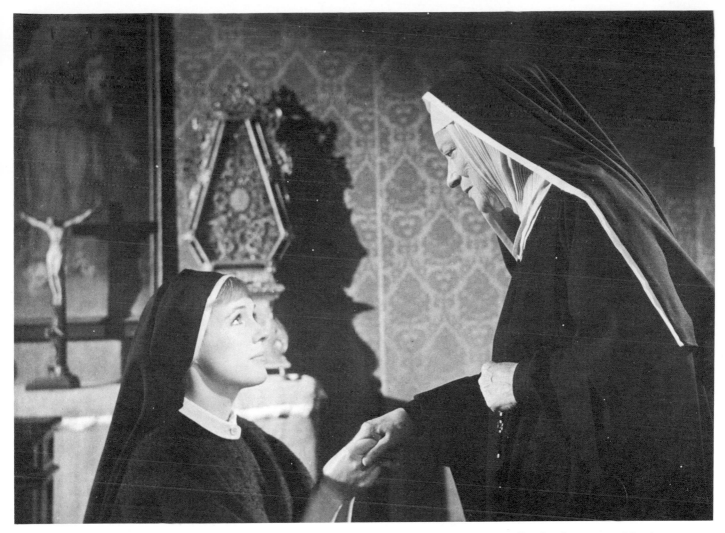

Julie Andrews, as Maria, seeks direction from the Mother Abbess.

give their first concert tour in Europe.

Germany takes over Austria, and the Captain is offered a commission in the German Navy. Then the eldest child, Rupert, who is now a doctor, receives notice from the Third Reich that there is a job waiting for him in Vienna. As they mull over these two orders, Hitler invites the family to perform for one of his parties. They know they cannot refuse Hitler three times, so they decide to escape. Maria is pregnant with her third child, but still they cross over the Alps into Italy, travel to England, and from there take a ship to America.

They begin touring the country, but their stay in America comes to an abrupt halt when their visas expire and they are forced to return to Europe.

The von Trapps begin touring overseas again, but Europe does not welcome them back with open arms. In each country they visit, the officials ask the family to leave after just a few months. It seems no one can understand why Austrians would voluntarily leave their country if they were not Jewish. The Europeans are convinced that the von Trapps must be Nazi spies.

When the family is finally allowed to move back to America, the von Trapps resume their performing. In their travels they come across

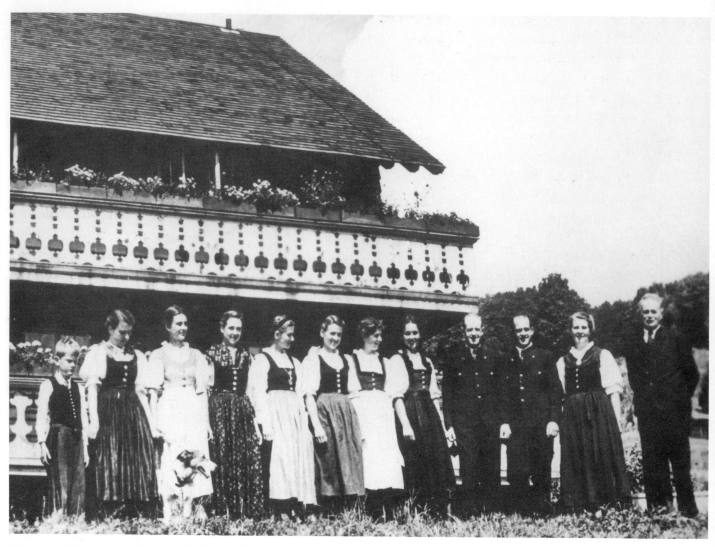

The von Trapps at the family lodge in Stowe, Vermont.

an old, run-down farmhouse high on a hill in the Green Mountains of Stowe, Vermont. They buy the farmhouse and the acres of property surrounding the home, and they rebuild the farm. This becomes their permanent home and is eventually turned into the vacation and ski resort the Trapp Family Lodge.

Whew! How could all that fit into one movie or play? Wolfgang Reinhardt's company, Divina Films, had resorted to making two films out of Maria's story. The German film scripts, credited to Herbert Reinecker with the

book by Georg Hurdalek, were closer to her original tale than any of the other versions would be. Still, the writers did fictionalize, and some of these fictional scenes managed to find their way into both the stage play and the American film version. For instance, the German writers created the bedroom thunderstorm scene and a scene where the children perform a shadow play for the princess.

On January 14, 1963, one month after he was hired, Lehman went to see the dubbed Fox version of the German films,

which combined *Die Trapp Familie* and *Die Trapp Familie in Amerika*. Lehman was not very impressed with *The Trapp Family* and used the playscript and Maria's book *The Story of the Trapp Family Singers* for most of his source material. But regardless of where his inspiration originated, Lehman enhanced his reputation for taking good material and making it even better.

For example, Lehman transformed the German film's shadow play into the marvelous "Lonely Goatherd" puppet show.

He also rethought how to convey Maria's emotional struggle as she leaves the abbey for the first time. In Maria's book she recounts that when she left for the von Trapp house she gave herself a mental pep talk, trying to convince herself that this was just a new adventure. In the German film the writers used narration over the action to communicate her internal monologue. In Lehman's version Maria's thoughts were externalized through the energetic charm of "I Have Confidence," a musical number conceived specifically for the Fox film.

The emotional impact of the final film was due in large part to Lehman's marvelous job of taking the best from both the German films and the play. In the German film the princess (who became Frau Schraeder in the play and Baroness Elsa Schraeder for the film) tells Maria that the Captain is in love with her. In the play, Brigitta, not the princess, tells Maria of the Captain's feelings. Lehman had Elsa tell Maria but declined to use the rest of the German story line, in which the Captain, upon finding out what the princess has told Maria, breaks off his engagement. He then rushes up to Maria's room and stops her from leaving by proposing to her. In Lehman's version, Maria, alarmed by the Baroness's news, packs her bag and returns immediately to the safety of the abbey.

In *The Trapp Family*, Maria's wedding scene is followed by one in which Maria has her first baby. Father Wasner then meets the family and is taken in as one of their own. Next the Captain loses his money, as in Maria's original story, but the family flees Austria not because the Captain is forced to join the German Navy but because he hits a Nazi officer when the officer orders him to raise the Nazi flag.

While Lehman's job was to expand upon a successful play, Howard Lindsay and Russel Crouse's task had been to scale down the German films into play form for the New York stage. They structured the story line much more dramatically, condensed the time frame of the story, changed events (even going so far as having Maria and the Captain marry at the time of the Anschluss), and ended the play with the family's escape rather than in Vermont.

Richard Rodgers wrote in his autobiography, *Musical Stages*, "Howard and Russel tried to steer clear of making [*The Sound of Music*] one more old-fashioned dirndl-and-lederhosen Austrian operetta, and to keep the plot believable and convincing. Admittedly, it was a sentimental musical, but the truth is that almost everything in it was based on fact. No incidents were dragged in to tug at heart strings. This, more or less, is what had happened."

Well . . . more or less. First of all, the character's names changed. Maria's maiden name became Rainer—actually Maria's mother's maiden name and the name of her Tyrolean ancestors, who were singers and had toured Europe—and all the children's names were different. Second, several of the characters were completely transformed. Rupert, the eldest boy, became Liesl, the eldest, lovesick girl. Lindsay and Crouse then created a romance between Liesl and Rolf, a young Nazi, thus adding even more tension to the story line. The von Trapps' great friend and music mentor, Father Wasner, became the urbane and cynical Max, who, like Father Wasner, was instrumental in getting the family to perform at the festivals.

The play altered a number of other incidents as well, but all these changes created more conflict, the essence of good drama. The Nazi issue, for example, became a strong plot device early in the play, so much so in fact that Elsa and the Captain break up in the play not so much because of his love for Maria but because they disagree politically! By contrast, in the combined version of the German films, the Nazi angle was hardly played up at all. The Nazis are there at the end, of course, to chase the von Trapps up the mountain. But in a story whose entire climax revolves around Hitler taking over Austria, the Nazis are not even a threatening element until the middle of the story.

The other major change in the play was, of course, the music. According to Hugh Fordin's biography of Hammerstein, *Getting to Know Him*, Rodgers and Hammerstein began writing

the music in March 1959. This was one of the few Rodgers and Hammerstein musicals for which Hammerstein wrote only the lyrics, not the libretto. Lindsay and Crouse wrote up an in-depth outline of the story for Rodgers and Hammerstein to work with. Using those 60 pages, the musical team figured out where to intersperse songs and decided on temporary titles for them. Then they began writing the songs.

Rodgers wrote in his autobiography:

> It was essential that we maintain not only the genuineness of the characters but also of their background. "The Sound of Music," the first real song in the play, was an arm-flinging tribute to nature and music. "Do-Re-Mi" offered an elementary music lesson that Maria employed to ingratiate herself with the von Trapp children. "My Favorite Things," a catalogue of simple pleasures, had a folkish quality, while "The Lonely Goatherd" and the instrumental "Laendler" evoked the atmosphere of the Austrian Alps. "Climb Every Mountain" was needed to give strength to Maria when she left the abbey and at the end to the whole family when they were about to cross the Alps.

Richard Rodgers wasn't worried about authenticity. "I didn't go to Siam to write *The King and I*, and I didn't go to Vienna to write *The Sound of Music*," he once told Irwin Kostal, who adapted the score for the American film. But Rodgers did strive for a measure of realism in his handling of the Latin chant "Dixit Dominus." He even contacted the Reverend Mother who was head of the music department at Manhattanville College in Purchase, New York, and she generously invited him to a few of her concerts.

Ironically, the one song that everyone thinks *is* an authentic Austrian folk song is "Edelweiss," which happens to be the last song Rodgers and Hammerstein ever wrote together. Hammerstein died in August 1960, nine months after the play opened. He knew he was dying when he wrote the number, which makes the simple song about a man's love for his country even more powerful. The last lyrics Oscar Hammerstein II ever wrote were for the song, but they were discarded from the final version. They went:

> Look for your lover and hold him tight
> While your health you're keeping.

Lehman knew all along that the marvelous Rodgers and Hammerstein music was the star of the show. In a March 7, 1963, memo to Willy Wyler, who had not yet been replaced by Wise, Lehman reiterated some of the suggestions Wyler had made upon reading the first 30 pages of the screenplay. "This picture is not to be approached as a 'play with music.' It is not to be a picture in which we feel slightly apologetic every time anyone sings. On the contrary, our aim is to be slightly apologetic every time anyone *talks*."

Lehman had written 30 pages of the screenplay but then switched over to the outline form so that Wyler would have something to go by when they went to Salzburg to scout locations. Even in this draft, he had already started to add scenes and elements that were not in the play but that gave more depth to the characters and the situations. Lehman began, for example, to toy with the idea of the children's hostility toward their new governess. The play did not suggest any of this animosity, yet there had to be a reason the children had had so many governesses. He also added a dinner scene in which Maria has her first meal with the family. The German filmmakers had included such a scene, but it had not accomplished much. In Lehman's outline version he used the dinner table scene to show Maria's embarrassment at her ignorance of table manners (this was eventually played down in the film) and, again, to add to the hostility, especially Liesl's, that all of the children initially felt toward their new teacher.

The stage version was also a little too politically heavy-handed at times, something Lehman made an effort to play down in the final drafts. But in the outline some of that heaviness remained. One scene, which was later excised, is a perfect illustration. At the ball the

Captain throws for Elsa, the guests, including Maria, are all sitting down to dinner, and Elsa begins to talk about appeasing the Nazis. Maria cannot resist saying something highly patriotic, and the Captain is obviously moved.

The outline also had a somewhat different ending from the final film version. Lehman knew he had to make the climax more suspenseful, so in the outline he added a car chase between the von Trapps and the SS men. Distrustful of their motives, the Nazis escort the family to the concert. On the way the Captain decides to escape. He tries to lose them, and a chase begins. The family eventually gets out of the car and tries to get lost in the festival crowd, but the SS men quickly surround them.

Forced to sing at the concert, they devise another escape and, after the concert is over, try leaving through the abbey garden. Rolf discovers them but, as in the play, he lets them escape, and off to the mountains they go. Later, Lehman would make further changes in these final scenes; in the finished film, of course, there is no car chase, and Rolf does reveal the von Trapps' presence to the other Nazis. The family is able to make their escape with the help of Sister Berthe and Sister Margaretta.

Lehman's outline was completed by the end of May 1963. Less than a week later, he and Roger Edens traveled to Austria, where, as discussed in Chapter 1, they met Willy Wyler

and began looking for locations to use in the movie. They were in Salzburg for 15 days and scouted approximately 75 locations.

Despite all the problems Lehman had with Wyler, the scouting trip turned out to be very successful. The beauty and vibrancy of the city filled Lehman

with ideas for broadening the stage play, and he found images he would later recapture in his final screenplay. Having seen Salzburg and its environs, Lehman could now begin to envision exactly how he could use "Do-Re-Mi" to advantage. In retrospect, his conceptualization

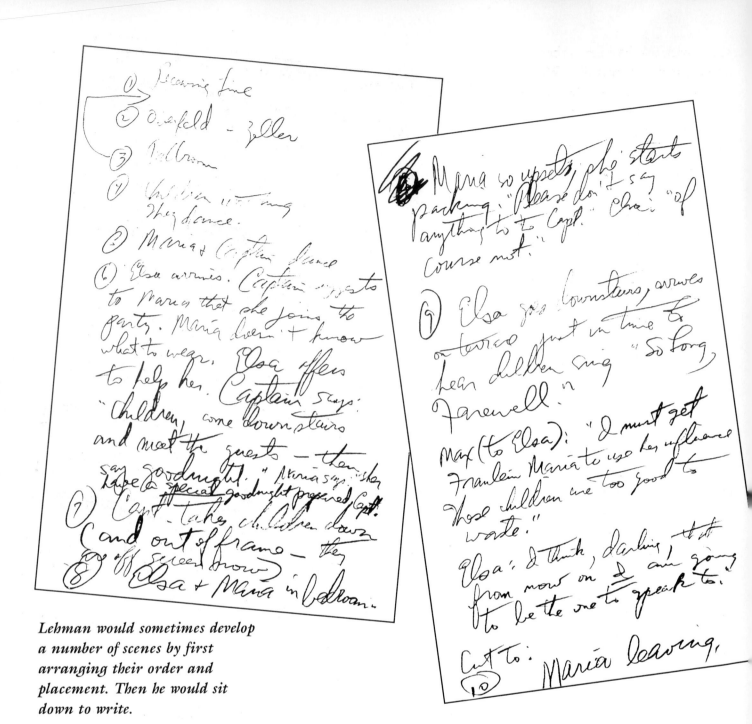

Lehman would sometimes develop a number of scenes by first arranging their order and placement. Then he would sit down to write.

of the sequence was brilliant. It not only made the song more visually interesting, but by breaking it up into different locales and using different costumes he reached two important objectives. First, he showed the passage of time. The song begins with the Captain leaving for his visit and ends when he comes home with Elsa. This gives us a chance to see what the children and Maria have been doing together while he is away. Plus, the montage shows the rapport developing between Maria and her charges, who begin by mistrusting her and end up loving her. This was the perfect way to show the gradual change in their attitudes.

"I took pictures with my home movie camera while I was in Salzburg," recalled Lehman, "and that helped when I got back home. I remember one time my wife and I took one of those carriage rides. That's where I got the idea for using that in the 'Do-Re-Mi' segment."

One of the first places Lehman and Wyler visited was the Nonnberg Abbey. They wanted to

speak with the Mother Abbess about Maria. "It was like 'Who's Maria?' " Lehman recalled of his meeting with the Reverend Mother. "The Reverend Mother hardly remembered who Maria was. Maria had made it seem like she was the most important thorn in their side. I think Maria exaggerated her importance at the Abbey enormously in the story."

When Wyler and company returned to L.A. and Lehman recounted his experiences with Willy Wyler for Dick Zanuck, Zanuck immediately began pressuring Lehman to rush through the first draft of the screenplay.

Lehman had his outline and first 30 pages of his screenplay, the play script, the Broadway cast album, location photos, and Maria's autobiography, which had become worn and dog-eared from overuse.

"I was working all by myself in my office," Lehman recalled. "I never even had a secretary in the next room. It made me uncomfortable. So, even when I was at Fox, I kept my secretary over at MGM, where I'd just finished *The Prize*, and then I'd send her the pages to type up."

Of the now famous opening scene, in which Maria, brimming with life, escapes the abbey for a walk in the mountains and sings about the outdoors, Lehman said, "I was sitting at my desk with my eyes closed, and I just visualized the whole opening number. I'd never been above the Alps because I wouldn't go up in the plane

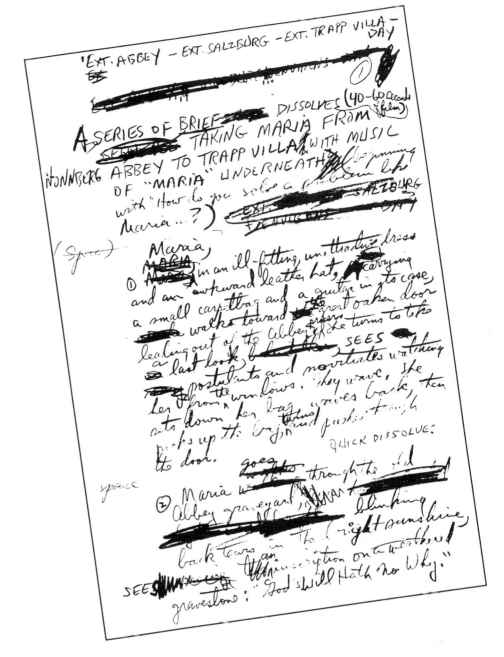

with Wyler, but I just kept playing the cast album, and I imagined it."

Lehman turned in the first draft on September 10, 1963, in about half the time it would normally have taken him to write a screenplay had he not been so anxious for Wyler's reaction. Amazingly, the quality of his work did not suffer. In fact Lehman did more than just open up the play of *The Sound of Music*. He added much more humor to

Lehman often wrote in longhand on legal-size paper. He'd then give his notes to his secretary, stationed across town at MGM, and she would type them up. This is the writer's first attempt at the scene that would eventually become "I Have Confidence."

the story. Characters became more distinct, lively, interesting. Lehman added more sparring, more interplay between Maria and the Captain at their first meeting so that you could see their emerging chemistry. The dialogue became much more witty and inventive. Lehman managed to capture Maria's spirit and to focus viewers' emotions in a story that included an overabundance of dramatic elements.

Lehman also departed from his original outline. Elsa and Max became less political, and both parts were cut considerably. He added scenes that were not in the play or the outline, such as the berry-picking scene and the scene in which the children go to the abbey to look for Maria. As mentioned, he also took out the car chase at the end. The family still hides in the abbey garden, but this time Rolf does turn them in.

Robert Wise came on board the picture in October 1963. A few days later he wrote a letter to playwright Robert Anderson, who was working on the screenplay of *The Sand Pebbles*, which said in part:

I do feel a definite sense of embarrassment for having laughed at one point about Ernie doing "Music" and now finding myself on it too, but he had done a damned good job and has improved the original so very much that I do think that, if given the proper treatment and cast, we can get a helluva good film and a popular one. I'm not kidding myself—it's no "West Side Story." But if we can fight off too much sentimentality and the syrup that is inherent in the basic material and give it an exciting cinematic treatment, perhaps we can make it a much better picture than it was a play. What am I talking about—the picture should only be as successful!

Once Wise was hired, Dick Zanuck asked Lehman to take a four-week vacation so that the director could catch up. So Lehman went off to relax in Palm Springs while Wise traveled to Salzburg to scout locations with his crew (see Chapter 4). When he returned, he started working on the script. Wise, of course, had his own vision of how this film should look and play, but unlike Wyler, Wise was in complete agreement with his colleagues. He wasn't about to use tanks and guns, but he did want to get rid of as much "sugar" as possible. "We were all agreed that the more realistic medium of film demanded that the material be treated differently than it was on stage," he wrote in his *Los Angeles Times* article. "The sentimentality and 'gemütlichkeit' that worked fine on stage could easily become heavy-handed on the screen."

The changes Wise made in the script itself were subtle. He did, however, have some big disagreements with Lehman. "I read the script and liked it very much," recalled Wise, "but I had problems with the aerial opening. I thought we were just copying ourselves because we'd used the same type of opening for *West Side Story*."

When Wise informed Lehman of his reservations, Lehman replied that he was perfectly happy to go in another direction if Wise could come up with something better. Wise and Saul Chaplin, who had agreed to act as associate producer on the film, worked with the opening for a few days and then finally decided that Lehman was right. "I realized that we just had to go along with what was right for that film. And now I think people mention the aerial opening of *Music* more than the opening of *West Side*!"

They had another disagreement, but this time Wise scored a victory. Wise and Chaplin wanted to eliminate the song "An Ordinary Couple," which, in the stage version, Maria and the Captain sing after they confess their love for each other. It's a song about how they will be an ordinary couple and live a long life with their children at their side.

"It was a song two old people might sing to each other," Wise argued, "not a young, vibrant couple."

Lehman wanted to keep it in, although he admits now that Wise was right. Even Richard Rodgers acknowledged disliking the number. He confided to Irwin Kostal over lunch one day, "I never liked that song. It's about two people telling each other how

"THE SOUND OF MUSIC"

BEFORE MAIN TITLE AND CREDITS

① FADE IN:
HIGH PANORAMIC SHOT OF THE AUSTRIAN ALPS - LATE
AFTERNOON IN SUMMER

2ND UNIT.

I will not describe the specific locations. I will
tell you the mood, the feeling, the effect that I
would like to see. We are floating in UTTER SILENCE
over a scene of spectacular and unearthly beauty. As
far as the eye can see are majestic mountain peaks,
lush green meadows, deep blue lakes, the silver
ribbon of a winding river. Isolated locales are
selected by the camera and photographed with such
stylized beauty that the world below, however real,
will be seen as a lovely never-never land where stories
such as ours can happen, and where people sometimes
express their deepest emotions in song. As we glide
in silence over the countryside, we see an occasional
farm, animals grazing in the meadows, houses nestling
in the hills, the steeples of churches, a castle
surrounded by water. And now something is subtly
happening to us as we gaze down at the enchanted world.
FAINT SOUNDS are beginning to drift up and penetrate
our awareness...the tinkle of cowbells...the approaching
and receding song of a swiftly passing flock of birds...
the call of a goatheard echoing from one mountain side to
another. And with this, we are aware that the ground
seems to be rising. The treetops are getting closer.
Our speed seems to be increasing. Without knowing it,
we have started to approach a mountain. A MUSICAL NOTE
is heard, the first prolonged musical note that leads to
"THE SOUND OF MUSIC". Faster and faster we skim the
treetops. And then suddenly we "explode" into:

② MARIA ON HER MOUNTAIN-TOP

WITH OR WITHOUT MANTILLA? WILL WE KNOW SHE'S A POSTULANT WITHOUT?

It is a soft and verdant place with a magnificent
panorama of the surrounding countryside. Dressed in the
black mantilla of a postulant, gazing about at all this
breathtaking beauty, is MARIA. As the musical bridge
ends, she begins to sing "THE SOUND OF MUSIC", and the
CAMERA will drift with her as she moves about:

*The first two pages of the script,
with hand-written notes from
Robert Wise. The first paragraph
shows how Lehman described the
now-famous aerial opening. The
second page illustrates how Wise
intended to break up the opening
song into a series of sections. He
then planned to shoot the number
in pieces.*

2 Cont.

① *HELICOPTER*
② *C.U.* + *TRAVELING*

MARIA
The hills are alive
With the sound of music,
With songs they have sung
For a thousand years.
The hills fill my heart
With the sound of music
My heart wants to sing
③ Every song it hears.

My heart wants to beat
Like the wings
Of the birds that rise
From the lake to the trees,
My heart wants to sigh
Like a chime that flies
④ From a church on a breeze,
To laugh like a brook
When it trips and falls
Over stones in its way,
To sing through the night
⑤ Like a lark who is learning to pray -

I go to the hills
When my heart is lonely,
I know I will hear
What I've heard before.
My heart will be blessed
With the sound of music
And I'll sing once more.

The MUSIC STOPS. In the silence, DISTANT CHURCH BELLS ARE
HEARD. Maria reacts with alarm. She starts to run. And
as a rousing, full-orchestra take-away of "THE SOUND OF
MUSIC" begins we:
GRABBING MANTILLA ON WAY

CUT TO:

③ A SERIES OF STYLIZED SHOTS OF THE MAGNIFICENT BELL-TOWERS
OF AUSTRIA'S CHURCHES AND ABBEYS. Over these shots, THE
MAIN TITLE AND CREDITS APPEAR. The bells are heard
2ND UNIT beneath the music, which now includes the strains of other
tunes..."You Are Sixteen"..."My Favorite Things"..."Do Re
Mi"..."Climb Every Mountain". And as we come back to
"The Sound of Music" for a soft and gentle finish, the
MUSIC ENDS, THE BELLS FALL SILENT AND THE LAST CREDIT
FADES over:

④ LONG SHOT OF MARIA'S ABBEY - DUSK

It is a place of stark and simple beauty, weathered by
the years. Over the shot, a SUB-TITLE appears briefly,
and fades:

WITCHING HOUR SHOT

Cont.

Rodgers, Wise, and Chaplin meet in New York to discuss the new songs for the movie.

ordinary they are. She was a nun who left the convent, and he was an honored naval Captain. They were far from ordinary!"

Wise, Lehman, and Chaplin agreed to replace "An Ordinary Couple" with a more romantic song, which they would ask Rodgers to write. They also liked the idea for a completely new song to be used when Maria leaves the abbey and is on her way to the von Trapp home. Their working title for this was "Walking Soliloquy."

All of these musical changes presented a challenge. Contractually, Richard Rodgers had to approve any alterations in the score and was to have the choice of composing any agreed-on new songs himself if he so desired. Since Hammerstein had

died, Rodgers would probably want to do the lyrics himself. This was obviously a very sensitive and important issue, one that had to be discussed face to face with Richard Rodgers, so Wise and Chaplin flew to New York to meet with the composer in his Madison Avenue office. Chaplin was a friend of Rodgers's, but this was the first time Wise had met him. After a brief introductory chat, they all went off to lunch at the Four Seasons, Rodgers's favorite restaurant.

It was here that Wise and Chaplin broached the subject of changes and additions to the score. Rodgers had no problem with dropping the two songs for the secondary characters. He understood the reasoning behind the elimination and agreed at

once. Then Chaplin brought up the idea of a new song to replace "An Ordinary Couple." Chaplin explained what was needed, and after listening to an elaboration of why a new song could benefit the film, Rodgers started nodding his head. "You're right," he said. "It *is* kind of an ordinary song. In fact, if Oscar had not been so ill when we were trying out the stage version of the show, we would have written a replacement song back then."

Then Wise and Chaplin told Rodgers about the idea for the "Walking Soliloquy." Chaplin envisioned the song breaking down into three parts, with each verse mirroring Maria's emotional growth until the song climaxes in the phrase "I have confidence in me."

1. When Maria first leaves her secure world at the abbey for the unknown life at the von Trapp home, she is uneasy about the assignment; she doesn't want to leave the abbey and isn't sure she can handle the job of governess to seven children, yet she knows it is God's will.

2. As she walks toward the bus that will take her to the villa, her faith takes over and she begins to realize she doesn't have to be afraid.

3. Finally she talks herself into this new adventure, and by the time she arrives at the Captain's home she is anxious to begin her new post.

Once again, Rodgers responded enthusiastically to the idea of a new song. The luncheon ended with Rodgers agreeing to write both the music and the lyrics for the two new numbers.

One month later, with most of the adult casting done, Wise and Chaplin were in New York interviewing child actors. They met Rodgers in his office and listened to the two new songs Rodgers had just completed.

Rodgers first played them the ballad "Something Good," and Chaplin and Wise were thrilled with the new song. It was everything they had hoped for. Then Rodgers played "I Have Confidence."

Chaplin was very disappointed. It was a rather slow, laborious number, not at all as upbeat as he had expected it to be. Chaplin told Rodgers that he

wanted to take the song back to California with him and work out exactly what he was aiming for. Rodgers agreed.

Chaplin returned to Los Angeles, and soon he wrote a letter to Rodgers reiterating all his objectives. Maria's character was to go through an emotional metamorphosis: she begins by being lost, fearful, and unsure, and by the end of the song she is brimming with confidence and spirit. The song should show the progression of her change in attitude.

After reading Chaplin's letter, Rodgers created what was essentially a different song for the "Walking Soliloquy." This one was more upbeat and lively, yet Chaplin felt that Rodgers still had not captured the growth that Maria was supposed to undergo between the beginning and end of the song.

Through letters and phone calls Rodgers and Chaplin finally agreed that Chaplin should rewrite the song himself and that they would then decide which version to use. As uneasy as

Chaplin was with writing for the legendary composer, he had gotten the impression that Rodgers felt he couldn't or wouldn't write it himself.

Chaplin called in Ernest Lehman and, using both some of Rodgers's melody from his try at "Confidence," parts of the introduction to the song "The Sound of Music" (which had been discarded for the film), plus Chaplin and Lehman's own lyrics and music they rewrote the beginning of the number. When they were finished, they played the song for Wise. After Wise gave his OK, Chaplin secretly hired Marni Nixon to come into the studio and record the number to send to Rodgers. Marni, a well-known "ghost" singer, had dubbed Deborah Kerr's singing voice in *The King and I*, Audrey Hepburn's in *My Fair Lady*, and Natalie Wood's in *West Side Story*. She would also make her onscreen film debut in another well-known musical, *The Sound of Music*.

Chaplin wanted Nixon's recording kept quiet because he didn't want Julie Andrews, who

TWENTIETH CENTURY-FOX FILM CORPORATION
INTER-OFFICE CORRESPONDENCE

DATE 13 March 19-64

TO: ROBERT WISE FROM SAUL CHAPLIN

SUBJECT "THE SOUND OF MUSIC"

Richard Rodgers has now completed, and we have accepted, the words and music to two new songs entitled:

"I HAVE CONFIDENCE IN ME"

and

"SOMETHING GOOD"

SC:bal
cc: Messrs. Frank Ferguson Lionel Newman
 George Stevenson Urban Thielmann

by now had been signed to play Maria, to know that she would be recording a song that had not been written entirely by Richard Rodgers. As it was, she kept asking when her new song would be ready, and Chaplin kept stalling.

Finally Chaplin sent Rodgers the Marni Nixon version of his song, and Rodgers sent back a telegram stating that he liked his own version better, but he gave Chaplin permission to use the new version if he so desired.

And Julie Andrews? She didn't find out until after filming was completed that the song she sang in the movie wasn't written entirely by the old master himself. (It must not have had a big impact on her; when reminded of the incident years later, she recalled only that she'd heard rumors to the effect that Rodgers hadn't written the song, not that he actually hadn't written it.)

Lehman completed the second draft of the screenplay on December 20, 1963. But the script was far from being final. There would still be many revisions to make and many people to give suggestions. Lehman welcomed them all. One day Robert Wise came into his office and told him that Boris Leven, the production designer on the picture, had suggested that the location of the climax scene be changed from the abbey garden to a graveyard. Lehman thought the idea was terrific and made the change.

Maria von Trapp was one of the first to suggest changes, before one word of the screenplay had been written. Just after Lehman was hired to write the script, Maria called Lehman to tell him she had been very unhappy with the way her husband was characterized in the play. She wanted to sit down with the writer and set the record straight. So, on January 24, 1962, Lehman met Maria for lunch in New York at the King Cole Grill in the St. Regis Hotel.

"It was interesting meeting her, but I knew that she was going to be sort of a force," Lehman reminisced. "My impression was that she was a powerful woman, great at promoting herself. Maria von Trapp had a good thing going for her. She took advantage of it. She *became* the Trapp Family Singers."

As it turned out, Lehman soon realized, Maria was quite helpful. She told Lehman about her life at the abbey, and he was able to use some of the information she gave him in his script. For instance, Maria told Lehman that it was against the rules at the abbey for a nun to look out the window. Why, the director of the school hadn't looked out the window in 50 years! If a postulant disobeyed this rule, she had to kiss the floor. So, Maria said, she used to kiss the floor *first*, then disobey.

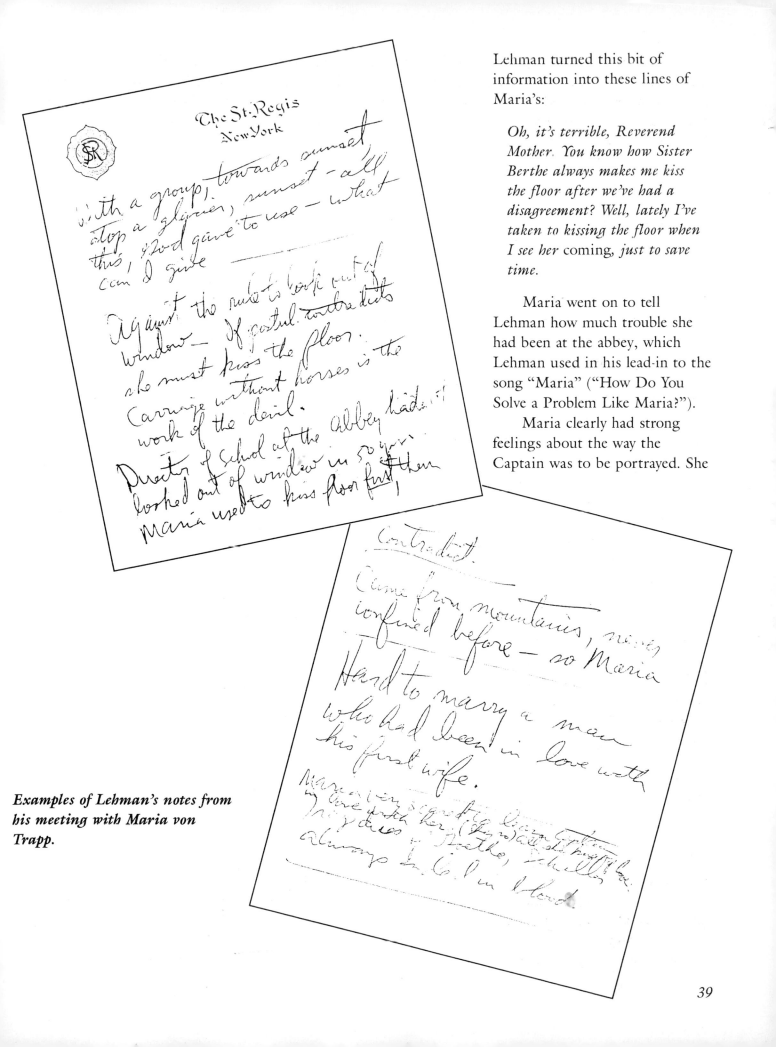

Lehman turned this bit of information into these lines of Maria's:

Oh, it's terrible, Reverend Mother. You know how Sister Berthe always makes me kiss the floor after we've had a disagreement? Well, lately I've taken to kissing the floor when I see her coming, *just to save time.*

Maria went on to tell Lehman how much trouble she had been at the abbey, which Lehman used in his lead-in to the song "Maria" ("How Do You Solve a Problem Like Maria?").

Maria clearly had strong feelings about the way the Captain was to be portrayed. She

Examples of Lehman's notes from his meeting with Maria von Trapp.

39

Gone but not forgotten! This postcard was sent to Lehman by the company when they were in Salzburg to begin shooting the film. Lehman had already left the picture to begin work as writer/producer on **Who's Afraid of Virginia Woolf?**

felt that his character was much too dull and strict. She told Robert Wise the same story nine months later, after he signed on to direct the film. She called Wise a couple of times from her home in Vermont and wrote him a few letters. But Wise got the feeling that she was not only asking that the character of her husband be changed; he felt that she wanted to be employed as an adviser on the film.

"When you're doing a film based on a true character," explained Wise, "the last thing you want is the actual person on the set. His or her memories of what happened and your *fictional* account don't always mesh. Plus, I'd heard stories about Maria when they were doing the play. I'd heard that she'd wanted to get into the act there, too. From what I was told, she was a pretty strong character."

In a memo to Dick Zanuck on March 19, Wise explained how he was going to handle "the old gal":

I'm going to write her to this effect—diplomatically but firmly—that our movie is a musical based loosely on the Trapp family. It is not a documentary or realistic movie about the family and, therefore, we feel we must approach the script and all aspects of the movie with complete dramatic freedom. Our goal is

40

to make a really fine and moving film, one that all of us, from Maria von Trapp on, can be proud of.

Messages are from Saul Chaplin, Robert Wise, Julie Andrews, Maurice Zuberano, Pat (Mrs. Robert) Wise, Richard Haydn, and Eleanor Parker.

Christopher Plummer was another champion in the fight to refashion the character of the Captain. "I wanted to give him a little edge," said Plummer, "a little humor. The character didn't have much substance. He came off as a fearful square. I wanted him to be equal to Maria von Trapp."

Wise agreed. "We needed somebody with a little bit of a dark side now and then. Someone stronger, more forceful and definitive than the Captain appeared to be in the stage show. That's why I had chosen Chris."

Plummer wrote Wise a letter explaining his own ideas to change the character, and Wise sent the letter to Lehman. Plummer's basic objective was to make the Captain more worldly and complex, which would make the character and Plummer's acting much more interesting. He suggested a few ways to accomplish this.

First, he wanted to give the Captain a wry kind of humor that the character would use to cover up his own inadequacies; second, he wanted to show the contrast between his relationships with Elsa and

Maria through his dialogue with his two leading ladies—his conversations with Elsa would have a more sophisticated, playful quality, while his scenes with Maria, as he is falling in love with her, would be more down-to earth, human. Third, he wanted Rodgers to write a solo for him to sing, showing his inner struggle as his love for Maria grows.

Plummer also made a suggestion for action in a scene that originally had been used in the play. This was the scene in which the Captain, hearing the children singing "The Sound of Music" for the first time, is surprised to feel himself compelled to sing along; Lehman incorporated this action into the script.

Plummer and Lehman locked themselves in a room together for days and worked on the character. "I've never worked with an actor who was so intelligent about how his scenes should work," said Lehman. "This guy insisted that I ＿ a good writer."

Lehman used many of Plummer's suggestions, and Plummer seemed satisfied enough. Still, he confessed later, he never actually liked the character of Captain von Trapp. "I've played the greatest parts that were ever written," said Plummer 27 years later, "and yet Captain von Trapp was the hardest part I have ever played. He was so dull! I had to reach to give him any kind of sense of humor. I once met a poor relation to the von Trapps. A cousin. He lived outside of Salzburg. He was a sculptor. I asked him what his uncle was really like, and he said he was the dullest man who ever lived!"

Lehman completed the final revision of the script on March 20, 1964, and his job was done. But his next assignment was just as exciting—writing and producing the film version of Edward Albee's *Who's Afraid of Virginia Woolf?* starring Elizabeth Taylor and Richard Burton. He said good-bye to Wise and Julie Andrews and Christopher Plummer, and he packed up his office and left. It was hard to separate himself from a project that had meant so much to him, but he knew his screenplay was in capable hands.

BIOGRAPHIES

Robert Wise

ROBERT WISE WAS BORN ON September 10, 1914, in Winchester, Indiana, the son of a meat packer. As a youngster he became a movie fan, going to the dime matinees as many as three times a week. From this early interest grew his desire to become a part of the magic he saw on the screen. Another of Wise's interests was journalism, which he pursued at Franklin College; but when the depression hit the country, Earl Wise's meat packing business was

seriously affected, and his son was unable to continue his studies beyond his freshman year. In 1933 Robert Wise's brother David, who worked as an accountant at RKO Studios, found his younger brother a job as a messenger in the film editing department. For $25 a week Wise shuffled film around the lot; occasionally he was allowed to inspect or patch it. He was fascinated by the way movies were cut, and before long he was given

the opportunity to try his hand at the art. After nine months he was made an apprentice sound effects editor and later a music editor.

Wise recalls one period when he sat hunched over a moviola (a film-viewing machine used in editing) for a 72-hour stretch, with only two hours' sleep, to help get George Stevens's *Alice Adams* ready for a sneak preview. Another time he pulled thousands of feet of film from an abandoned movie and, with sound effects

cutter T. K. Woods, spent hours putting together a 10-minute short subject. It brought Wise's first film credit and a $500 bonus from the studio.

After a period of time Wise was promoted to assistant film editor, and finally, in 1938, he became a full-fledged film editor. His many editing credits include *The Story of Vernon and Irene Castle*, *The Hunchback of Notre Dame*, and *My Favorite Wife*. The highlight of his "cutting" days came when he edited the movie many regard as the greatest film of all time—*Citizen Kane*. The skill and imagination Wise demonstrated in *Kane* led director Orson Welles to hire him again on his movie *The Magnificent Ambersons* (1942). Then came an unexpected opportunity. While Welles was shooting a film in South America as part of the U.S. government's good neighbor policy, studio heads discovered from previews that *Ambersons* needed some additional scenes. In Welles's absence the studio assigned Wise to direct the scenes.

After that, Wise began bombarding studio executives with requests to direct. Then, in 1943, he was editing *The Curse of the Cat People* when its director, far behind schedule, was fired. Wise was given the job, and the movie became a hit. His career as director was now firmly established.

Over the years Wise has directed films on so many different topics, themes, and moods that he is known as one of the most versatile directors in the business. A sampling of his credits before *Music* includes: the boxing picture *Somebody Up There Likes Me*, the horror film *The Haunting*, the science fiction cult favorite *The Day the Earth Stood Still*, and the Oscar-winning musical *West Side Story*.

It was his brilliant work on *West Side Story* that paved the way for his directing *Music*.

Julie Andrews

JULIA ELIZABETH WELLS WAS born on October 1, 1935, in Walton-on-Thames, England, and was exposed to dance and music even before she could walk or talk. Her mother, Barbara, played piano at her sister's evening dance school so night after night the toddler was shuttled off to dance class, where she watched rehearsals. Her parents divorced when she was four, and she went to live with her mother and her stepfather, Ted Andrews, whose name she legally adopted.

Soon after their marriage, Barbara and Ted Andrews formed a vaudeville act, thus introducing young Julie to performing as well. When Ted Andrews discovered that his stepdaughter had perfect pitch, he enrolled her in singing lessons. At 10 Julie joined her parents' vaudeville act and became so popular that at 12 she opened on her own at the London Hippodrome. Her career soon eclipsed her parents', and at 13 she performed for the queen. Her parents retired as Andrews's career blossomed, making the teenager the breadwinner for her parents and siblings.

Andrews was performing a pantomime of *Cinderella* at the London Palladium when Vida Hope, the director/producer of London's smash hit *The Boy Friend*, spotted her and offered her the leading role in the American version of his musical.

Andrews made her Broadway debut in 1954 in the old-fashioned musical whose plot revolved around an aspiring actress given the chance to go onstage when the prima donna fractures her ankle. America was smitten with this teenage star, and only a year later she capped her *Boy Friend* success by winning the starring role in the new Lerner and Loewe musical *My Fair Lady*.

In this now-celebrated show Andrews was to play a cockney flower girl, Eliza Doolittle, who is transformed into a lady by Rex Harrison's Henry Higgins. But even though Andrews was already a seasoned performer, she had never had such a substantial acting role. Rehearsals started off

poorly, and Andrews was worried that she might not be able to handle the part. "This was my first legitimate role," she recalled. "Although I had done *The Boy Friend*, it was a rather silly piece. This character was totally different. Eliza is a great role for women. It has everything. But the weight of the show and the role itself were so demanding, I hadn't a clue as to how to play it."

It wasn't just the role that had her feeling lost; it was also her costar, Rex Harrison. "Rex was scared to do a musical, and he was very involved in getting it right, so, consequently, he was very demanding. Moss [director

Moss Hart] was so busy helping Rex that he didn't have time for any of the rest of us. I just sat around thinking, 'Well, I guess someone's going to get to me.' I was really afraid I would be sent back to London if I didn't get it soon. I'd heard of that happening before."

The rehearsals got to be so bad that Hart finally sent the whole company home and asked them not to return to the theater for 48 hours. But he asked Andrews to stay; he wanted to work with her on the part. For two days, according to Robert Windeler's biography, *Julie Andrews*, Hart "bullied and

pleaded, coaxed and cajoled" her. Andrews took the abuse so well, however, that when Hart went home, he told his wife, "She has that terrible English strength that makes you wonder why they lost India!" Hart's lessons paid off. Both the play and Julie Andrews became tremendous hits in New York and London.

Soon after *Lady* closed in London, Andrews returned to Broadway to play the beautiful but unfaithful Queen Guinevere in *Camelot*. She and her costar, Richard Burton, got along famously, although he later commented that she was the only leading lady he *never* went to bed

45

with. According to Windeler, when the actress heard that line she countered, "How dare he say such an awful thing about me!"

Walt Disney went to see a matinee of *Camelot* one afternoon and knew immediately that Andrews would be perfect to play the role of the magical nanny in P. L. Travers's Mary Poppins books. But Andrews wasn't so sure. "Do you think I ought to work for Walt Disney?" Windeler quotes her as asking her friend Carol Burnett. "The cartoon person?" Burnett assured Andrews that Disney did more than just cartoons and, after Andrews gave birth to her daughter, Emma Kate (with husband art designer Tony Walton), she journeyed to California to make her movie debut.

By this time Andrews had already lost the role of Eliza Doolittle in the film version of *My Fair Lady*. Jack Warner, who was producing *Lady*, felt that he needed a "name" to sell the picture and cast Audrey Hepburn instead, although it was well known that Hepburn could not sing. (Her singing voice would be dubbed in the film.) Even though this would have been the part of a lifetime, Andrews took the disappointment well. "I totally understood why Audrey got the part," Andrews said. "I hadn't done any films yet. I was known only as a Broadway actress."

Andrews had *Mary Poppins* to soften the blow. And when the 1964 Academy Awards rolled around, Andrews even got her revenge. *My Fair Lady* was nominated in every major category

but Best Actress. That statuette went to Julie Andrews for *Mary Poppins*.

Andrews went from *Poppins* to a nonsinging role in *The Americanization of Emily*. In this black comedy by Paddy Chayefsky, she played a World War II widow who falls for an American commander, played by James Garner. Willy Wyler had been correct when he prophesied that Andrews would be right for the role, but despite the long-distance phone calls from Salzburg, Wyler never directed the picture. That assignment went to Arthur Hiller. It was while filming *Emily* that Andrews was approached for *The Sound of Music*.

Christopher Plummer

"[CHRISTOPHER PLUMMER IS] one of the most incisive and exciting actors of the English speaking world . . ." wrote *New York* magazine's Broadway critic John Simon of this Canadian leading man.

Christopher Plummer, born on December 13, 1927, always wanted to be a great concert pianist. A native of Canada, where his great-great grandfather, Sir John Abbott, was once prime minister, Plummer found acting the most attractive of all the arts his mother introduced him to in his hometown of Toronto. An

only child of divorced parents, Plummer was bored by his peers, so he acted out stories. His first acting role was that of D'Arcy in a Montreal High School production of *Pride and Prejudice*. This led to other amateur productions, many of them Shakespearean, and when he turned 17 he landed his first professional engagement, with a visiting English repertory company that played in Ottawa, Canada.

His first acting experience outside Canada was in a repertory company in Bermuda. There he

appeared with such classical actors as Florence Reed, Burgess Meredith, Franchot Tone, and Edward Everett Horton. Horton invited Plummer to join the American touring company of their show *Nina*, and that brought the young actor to the States in 1953.

Plummer's Broadway career started off slowly. He began as an understudy in the touring company of *The Constant Wife*, which starred Katherine Cornell, and then, in 1954, he had roles in two Broadway shows that closed after short runs. His first

substantial role on Broadway was in Christopher Fry's drama *The Dark Is Light Enough*, which ran for two months in early 1955 and then toured American cities. On July 12, 1955, Plummer opened in *Julius Caesar* at the Stratford Company and stayed with the group for *The Tempest*.

Plummer's ambition was to play all the great classics before he turned 30. He not only fulfilled that dream but became a leading Shakespearean actor in Canada, America, and England, performing in both French and English. He won London's West End Best Actor Evening Standard Award for his work on the London stage, and his *Hamlet*, produced on television by the BBC and filmed in the original setting of Elsinore Castle in Denmark, was a great success.

In 1956 Plummer married actress Tammy Grimes, who soon gave birth to his only child, actress Amanda Plummer. The next year Plummer made his film debut in Sidney Lumet's *Stage Struck*, playing a young playwright in love with stagestruck Susan Strasberg. From there he went on to appear in *Wind Across the Everglades* and *The Fall of the Roman Empire*.

In 1960 he and Tammy Grimes divorced, and in 1962 he married British journalist Patricia Lewis. It was a year later that Plummer was first approached to play Captain von Trapp in Robert Wise's *The Sound of Music*, and were it not for the director's insistence, Plummer might never have taken the part.

". . . search high and low . . ."

CASTING

ERNEST LEHMAN WAS CONvinced from the beginning that there was only one actress perfect for the part of Maria von Trapp, and that actress was Julie Andrews. In fact, at a meeting with Richard Rodgers, Rodgers stated, "I suppose you're going to cast Doris Day, huh?" to which an adamant Lehman replied, "As far as I'm concerned, there's only one person to play this role, and that's Julie Andrews."

Lehman said the same thing to Wise when Wise was hired as director/producer. But there was a rumor circulating around town that Andrews was not photogenic—at least that was the excuse Warner Brothers mogul Jack Warner had used for not casting her in the movie version of *My Fair Lady*. Although Andrews had already completed two films, neither of them had been released, so no one had seen her yet on the big screen. One of the first things Wise and Lehman did was go to Disney Studios and look at some footage of the not-yet-released *Mary Poppins*. After only a few minutes Wise turned to Lehman and said, "Let's go sign this girl before somebody else sees this film and grabs her!"

Interestingly enough,

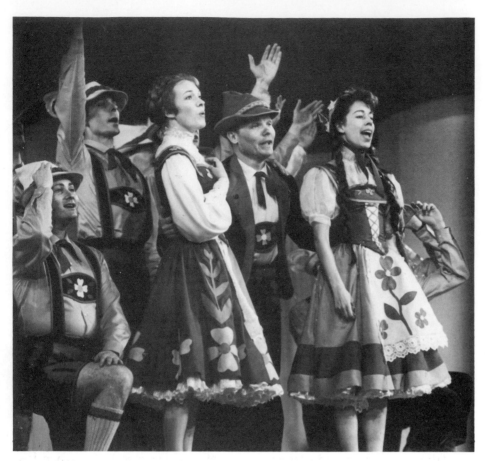

"The Pratt Family of Switzerland."

Andrews had already played the role of Maria. During the run of *Camelot* in 1962, Andrews had costarred in a television special with her friend Carol Burnett. (This was her third television special; she had already played opposite Bing Crosby in *High Tor* and had starred in the title role in Rodgers and Hammerstein's *Cinderella*.) This special, "Julie and Carol at Carnegie Hall," included a parody of what was Broadway's biggest hit at the time—*The Sound of Music*. According to biographer Robert Windeler, Andrews and Burnett joked about the musical. They made fun of "that happy nun." In "The Pratt Family of Switzerland," Julie performed a campy imitation of Mary Martin's "Maria." It never occurred to her

that three years later that very role would put her career over the top.

"I thought [the movie] might be awfully saccharine," Andrews was quoted in the biography. "After all, what can you do with nuns, seven children and Austria?" Besides, after doing a straight role in *Emily*, Andrews thought she might want to play a nonmusical part again.

Before Robert Wise came aboard, other actresses had been suggested for the part of Maria von Trapp. Stage star Mary Martin never had a chance because of her age: Maria had to be in her early twenties, which Andrews, 28 in 1963, could pass for; Martin, at 50, could not, because although the stage can create many illusions, the camera does not lie. Wyler had once

suggested Audrey Hepburn, and of course Paramount had originally bought the German films with her in mind. Doris Day's husband, Martin Melcher, campaigned very hard for her to get the role.

When Wise eventually signed on to do the picture, he made a list of the actresses he was considering. They included

> Julie Andrews
> Leslie Caron
> Grace Kelly
> Anne Bancroft
> Angie Dickinson
> Carol Lawrence
> Shirley Jones

But there was only one person Wise and Lehman seriously considered—Julie Andrews.

When Andrews was offered the role, she had two concerns. First, of course, was the amount of "sugar" in the role. Her second concern was the fact that Fox wanted to tie her into a four-picture commitment with the studio. Her agent didn't like that idea. So she and Fox finally agreed on a two-picture contract. (The second film turned out to be the ill-fated *Star!*, also under Robert Wise's direction.) Andrews signed a contract to star in both *The Sound of Music* and the second film for the flat fee of $225,000, with no share in either movie's profits. The following year, when her name would be connected with "The Golden Trio"—the stage version of *My Fair Lady* and the movies *Mary Poppins* and *The Sound of Music*—her price would skyrocket to $1 million per picture.

Wise, who was off scouting locations at the time, was not involved in Andrews's negotiations at all. But every day, Wise and associate producer Saul Chaplin checked their hotel for a message from the studio. They were anxious to know how Andrews's negotiations were progressing, but they heard nothing. Finally Chaplin learned from a friend, who had read the news in Louella Parsons's column, that Andrews was on board. Wise and Chaplin were elated, although somewhat disgruntled that they had not been informed of this important decision directly.

Right after Wise returned from his trip, he went over to MGM, where Andrews was filming *Emily*, and invited her to lunch at Twentieth Century Fox on her next available afternoon. The studio's executives wanted to meet their new star. A week later Andrews took him up on his invitation. She was still a bit leery about her new role, and as Wise led her into the private executive dining room in the Fox commissary, she stopped him and asked, "How are you going to get all the sugar out of this picture?" Wise grabbed her hand and replied, "My dear, you and all the rest of us are thinking the same way." He then explained his ideas for extracting the excess sweetness from the story without taking away from its appealing qualities.

Wise wanted to keep the picture visually clean and spare. No filigree, no turreted castles, no carved woods. This would work in counterpoint to the romance and music of the film. Andrews listened to Wise's concept, and when she was satisfied with his ideas, she shouted, "Then let's get to it!"

When a director, producer, and casting assistant start bandying names about for their casting lists, the results are often like what happens when you throw a net out in the middle of the ocean: you catch a lot of fish, regardless of whether or not you can use them. And sometimes the results are a little wild. Two names that kept surfacing on most lists for Captain von Trapp were Bing Crosby and Yul Brynner. But Wise had other ideas. He wanted an actor with more of an edge. The Captain in the stage version was a stock character. Wise wanted to juice him up a bit.

He remembered being impressed by Christopher Plummer, whom he had seen onstage in New York. Six feet tall and dangerously handsome, Plummer not only was leading man material but also displayed an unsettling restraint in his film and stage roles that could sometimes seem menacing. There was an intensity in his characterizations that made for some powerful performances.

In the fall of 1963, after garnering only modest success in his first three pictures, Plummer wasn't particularly anxious to sign on for another movie; he much preferred the stage. Yet, when his

"THE SOUND OF MUSIC"

Casting Suggestions

MARIA -- (Julie Andrews.) -----

CAPTAIN VON TRAPP -- A tall, aristocratic man of 40 to 45. He
is stern and military when we first meet him but must be convincing
later on as a warm, emotional father and romantically appealing
in the love story with Maria.

(CHRISTOPHER PLUMMER)

HARDY KRUGER	STEPHEN BOYD	ANTON DIFFRING
*KEITH MICHELL	*SEAN CONNERY	ERIC PORTER - ?
PETER FINCH	JOHN JUSTIN	*PAUL SCOFIELD
STANLEY BAKER	MASSIMO SERATO	DENIS QUILLEY
BRIAN KEITH	VITTORIO GASSMAN	~~ANTHONY STEEL~~
LOUIS JOURDAN	JEROME COURTLAND	MICHAEL CRAIG - ?
MAX SCHELL	KARL SCHONBOCK - ?	CARLOS THOMPSON

BARONESS ELSA SCHRAEDER -- A tall, handsome woman in her mid-to-late
thirties, cosmopolitan, alert and attractive.

*DANA WYNTER	(*ELEANOR PARKER)	IRENE WORTH
DIANE CILENTO	ELIZABETH SELLARS	HAZEL COURT
~~*PAT NEAL~~	MARY URE	VIVECA LINDFORS
ELIZABETH ALLEN	*YVONNE FURNEAUX	LILLI PALMER
NANCY WICKWIRE - N.Y.	VICTORIA SHAW	DAWN ADAMS
RABY ROGERS - N.Y.	JOYCE REDMAN	ANNA-LISA
JOAN TETZEL - N.Y.	ANOUK AIMEE	MARTINE BARTLETT
~~ANNY GOLDEN~~		*CAPUCINE

MAX DETWEILER -- A pixyish, hand-kissing impressario who would "sell
his grandmother down the river only if he couldn't get more money
up river." Can be anywhere from forty to fifty or so and must have
genuine charm, appeal and enthusiasm.

*VICTOR BORGE	ROBERT COOTE	(RICHARD HAYDEN)
~~*WALTER MATTHAU~~	ROBERT MORLEY	ROGER C. CARMEL
HERSHEL BERNARDI	*CLAUDE DAUPHIN	GEORGE VOSKOVEC N.Y.
HAL HOLBROCK	*NOEL COWARD	SORRELL BOOKE
BURGESS MEREDITH	*CYRIL RITCHARD	PEDRO ROSE
~~ROCK GIBSON~~	*EMLYN WILLIAMS	HEINZ RUEHMANN (P.K.)
WALTER SLEZAK	WYN SONNEVELD	*FRED ASTAIRE
LOUIS NYE	JOHN McGIVER	*KURT KAZNER
		EDGAR BERGEN

Many of Hollywood's top stars were considered for the major roles in the film.

Casting Suggestions (cont'd) -2-

MOTHER ABBESS -- A warm, ethereal but knowing woman of sixty or so.
If possible she should be on the tall and rather large size. She
sings an important song but the actress does not, necessarily, have
to do her own singing. Quality and acting are most important here.

*IRENE DUNNE	*ISOBEL JEANS
JEANNETTE MacDONALD	*EDITH EVANS
MONA WASHBOURNE	CATHLEEN NESBITT
CICELY COURTENAGE	PEGGY ASHCROFT
FAY BAINTER	ANNA NEAGLE
LILLIE DARVAS - ?	HERMIONE BADDELEY
ATHENY SEYLER	(*PEGGY WOOD)

SISTER BERTHE -- A rather tart and dour nun who is "anti-Maria."
Berthe is very positive and could be anywhere from 40 to 50. Would
be good if she did her own singing.

(PORTIA NELSON)

SISTER MARGARETTA -- A warm, friendly nun who is Maria's supporter.
She could be anywhere from 40 to 55 and it would be good if she
did her own singing.

~~DOROTHY FRANKLIN~~

(*ANNA LEE)

*MARRO

52

agent first approached him to play the role of Captain von Trapp, Plummer thought it might be a good idea. He was planning on doing a musical version of *Cyrano de Bergerac* onstage, and he thought that doing a film musical might be good practice.

Ironically, just as Andrews had once played the role of Maria von Trapp, albeit comically, Plummer too had previous experience with the role of the Captain.

"I was doing *The Lark* on Broadway with Julie Harris," recalled Plummer, "and I was told that Mary Martin wanted to meet me. They were considering me for the part of the Captain in the stage version. Now, I was only twenty-six years old at the time, and Martin must have been about fifty or so. The Captain was supposed to be older than she was! So I went to Mary's penthouse to meet with her. She was like a little pixie; she came dancing out to greet me. Rodgers and Hammerstein were also there.

"So I told them, 'I hate to say this, but don't you think our age differences are a little staggering?' Well, they were stunned. Apparently they were just seeing anybody who was hot at the time,

and some casting director made a boo-boo."

Wise sent a copy of the screenplay to Plummer and, even though Plummer was open to the *suggestion* of doing a film musical, he found he had strong reservations about playing the role of the Captain because of the way the character was written. So Plummer's first response to Wise was an adamant "No thanks!"

Wise had other names on his list:

> Sean Connery
> Stephen Boyd
> Richard Burton
> David Niven
> Peter Finch

He saw all of these men, as well as Walter Matthau, Patrick O'Neal, and others, but none was right for the part. Peter Finch was Wise's second choice, but he was unavailable. Yul Brynner fought very hard for the role, but Wise felt there were two problems with Brynner as the Captain. First, it would have been typecasting for Brynner to play another hard nosed patriarch after his similar role in *The King and I*. Second, Brynner had an accent.

All the characters in the movie were Austrian, so naturally

they had to sound the same. "One of the strikes against Yul Brynner and some of the other foreign actors," explained Wise, "is that they would have a different accent than everyone else. All the other actors in the cast were either English or American. I was determined to have this pure. Starting with Julie, I decided early on to have this done in mid-Atlantic English. I wanted the language to be a common thread throughout the film." To accomplish this, he hired a special dialogue coach, Pamela Danova, to stay with the American cast during the entire shoot and teach them an English dialect.

Even though Plummer repeatedly turned down the role of the Captain, Wise did not give up. Plummer's agent, Kurt Frings, was also very much in favor of his doing the movie; he thought it would be a good career move for the actor. So he suggested that Wise go to London to meet with Plummer and try to persuade him to sign.

Wise did just that. He flew to London specifically to meet with Plummer and try to talk him into taking on the role. The two of them met at the Connaught Hotel, and after a few drinks Wise

Wise wrote this out on paper to see how it looked. Apparently he didn't like it.

THE SOUND OF MUSIC
STARRING
YUL BRYNNER AND JULIE ANDREWS

explained his concept for the film. Plummer thought Wise's ideas were very good and, after the meeting was over, decided to commit to the picture. But Plummer was still apprehensive about the part of the Captain. So Wise told him that he could work with Ernest Lehman to try to improve the character.

Dick Zanuck approved of Wise's choice of Plummer for the role, but Wise still had to convince the studio chief that Plummer looked the part. Even though this was a few years after Plummer's fiasco in Mary Martin's penthouse, Plummer was still too young to play the Captain. Wise wanted to age the actor a bit—add a little gray to the hair and a few lines around the temples—and then do a makeup test on him. Plummer refused to do the test. But he did allow Wise to bring a still photographer and some lights and makeup to his London apartment to take some pictures. Wise then took those stills back to Los Angeles and showed them to Dick Zanuck. Zanuck was convinced that Plummer could handle the age, and in January 1964 he was signed for the role.

As in all his pictures, Wise put as much thought into casting the secondary roles as he did the leading parts. He knew that each character had to make his or her own distinct impression on the audience and keep the viewers interested in the story even when the stars weren't in the picture.

One character actor who certainly lit up a screen was Richard Haydn. Maybe this was because Haydn's own *life* played like a movie script.

Haydn started out dancing in a professional chorus in Scotland at age 19. But when he tired of leaping about he turned to the classics. He was on tour with *Journey's End* when he unexpectedly inherited 100 pounds from his aunt. Feeling independently wealthy, he retired from show biz to lead a life of sophisticated leisure in Paris. His wild romp lasted all of two months.

Totally broke, he joined a singing group called the Sterling Players, but after they bombed out at the London Palladium he quit acting a second time and moved to a banana plantation in Jamaica. His life on the beautiful island was anything but idyllic. He grew bananas and eggplant and, when a hurricane demolished his house, lived in a corrugated iron shed in a neighbor's backyard.

When a Canadian film company came to the island to make a picture its makeup man became ill, and Haydn took over. Once again, he was back in show business. From there he joined a repertory company and came to America where he performed in radio, film, and television productions, creating such characters as Mr. Edwin Carp, who, among his other talents, could imitate the love call of the red-bellied gudgeon. A few of his films were *Charley's Aunt, Ball of Fire*, and *The Late George Apley*.

Wise knew of Haydn's work and thought he would be perfect for the role of impresario Max Detweiler. Wise had already met with Victor Borge and was considering him for the part, but Borge felt that the character of Max, as written, was not particularly strong; Borge had not been in a movie before and felt he needed a really stellar role his first time out. He wanted the character to have more of what he termed "a handle." Wise could not see his way clear to having Lehman redo the screenplay with the idea of expanding Max's character. Not only would it divert attention from the two main characters—and thus the emotional thrust of the film—but there was also some concern about adding new scenes to the script, which was on the long side to begin with. As it turned out, Borge couldn't change his own personal appearance schedule, so he was ruled out.

Wise also considered Noel Coward, whose stinging wit would have played well in the part. Other names included on Wise's list were Cesar Romero and Hal Holbrook. But Haydn was ideal. Not only did he have great comedic timing, but word was out that he was a delightful person to work with. And, most important, he loved children. In fact, while the cast was working in Salzburg, they ended up calling Haydn "Herr Dad."

The cool, sophisticated Baroness Elsa Schraeder was played to perfection by Hollywood veteran Eleanor

Richard Haydn.

Eleanor Parker.

Parker. Still in her teens when she was discovered in a production at the acclaimed Pasadena Playhouse, Parker signed a contract with Warner Brothers Studios on her 19th birthday. Her first movie was 1941's *They Died with Their Boots On*, where her walk-on part met its fate on the cutting-room floor. That inauspicious debut did not hinder her career, however, and she went on to do numerous B pictures until her first major role, in the film *Mission to Moscow*. Her career reached its peak in the 1950s, when she received three Academy Award nominations, for *Caged* (1950), *Detective Story* (1951), and *Interrupted Melody* (1955).

Parker never became a superstar like her contemporaries Lana Turner and Ava Gardner. Her family was too important for her to devote all her energies to acting. Thus, by the 1960s, her career had slowed down and she had begun to take on more supporting roles.

Wise had worked with Parker in 1950 on *Three Secrets*, so he knew of her talent, but more important, Wise cast her because she had "name" value. At the time, Julie Andrews and Christopher Plummer were just beginning their careers and weren't yet known to the public. Parker, on the other hand, had been a film actress for 20 years. Supporting parts or not, Parker was still a "star," and Wise felt he needed a star to sell his picture.

Ben Wright was Wise's first choice for the role of Zeller, the

Memo from

ROBERT WISE

Cyd Charisse
Jan Clayton
Rita Gam
Eva Gabor
Jane Greer
Vera Miles
Patricia Owen
Grace Kelly
Ida Lupino
Eva Marie Saint
Christine White

Wise listed his other choices for the baroness.

Casting sheet for secondary characters.

TWENTIETH CENTURY-FOX FILM CORPORATION

INTER-OFFICE CORRESPONDENCE

DATE __February 26__ 19 _64_

TO: __LEE WALLACE__
cc: Saul Chaplin

FROM __BOB WISE__

SUBJECT __THE SOUND OF MUSIC__
Casting

Here are some additional ideas. I know some of them, many others are only recognizable names. A lot of them may not be at all right for our parts, so let's discuss them before calling any in. You might check out the singing on any of the nun suggestions that you think are possibilities.

NUNS	FRAU SCHMIDT
Edith Atwater	Eleanor Audley
Judith Evelyn	Isobel Elsom
Anna Lee	Kathryn Givney
Peggy Converse	Hilda Plowright
Shirl Conway	
Doris Dowling	
Mary Munday	
Frances Reid	
Marian Seldes	
Beatrice Straight	
Joan Gaylord	
Alice Ghostley	
Josephine Hutchinson	
Anne Loos	
Elizabeth Morgan	
Erin O'Brien Moore	
Amzie Strickland	
Ann Tyrrell	
Rosemary de Camp	
Irene Tedrow	
Mary Wickes	

ZELLER	FRANZ
Ben Wright (Ideal, I believe, if he's available)	Eric Berry
Robert Ellenstein	Leslie Bradley
Robert Gist	Edward Colmans
Gavin MacLeod	Eduard Franz
Alfred Ryder	Gavin Gordon
Fritz Weaver	Jonathan Harris
	Hedley Mattingly
	Sheppard Strudwick

Nazi leader who tried to force Captain von Trapp to join the German Navy. Wright, a native of London, had studied acting at the prestigious Royal Academy of Dramatic Arts and, in 1934, made his professional debut in the West End theaters. He came to Hollywood in 1946, becoming a well-known character actor in films such as *Judgment at Nuremberg*, *Witness for the Prosecution*, and *Until They Sail*, the last directed by Robert Wise.

Gil Stuart, who won the role of the von Trapps' butler, Franz, was another London native. He too studied at the Royal Academy of Dramatic Arts, then he came to Hollywood under contract to Metro. He has been seen in such films as *Mutiny on the Bounty* and *Doctor Dolittle* and did hundreds of television shows, including 16 years as a regular on "The Red Skelton Show."

Norma Varden, who played the von Trapp housekeeper, Frau Schmidt, studied piano in Paris before deciding to give up her music career for the theater. She made her theatrical debut as Mrs. Darling in a London production of *Peter Pan*. From there she did numerous stage shows in Europe and then decided to try Hollywood, where she worked in more than 100 films and television shows.

The actresses who portrayed the nuns represented years of talent and experience. Classical actress, opera singer, USO entertainer, author—Peggy Wood, who played the Reverend Mother, did it all. Her career took off in

Ben Wright as Zeller.

Gil Stuart and Dan Truhitte.

Julie Andrews and Norma Varden.

Peggy Wood.

Peggy Wood, Portia Nelson, and Anna Lee.

1910 when she starred in *Naughty Marietta* on Broadway. From there she did more than 70 Broadway plays and numerous films and was one of the first actresses to have her own hit television series when TV was in its infancy. She played Mama, the mother of a Norwegian family in the series of the same name, which aired from 1949 to 1956.

Irene Dunne and Jeanette MacDonald were two actress/singers on Wise's list to play the Mother Abbess, and they both would have been excellent in the role. But Peggy Wood was special. Wise knew her as a warm and generous person, and these

qualities certainly translated to the screen. She gave the Mother Abbess a commanding yet serene presence, but above all, sprinkled her characterization with humor and understanding.

Wood was thrilled with the part even though she knew her voice was going to be dubbed. Wood had begun her career as a singer, but she was in her 70s when *Music* was filmed, and by then her voice was gone.

It's impossible to stick Portia Nelson into one category. She is an actress, composer, lyricist, painter, and photographer. "I always do about ninety things at once," said Portia, who played

Sister Berthe or, as she calls her, "the mean nun." Portia began her career as a cabaret singer during the 1950s Golden Age of New York. She performed at the Blue Angel, the Bon Soir, and La Ruban Bleu. She was the toast of café society and performed with some of the funniest names in show business, including Mike Nichols and Elaine May and political satirist Mort Sahl. She even arranged Carol Burnett's first audition in town.

Music was Portia's first film. At her initial audition she sang an old standard that she had actually introduced into the clubs—"Fly Me to the Moon." The next day

Marni Nixon as Sister Sophia.

she came back and read a scene. After the reading Wise looked at Lee Wolf, one of the casting directors, and said, "Have you been coaching her?" An hour later she was hired.

Anna Lee, Sister Margaretta, had known Robert Wise when he was a film editor at RKO. When her agent sent her down to see Wise for the *Music* auditions, she thought she would be reading for the role of Elsa. But Wise asked her to audition a part as one of the nuns. "I wasn't sure if I would be right for the role because I sing slightly off-key," said Lee, "but he said that's exactly what he wanted. He wanted someone who

wasn't a professional singer."

Lee was a leading lady in England and had starred in nine pictures overseas before she came to Hollywood with her husband, Robert Stevenson, who went on to direct *Mary Poppins*. She had planned to stay in the States for only two or three weeks. But it was 1939, and while she was away war broke out in England. It was impossible for her, a British mother with a nine-month-old baby girl, to go back home to her war-torn country, so she stayed on in the United States. But she wanted to get back home so badly that she joined the USO, thinking she would be sent home to

entertain the troops. Instead she was sent to the Persian Gulf! From there she went to Africa and then Sicily. It seemed that every time she got to the airfield to go to England she would get bumped by a major or a captain and put back at the bottom of the list.

So, Lee started working in Hollywood, but she was given only secondary parts and never regained the stature she'd had in England. Lee did get back home eventually, but by that time her star had faded.

Marni Nixon, who played Sister Sophia, made her screen debut in *Music*, but she was far

from a novice at filmmaking. As previously described, Nixon was the queen "ghost" singer in Hollywood.

Nixon's first stage experience was as a child prodigy violinist playing for the Los Angeles Philharmonic's children's orchestra. Studio casting directors often frequented the Philharmonic's concerts, searching for child extras. Thus was Nixon "discovered," and she began her career as a child bit player and extra. She got her first job as a "ghost" singer at 17, when she dubbed Margaret O'Brien's voice in *The Secret Garden* (1949). When the

Hollywood musical fell out of fashion, and voice dubbing was no longer needed, Nixon sang in commercials and jingles to pay for voice lessons. Her goal was to be a stage actress and concert singer, which is exactly what she is today.

For the only other two adult speaking parts in the film, Wise cast Evadne Baker (Sister Bernice) and Doris Lloyd (Baroness Elberfeld, who is a guest at the Captain's ball). Extras were later cast in Los Angeles and Salzburg.

Sharon Tate, Mia Farrow, Lesley Ann Warren, Patty Duke, Kurt Russell, Richard Dreyfuss . . . Those are just a few of the

"youngsters" who interviewed or tested for some of the children's roles in the movie. The casting search for *The Sound of Music* may not have been as infamous as the highly publicized search for Scarlett O'Hara in *Gone With the Wind*, but it was almost as extensive. Wise interviewed children from all over the country and in England and auditioned more than 200 youngsters.

On November 18, 1963, Wise traveled to London to audition children. He hired Michael Schwitleff, Inc., as his casting consultants, and they drew up a list of youngsters for Wise to meet. He saw Victoria Tennant

Kym Karath as Gretl.

A partial list of child actors auditioning in New York, the song they intend to sing, and the key they want to sing it in.

(an actress now married to Steve Martin), who was 13 at the time; Cathryn Harrison, Rex Harrison's five-year-old granddaughter; and Geraldine Chaplin, Charlie Chaplin's daughter. Wise seriously considered Geraldine for the role of Liesl, but they all thought that her father would be too difficult in the negotiations. When Wise returned to New York, he began interviewing children who had traveled from all over the country to try out for roles. Ironically, after all his traveling, Wise cast all but one part in Los Angeles.

Besides analyzing how the children played the scenes and delivered their lines, Wise was looking for certain subjective qualities. He wanted to see how they handled themselves, how "real" they were, whether or not they had that screen "magic." Wise, Saul Chaplin, and casting supervisor Owen McLean would first interview each child, next the child would read from the script, and then, if Wise and his associates liked what they saw, they would give him or her a screen test. For the first audition each child played a straight scene, and if they read well they might be asked to do a bit of singing and dancing. The only girls who were required to sing and dance from the first were the ones auditioning for the role of the 16-year-old daughter, Liesl. The singing, however, wasn't a major requirement in any of the roles, because a voice double could always be used.

Mia Farrow read three times for the part of Liesl, first on January 15, 1964, then on January 24, and again on February 17. The casting director's notes read that she was 19 years old and was 5'6". Wise wrote on his own casting notes that Mia had a "good reading—quality very nice, but soft . . . lack of energy." He also thought her dancing wasn't good enough, and that was a primary consideration for the role of Liesl. Lesley Ann Warren, age 17 and 5'5", tested on January 21. Wise wrote that she was "excellent." Teri Garr, 19

and 5'4", read on February 12. She was "too old but fun girl." Shelley Fabares read and gave a "good reading—good enough dancing. Like." Sharon Tate—"no dance."

The Osmond brothers read for many of the boys' roles. Wise wrote, "very nice and very talented." Richard Dreyfuss had "no dancing." Paul Petersen read and so did Ann Jillian, who was 15 years old at the time.

There is one child who still stands out in both Wise's and Chaplin's mind. They remember sitting in McLean's office waiting for the next candidate to arrive when in walked a little five-year-old pistol. She carried in an enormous book of photographs under her arm, marched directly up to them, and announced, "I'm here to interview for the part of the youngest child. I can sing and dance and have lots of acting

experience. I'm perfect for the part!" Wise remembers Chaplin turning to him and saying, "Get her out of here before she starts climbing the wall!" Wise scribbled in his notes—"Talks!!" Self-assurance was one of the attributes Wise was looking for, however, and Kym Karath won the role of Gretl.

Karath, who had already appeared in three movies, had memorized the entire score from the stage recording before the audition. She came from a family of performers: her mother had gone to opera and drama school in New York, where she had met Karath's father, a stage actor. Karath's brother and sister had also worked in television. In fact, her sister Francie, who was 20 years old at the time, auditioned on February 5 for the role of Liesl.

Debbie Turner tested on

February 7. Turner had appeared in a few television shows and commercials before winning the role of Marta.

Angela Cartwright was much more well known, having spent the preceding seven years as Danny Thomas's TV daughter on "Make Room for Daddy." Born in Cheshire, England, Cartwright had moved to Canada and then Los Angeles with her parents. She landed her first role at four, appearing as Paul Newman's daughter in Robert Wise's movie *Somebody Up There Likes Me.* From there she worked as a model and acted in commercials until "Daddy." In the seven years she worked on that show, she missed only one episode—the final show of the series. She had a good excuse; the filming of that important show overlapped with her first day of rehearsal on *Music,* where she played Brigitta.

GRETL	
Wendy Muldoon	M.F.T. – Dm – 4 (cold)
Pamie Lee	M.F.T. – Em – 5
Kim Karath	M.F.T. – Em – 4
MARTA	
Melody Thomas	D.R.M. – C – 5 (Can be taught)
Tracy Stratford	D.R.M.– 5 (weak)
KURT	
Jay North	M.F.T. – F – 6
BRIGITTA	
Andrea Darvi	M.F.T. – Em – 8
Angela Cartwright	M.F.T. – Dm – 6
ROLF	
Danny Lochin	You are 16 – G – 8
Jerry Bono	You are 16 – E flat – 7 No dance
LEISL	
Tish Sterling	
Melanie Alexander	You are 16 – E flat – 8

More screen tests, this time in Hollywood.

Duane Chase, whose parents had wanted him to get involved in acting so he could earn enough money for college, started acting in commercials when he was 11. His agent arranged for an interview, and he met with the casting supervisor on February 18 so he could be considered for the role of Kurt. He remembered, "Kids were lining the hallway, sort of like a cattle call. I don't remember who I auditioned for, but it wasn't Mr. Wise. I read some lines and sang a song, and did a few dance steps. Then I was told to wait in the hall. I thought, 'Oh great, I have it.' Then someone came out and told me to go home."

Duane was called back for a second audition. This time he read for Wise, Saul Chaplin, and Reggie Callow, Wise's assistant director. Again, he was told to wait in the hall after the audition. But this time someone came out and told him to be back the next day at 8:00 in the morning.

"The next morning, I was directed to go to the stage, and I saw Mr. Wise. He walked up to me and said, 'How would you like to go to Salzburg?' I was so hyped up by this time, I said, 'I'd love to. You don't even have to pay me!' "

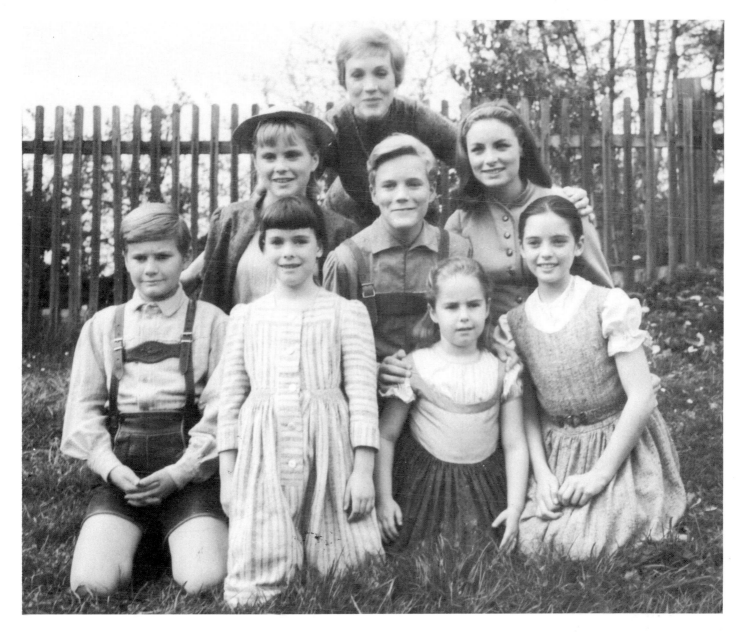

Top: *Julie Andrews.*
Middle row: *Charmian Carr,*
Nicholas Hammond, Heather
Menzies.
Bottom row: *Angela Cartwright,*
Kym Karath, Debbie Turner,
Duane Chase.

Heather Menzies began her career with the intention of becoming a dancer but was spotted by an agent at a ballet recital and was bitten by the acting bug. She had had no acting experience when she auditioned for the role of Louisa. Later, she recalled in an interview for the British television show "This Morning," "I had to stand in front of a piano and sing a song I had prepared. I had never had a singing audition and I have never had one since. It was awful." But somehow, she made it work, because she was cast right away.

Nicholas Hammond credits Julie Andrews with being instrumental in his decision to become an actor, way back when he was only nine years old.

"The first play I saw was 'My Fair Lady,' " he told interviewer Michael Carmack for the *Los Angeles Herald Examiner* in 1974. "It was the original staging with Rex Harrison and Julie Andrews, and from that moment on I decided to be an actor. The fan adulation and magic of the stage excited me."

65

Charmian Carr.

Soon thereafter, Hammond started working as an actor. He had a role in the British film *The Lord of the Flies*, which led to Broadway, where he played Michael Redgrave's son in *The Complaisant Lover*.

Hammond and his family lived in Baltimore at the time Wise was casting the part of Friedrich, so Hammond came up to New York to test for the role. He had broken his arm in a skiing accident a few days before the audition, so he was not feeling very confident when he walked into the NBC Studio where Wise was holding the auditions. "In I walk with my two front teeth missing and my arm in a sling," Hammond told reporter Steven Jay Rubin in a 1981 article for the *Los Angeles Times* "Calendar" section. "I didn't think I had a chance because I don't sing, even in the shower." But, despite these handicaps, Hammond landed the role.

Charmian Farnon had never had a singing or dancing lesson and was not particularly interested in becoming an actress even though she was from a family of actors and musicians. Her mother, Rita Farnon, was an actress and comedian who had starred in a few westerns; her father, Brian Farnon, was the orchestra leader at Chez Paris in Chicago; and her uncle, Robert Farnon, was a well-known composer in England. Yet, despite her family's impressive credits, all Farnon was interested in was seeing the world. She had worked occasionally as a model for the Broadway Department Stores and was also working part-time in a doctor's office as an office assistant. Her plan was to save the $2 an hour that she earned at the doctor's office and use that for travel money. Then a friend who had heard about the casting search sent Farnon's

picture to Wise's office. Wise and Chaplin called her, and she came in for an interview.

"She was so pretty and had such poise and charm," recalled Wise, "that we liked her immediately." The only problem was that Wise thought she looked too old to play Liesl. So they interviewed others. Still, their thoughts wandered back to Farnon, and they called her in again. Once more they were torn. She had a lovely, natural voice and could dance well enough, but she didn't look 16. They let her go and saw several more young ladies. Again they were pulled back to Farnon. She came in for a third interview, and this time her charm won them over. She not only got the part of Liesl; she was

also signed to a seven year contract with the studio. Only then did she reveal that Wise's instincts were accurate. Farnon was 21 when she took the role.

Wise might have been satisfied with Farnon's performing skills, but one lingering problem remained. "It was Mr. Wise who changed my name to Carr," Carr told a Fox publicist at the time, "because too many people mispronounce even my first name [pronounced Shar-mee-in]. He felt with a complicated first name, I should have a short, uncomplicated last name." So Charmian Farnon, the office assistant, was transformed into Charmian Carr, the actress.

Another young actor, one who is sometimes forgotten

because he did not play one of the seven children, is Dan Truhitte. Dan played Rolf, the teenage boy whom Liesl falls in love with and who, in the end, tried to turn the family over to the Nazis. Dan was 20 years old when he did the film but had already had years of experience in show business.

"I've been acting since I was six," said Dan. "I wanted to be another Gene Kelly. I was a singer, a dancer, and a gymnast. At seventeen I won a scholarship to the Pasadena Playhouse, and that's where I got my start."

Dan was the last person in the picture to be cast. In fact the first day he reported to work production had already begun. Like the others, Dan had to go through a number of auditions

Dan Truhitte.

Kym Karath, Debbie Turner, Angela Cartwright, Duane Chase,
Heather Menzies, and Nicholas Hammond in publicity photo.

A moment alone.

TAKING A BREAK
DURING FILMING

Enjoying the carriage ride in "Do-Re-Mi."

Anna Lee.

Waiting for the crew to set up another shot in "I Have Confidence."

Andrews and on-screen "son," Duane Chase.

*Peggy Wood and Anna Lee begin a day of
sightseeing.* (From the personal collection of Portia Nelson.)

*Dee Dee Wood with baby, Michael. Julie Andrews
walking Emma Kate.* (From the personal collection of
Portia Nelson.)

A candid snapshot captures Julie Andrews with her daughter, enjoying the view of Salzburg from their hotel room. (From the personal collection of Portia Nelson.)

Portia Nelson taking a coffee break. (From the personal collection of Dee Dee Wood.)

Angela Cartwright. (From the personal collection of Portia Nelson.)

Relaxing between shots.

"Will the real Julie please stand up?" Julie Andrews and her stand-in, Larri Thomas (background).
(From the personal collection of Dee Dee Wood.)

Chaplin, Wise, Andrews, and Danova.

Trying to stay warm.

From left: Marc Breaux, Julie Andrews, Saul Chaplin, and Dee Dee Wood running through a rehearsal of "I Have Confidence." (From the personal collection of Portia Nelson.)

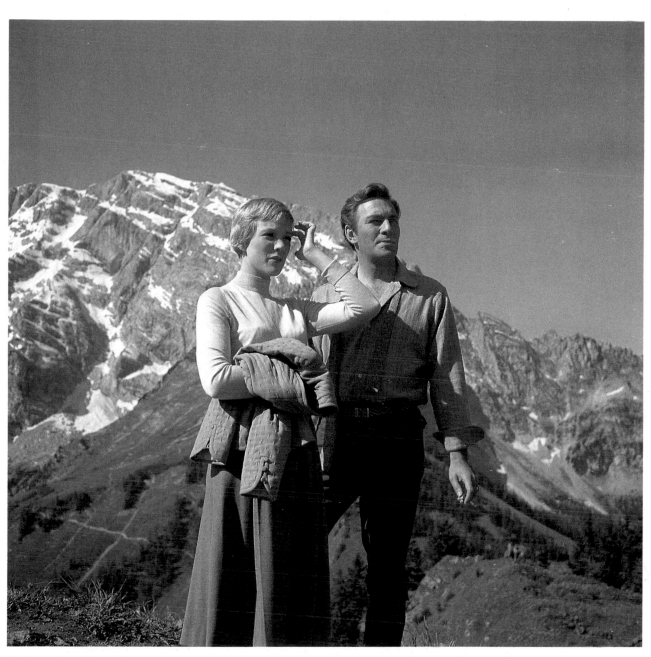

A breathtaking view.

Picking wildflowers. (From the personal collection of Portia Nelson.)

Wise looks on as the children sing.

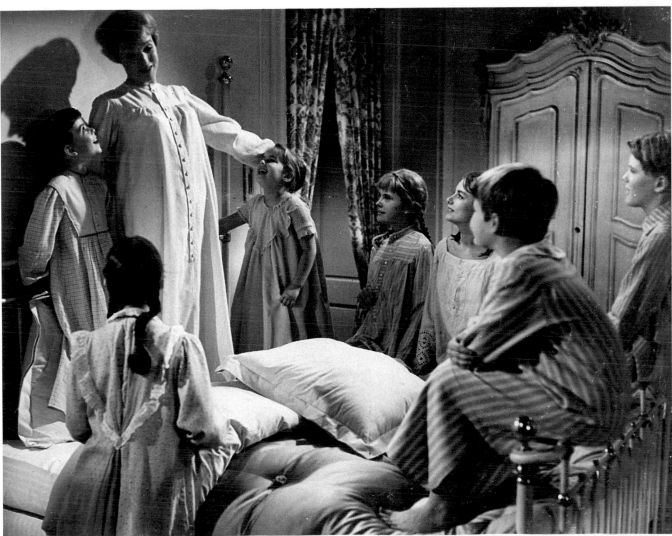

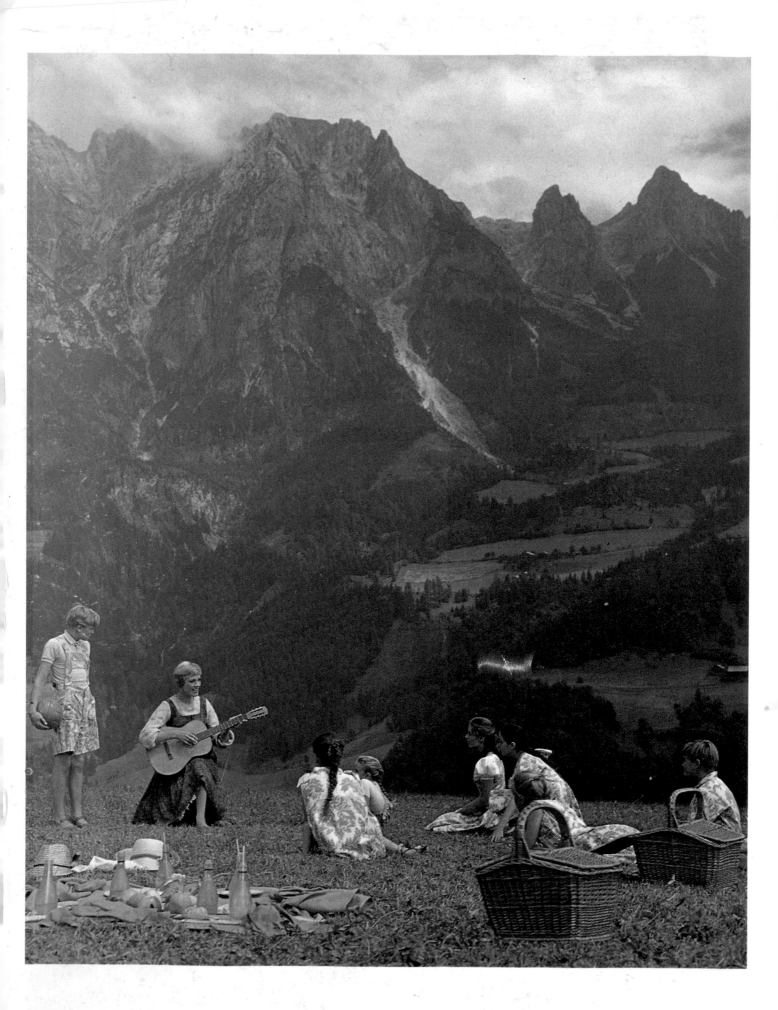

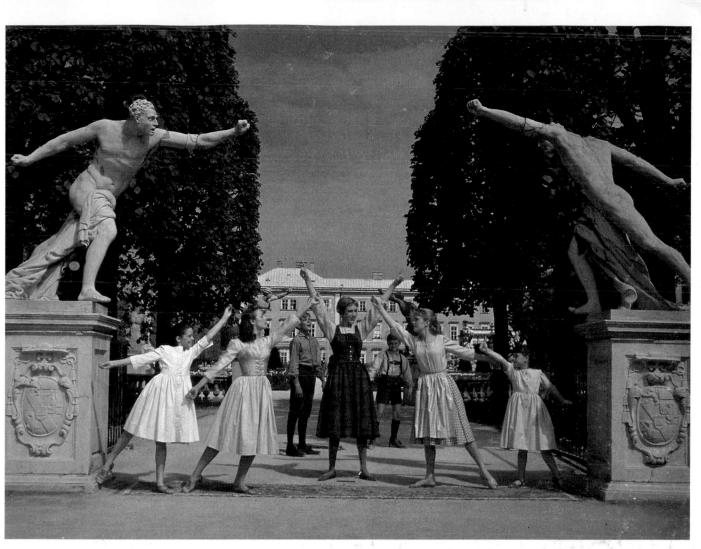

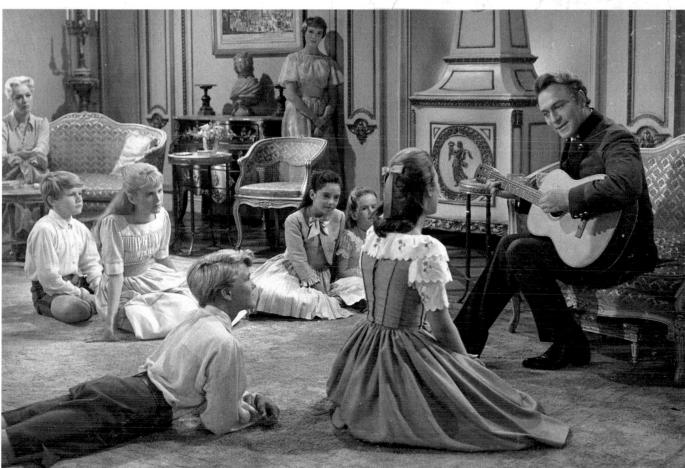

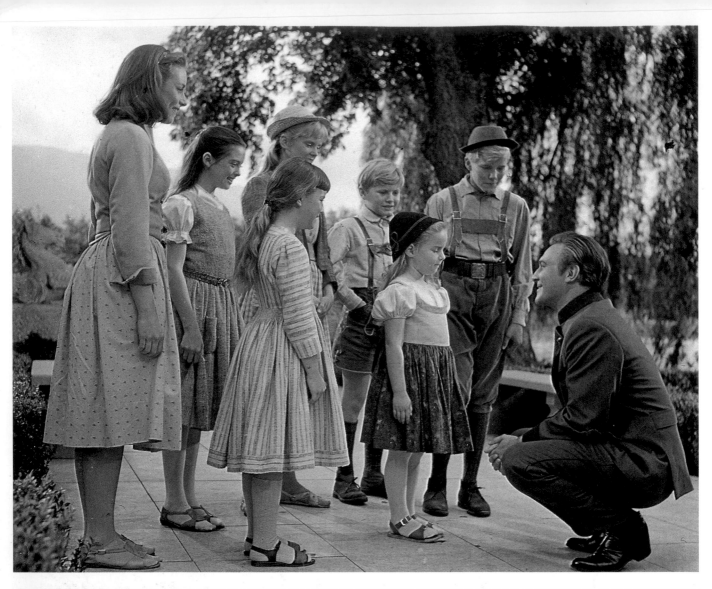

before he won the role. "My first audition was a real cattle call. There were twenty-five to thirty people there, and we just had about ten seconds in front of the camera. They were just concerned with the physical look. Then my agent went to a party and saw Pamela Danova. He knew she was working on the picture [as the dialogue coach], so he gave her my photo. She set up another interview with Bob Wise."

This time Truhitte had to read a scene for Wise and Chaplin. It was the Nazi scene at the end of the picture—a very dramatic scene for a reading. They seemed satisfied with Truhitte and sent him to audition for the choreographers, Marc Breaux and Dee Dee Wood. Dancing was Truhitte's forte, but they didn't really want a dancer. They wanted the "You Are Sixteen" number to look like two kids just having fun. Still, Truhitte got an *A* on the grading system that they had devised to rate the children.

But they weren't finished with Truhitte yet. "After the dancing they gave me a personality test. There was no time for a screen test, so I stood in front of the camera, and Bob talked to me for a few minutes. Finally, I asked them if I could sing. I sang 'You Are Sixteen,' and it was one of the best experiences of my life. They were all very pleased."

Wise knew which actors he wanted in each part and, aside from Christopher Plummer, had little trouble getting them. He was a highly talented and successful director who had a reputation for being a sensitive, soft-spoken gentleman as well—a rarity among the Hollywood elite.

He, in turn, cast actors who possessed the unusual combination of talent and stability. They were committed individuals who were very serious about their work—even the children. They needed to be serious. With dance and music rehearsals, costume fittings, prerecording sessions, photo sessions, dialogue coaching, and dialect lessons—all this before the first scene was shot—the cast had to have sturdy constitutions and a tremendous amount of patience for all that lay ahead.

STORYBOARDS

STORYBOARDS ARE A VERY IMPORTANT ELEMENT IN FILMMAKING.
They are a virtual map of the film: a series of drawings, matched with
dialogue or action, that depict each scene to be shot. To begin the
process for *Music*, Robert Wise met with his sketch artist, Maurice
"Zuby" Zuberano, and together they walked through each scene. Wise
then explained his objectives, what feeling he wanted to express in each
scene, and what visual information needed to be conveyed. After this
initial meeting Zuberano went back to his office and began drawing
sketches that would illustrate what happens in each of those scenes. He
penciled in as much coverage as he could. This means he anticipated all
the many angles, distances, and other variations from which the director
might want to shoot. Zuberano then captioned the sketches with a
description of the scene or the dialogue from the scene.

The meetings with Wise continued until the sketches were
perfected. A sketch artist normally spends about seven weeks on the
layout of a movie, but because *Music* was so intricate, Zuberano needed
10 weeks to complete his sketches. He then arranged the storyboards in
a folder, and Wise referred to these sketches as a kind of guideline when
shooting the picture.

The following are the storyboards from the opening sequence of
The Sound of Music. The first four sketches are the very beginning of
the scene. There is no dialogue; the camera zooms in to meet Maria
running up the hill. The remaining sketches plot out the various
segments of the opening song.

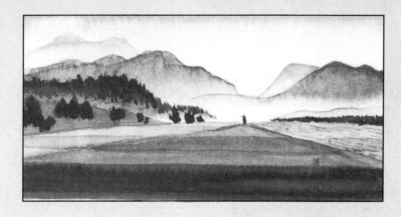

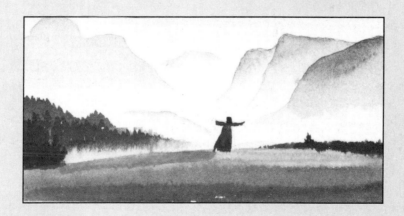

MARIA

The hills are alive
With the sound of music,
With songs they have sung
For a thousand years.
The hills fill my heart
With the sound of music—
My heart wants to sing
Every song it hears.

My heart wants to beat
Like the wings
Of the birds that rise
From the lake to the trees,
My heart wants to sigh
Like a chime that flies
From a church on a breeze,

To laugh like a brook
When it trips and falls
Over stones in its way,
To sing through the night
Like a lark who is learning
 to pray—

I go to the hills
When my heart is lonely,
I know I will hear
What I've heard before.
My heart will be blessed
With the sound of music
And I'll sing once more.

The MUSIC STOPS. In the silence,
DISTANT CHURCH BELLS ARE HEARD.
Maria reacts with alarm. She
starts to run. And as a
rousing, full-orchestra take-
away of ''THE SOUND OF MUSIC''
begins we:

CUT TO:

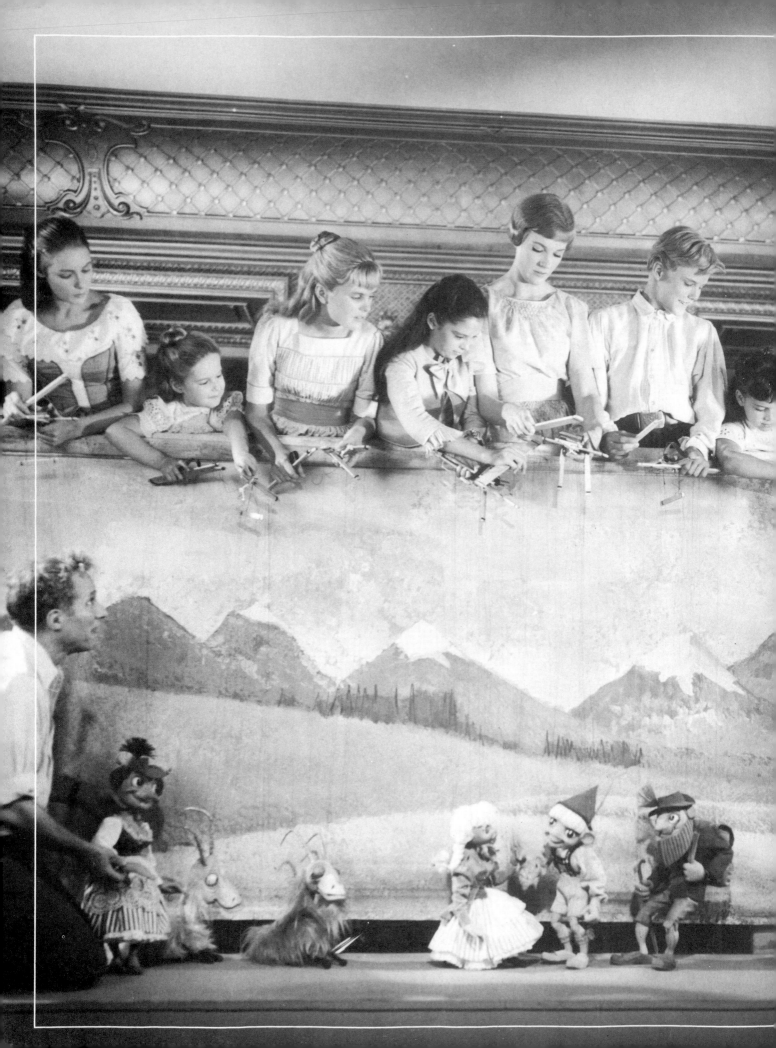

"With each step, I am more certain . . ."

\mathcal{P}REPRODUCTION

"DON'T THEY KNOW GEOGRAPHY in Hollywood? Salzburg does not border on Switzerland!"

> —*Maria von Trapp as she watched the final scene in the movie, quoted in* Our Sunday Visitor *in 1967*

"In Hollywood, you make your own geography."

> —*Robert Wise on set design, interviewed by author*

On November 1, 1963, just a few weeks after he was hired to work on *The Sound of Music*, Robert Wise flew to Salzburg on a reconnaissance—or "recce" (reckee) in film parlance—trip to scout locations. He wanted to get to Salzburg as soon as possible, because he knew if he waited too long there would be too much snow in the city and that would impede his freedom to travel.

He took with him Saul Chaplin, his associate producer; Saul Wurtzel, production manager; Maurice Zuberano, sketch artist; and Boris Leven, production designer. Saul Wurtzel, along with Assistant Director Reggie Callow, had the job of coordinating the entire

LOCATION NOTES - SALZBURG, AUSTRIA AND VICINITY

MONDAY, MAY 27th

1. Schloss Maria Theresia - old villa now used as guest house and restaurant. Conglomerate architecture - small garden area - badly run down - not satisfactory.

2. Hotel Kaiserhof - unattractive - nothing to recommend it.

✓ ③ SCHLOSS ANIF - very interesting old Gothic castle set in middle of small lake - good possibility for Trapp Villa - *N.G.* however Gothic architecture would inhibit the interiors. *Check*

4. Schloss ~~Frohnburg~~ *EMSLIEB* - small, attractive villa as seen from ✓ the gates to the estate. Private owner refused us admission.

✓ ⑤ SCHLOSS HELBRUN - quite famous, Italianate villa - possibly *N.G.* too large for Trapp Villa.- however has excellent approach from gate - beautiful water gardens and pools at one side with trick spritz fountain - also has large, formal gardens on other side of villa - also some very interesting areas throughout the estate. *Check*

✓ ⑥ LEOPOLDSKRON - beautiful, Baroque villa formerly owned by ✓ Max Reinhardt - now owned by American School - perfect location - with terrace leading down to lake - a side garden *Check for Terrace & Gardens* that would need to be restored. Wyler not pleased with the approach (which is important for story point), but this could possibly be worked out.

7. SCHLOSS KLESHEIM - enormous palace - historical importance - beautiful architectural example - beautiful gates and approach. However it is much to palatial for our purposes. ✓

✓ ⑧ KAVALIERHAUS - smaller villa on same estate with Klesheim. Smaller - with simpler facade - good gates leading into *Check* front court. General reaction that the facade was too severe - but that some Baroque decoration could be painted on it - making it a good possibility for front side of Trapp Villa - tying in to another location (possibly Leopold-skron) for rest of Villa.

SCHLOSS FROHMSBURR (OWNED BY MOZARTEUN) VERY GOOD BUT FOR VILLA + FRONT ✓

When Wise and company traveled to Salzburg for the "recce" trip, they took along Wyler's location list from the trip he, Lehman, and Edens had taken six months earlier.

production, including devising the shooting schedule and managing the film's budget. Zuby's job was to sketch the locations they found or take photographs of the locations and then later turn those images into the storyboards. Boris Leven would design and oversee the construction of all the sets, whether that involved changing an exterior location to fit the needs of the movie or designing a completely original set on the Fox lot. Pia Arnold, the German production manager on the film, met the group in Salzburg. It was Arnold's job to hire and coordinate all the technicians from Munich who were going to work on the film, plus handle any other problems or emergencies that might occur in Austria or Germany. Her diplomacy would come in handy many times before the filming was through.

Wise and crew wanted to shoot all the exteriors (outside scenes) in Salzburg; all the interiors would be shot on the Fox lot in Los Angeles. Not only did the group need to find attractive, historically appropriate sites for the many exteriors called for in Lehman's script, but they also had to bring back ideas that would enable Leven to design realistic and

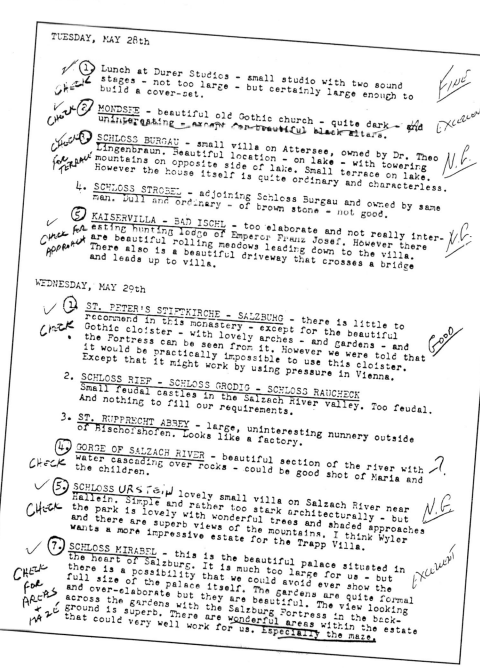

TUESDAY, MAY 28th

✓ ① Lunch at Durer Studios - small studio with two sound
CHECK stages - not too large - but certainly large enough to
 build a cover-set. Fine

✓ ② MONDSEE - beautiful old Gothic church - quite dark - and Excellent
CHECK uninteresting - except for beautiful black altars.

✓ ③ SCHLOSS BURGAU - small villa on Attersee, owned by Dr. Theo
for Lingenbraun. Beautiful location - on lake - with towering N.G.
TERRACE mountains on opposite side of lake. Small terrace on lake.
 However the house itself is quite ordinary and characterless.

 4. SCHLOSS STROBEL - adjoining Schloss Burgau and owned by same
 man. Dull and ordinary - of brown stone - not good.

✓ ⑤ KAISERVILLA - BAD ISCHL - too elaborate and not really inter-
Check for esting hunting lodge of Emperor Franz Josef. However there N.G.
APPROACH are beautiful rolling meadows leading down to the villa.
 There also is a beautiful driveway that crosses a bridge
 and leads up to villa.

WEDNESDAY, MAY 29th

✓ ① ST. PETER'S STIFTKIRCHE - SALZBURG - there is little to
 recommend in this monastery - except for the beautiful
Check Gothic cloister - with lovely arches - and gardens - and Good
 the Fortress can be seen from it. However we were told that
 it would be practically impossible to use this cloister.
 Except that it might work by using pressure in Vienna.

 2. SCHLOSS RIEF - SCHLOSS GRODIG - SCHLOSS RAUCHECK
 Small feudal castles in the Salzach River valley. Too feudal.
 And nothing to fill our requirements.

 3. ST. RUPPRECHT ABBEY - large, uninteresting nunnery outside
 of Bischofshofen. Looks like a factory.

✓ ④ GORGE OF SALZACH RIVER - beautiful section of the river with
CHECK water cascading over rocks - could be good shot of Maria and ?
 the children.

✓ ⑤ SCHLOSS URSTEIN lovely small villa on Salzach River near
 Hallein. Simple and rather too stark architecturally - but N.G.
Check the park is lovely with wonderful trees and shaded approaches
 and there are superb views of the mountains. I think Wyler
 wants a more impressive estate for the Trapp Villa.

✓ ⑦ SCHLOSS MIRABEL - this is the beautiful palace situated in
 the heart of Salzburg. It is much too large for us - but
 there is a possibility that we could avoid ever show the Excellent
Check full size of the palace itself. The gardens are quite formal
for and over-elaborate but they are beautiful. The view looking
ARCHS across the gardens with the Salzburg Fortress in the back-
+ MAZE ground is superb. There are wonderful areas within the estate
 that could very well work for us. Especially the maze.

*Wise checked off the spots he
was interested in seeing.*

accurate interior sets to be used in California. They began their search
as soon as they arrived in the city.

"Every morning we got up at 6:30 and began going around the
town," remembered Arnold. "Saul Chaplin was having such a hard time
getting up that early. It was very funny. Musicians are always used to
getting up later." Since she could not very well go around town
introducing her entourage as film people, especially when meeting the
priests and nuns at the abbeys (moviemaking was not a highly respected
profession in Austria at the time), Arnold found herself explaining the
presence of the crew in a unique way. "I told the nuns they were all
famous architects," she recalled laughingly.

Before they left the States, Wise, Chaplin, and Leven had gone over
the list of locations already found during the scouting trip Willy Wyler
had taken six months earlier and checked off the sites they wanted to
reinvestigate. It was quite an extensive list, and they ended up using

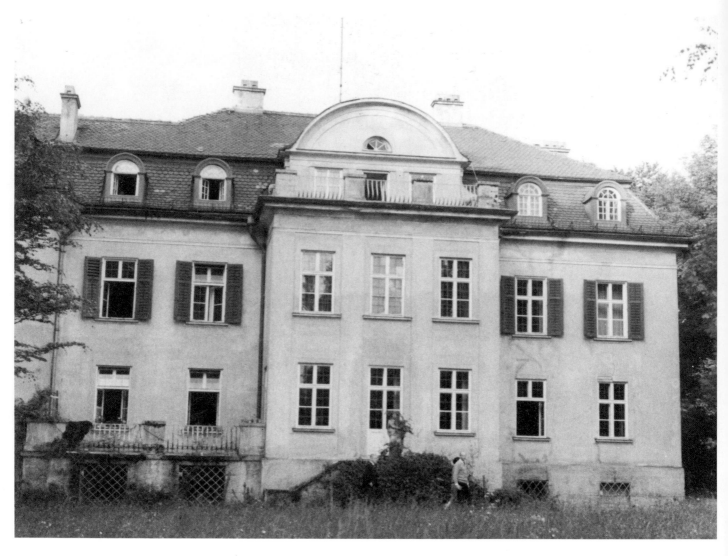

Villa Trapp.

many of the locations that Wyler and Lehman had originally discovered. Upon viewing some of the areas, Wise again realized how different his approach was from Wyler's. Wise, of course, wanted to cut down on the frills, even to the last detail. "I didn't want the von Trapp house to look like a Disney castle," Wise said.

Wyler, on the other hand, had wanted excess. "Wyler wanted to do the movie like the von Trapps were the Habsburgs," said Zuberano. "He wanted to do everything on such a grand scale. Bob didn't see it that way. Von Trapp was only a captain. Wyler wanted to do it as if they were the royal family!"

One of the first places Wise and his associates checked out when they arrived in Salzburg was the original von Trapp home. Villa Trapp was located in Aigen, a pleasant old market town in a peaceful wooded setting. Despite its idyllic locale, Wise found the villa unusable. After the family escaped in 1938, the Gestapo had taken over the home to use as its headquarters and had built a high wall around the entire estate. So Wise went looking for another villa to use as the family's home. They found the perfect spot.

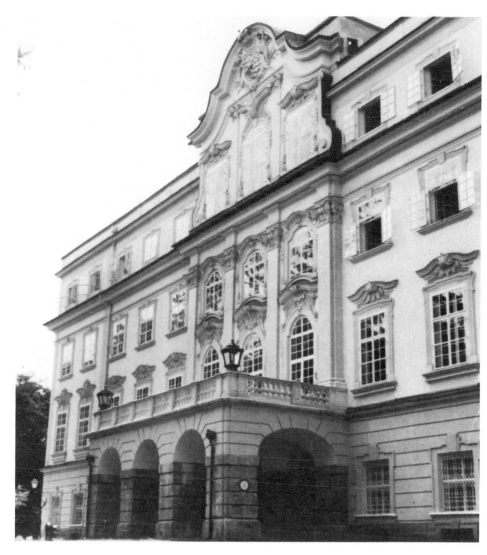

Leopoldskron is a large castle located on a small artificial lake outside the city of Salzburg. It was once used by German film director Max Reinhardt and, at the time of the filming, was leased out to the Salzburg Seminar in American Studies, an American school based in Cambridge, Massachusetts, designed to teach Europeans about American culture.

Wurtzel was put in charge of convincing the administrators at the Salzburg Seminar to allow the crew to film on their property. He contacted the business manager at the seminar, Frank Dickerson, and explained that the shooting would be limited to the exterior of the building—no one would need to go inside—and that the company would be filming May 3 to 11, when no seminars were scheduled at the school. He added that the crew would restore his terrace and garden to their pre-filming condition when the shooting was completed.

Wurtzel's offer of $1,500 for the use of the villa was turned down flat. The production manager then increased the offer to $5,000. Dickerson took the proposal to his home office in New York, and again the seminar declined. In a letter to John Shepridge at Twentieth Century Fox, Wurtzel described the situation. "It was evident they were trying to

A view of the front entrance to Leopoldskron as taken by Roger Edens on their scouting trip.

Setup and shooting in the back of Frohnburg.

hold us up for a considerable amount of money with talk of royalties on the picture and an endowment by 20th. [We] told them that this was out of the question."

Wurtzel asked for a counteroffer. Once more the seminar denied the crew permission, claiming that the filming would cause too much disturbance at the school. But, Wurtzel wrote, Dickerson "indicated that if a very attractive offer had been made in New York, the board might have found differently." Wurtzel then called Pia Arnold in Germany, and Arnold took the matter to the mayor of Salzburg and even the governor of Salzburg State! The mayor was anxious to placate the American film company because he knew how much money would be brought into his city if the

film was shot there. Yet even the mayor and the governor could not convince the seminar to allow the company on its property.

But the seminar's board of directors finally acquiesced a bit and allowed the company to shoot on another property the seminar owned next door to Leopoldskron. This property also bordered the lake and could work just as well. Wise and company grabbed it. (For point of reference, the production reports refer to the property as Leopoldskron, but research shows that the property that appears in the movie could actually have been an estate called Bertelsmann.)

Before Wise began filming, Boris Leven would re-create Leopoldskron's garden at Bertelsmann. He would also design a mock-up of the lower terrace with the gate and create a

glass summer house next to the lake. Wise and his director of photography, Ted McCord, planned to shoot all the nighttime lake scenes on the actual set built at Bertelsmann. These scenes included the "You Are Sixteen" number and the scene where the Captain meets Maria near the water and tells her he has called off his engagement to Elsa. But, as Wise and McCord found out later, their plans would have to be changed at the last minute.

Though Bertelsmann's *grounds* were ideal, the actual building was not right for the entrance to the von Trapp estate. Wise and associates had to search for another location to use for the house. They found what they needed at Schloss Frohnburg, a country house built in the 17th century. At the time Wise and

company came to shoot the picture, it was being used by the Mozarteum Music Academy. Leven fell in love with the villa. It had the simple, classic style that he and Wise were looking for, and they had no trouble getting permission to shoot there.

So the "von Trapp home" was Frohnburg, and the grounds, as seen from the "villa," were Bertelsmann. (Moviegoers never actually see the estate at Bertelsmann at all, only the lake and the garden Leven designed.) Of course, any of the scenes in which the camera would shoot toward the *back* of the von Trapp villa, where part of the villa would be shown on film, had to be shot at the back of Frohnburg, so the back of the house would match the front. Therefore, any of the scenes shot at the back of the house in which actors react to each other had to be shot in two different locations on two different days.

For instance, after Maria goes to the abbey and talks to the Reverend Mother about her feelings for the Captain, she returns to the von Trapp home. She comes back through the garden at Bertelsmann and meets the Captain, who is coming down the stairs (on another day) at Frohnburg. The Captain, standing on the steps at Frohnburg, gazes down at Maria (he is actually gazing down at Andrews, who is standing behind the camera, probably in street clothes, feeding him his lines). He says:

CAPTAIN: You left without saying goodbye, even to the children.

Maria's reaction, at Bertelsmann, is to look up at the Captain (this time it is Plummer's turn to be off camera) and say:

MARIA: It was wrong of me. Forgive me.

Back at Frohnburg, he replies, again to an off-camera Andrews:

CAPTAIN: Why did you?

At Bertelsmann, Andrews answers.

MARIA: Please don't ask me. Anyway, the reason no longer exists. . . .

This scene looks so fluid that one would never guess how it was filmed. In fact, at the end of the scene just described, Maria even walks up the steps and passes the Captain; because the banister at

```
         CUTS FOR REAR OF FROHNBURG - PAGE TWO

SCENE          DESCRIPTION

52M            FULL SHOT PAST SOME OF THE CHILDREN singing
               "Sound of Music" to CAPTAIN coming out of the
               house and reacting - DAY

52N            CLOSER SHOT - CAPTAIN - for above - DAY

52V            MED CLOSE - MAX at table reacting to the "New Mother"
               news and signalling the children to kiss Elsa. DAY

55 Y           FULL SHOT - CAPTAIN exits house - comes to stop
               at top of steps - Maria's POV - PIT, STEPS, AND
               BALLUSTRADE -DAY

55 YA          CLOSER SHOT OF ABOVE - CAPTAIN registers
               Maria's return - first dialogue to her - PIT. STEPS
               AND BALLUSTRADE   DAY

55 ZB          SIMILAR TO ABOVE - CAPTAIN moves down 3 or 4 steps
               with line to CHILDREN. They run through and into
               house. Captain continues dialogue to Maria. ELSA
               comes out of house - sees Maria - joins Captain
               and stops. PIT , STEPS, BALLUSTRADE   DAY

55 ZD          CLOSE-UP - CAPTAIN on steps for dialogue to Maria
               before Elsa's entrance. PITS, STEPS, BALLUSTRADE  DAY

55 ZF          CLOSER ANGLE - ELSA coming out of house and
               reacting to Maria's return  - DAY

56             MED SHOT - MARIA emerges from the house  - steps
               in middle of terrace - then moves to ballustrade -
               reacts to children's voices from house - exits to
               lake. PIT. STEPS AND BALLUSTRADE - DAY FOR NIGHT
```

This is a partial breakdown list showing a few of the scenes that were to be shot in back of Frohnburg. The scene described above is scene #55.

Scene 55, shot in two different locations.

Frohnburg was built to match the one at Bertelsmann, no one can tell that the scenes were shot on two different sets. (It is interesting to note that many directors don't require their stars to sit off camera and feed the other actors their lines. Often the actors on camera react to a stand-in giving them their cues. But that was a technique Wise would never permit.)

Of course, shooting out of sequence is very common in films. Still, it can be an odd experience for the actors. Portia Nelson (Sister Berthe) recalled, "I'll never forget running through the abbey in California to open a door in Salzburg!"

Another location that caused a bit of a stir was the Nonnberg Abbey. Pia Arnold, despite her stories to others about Wise, et al., being architects, had to tell the Reverend Mother at Nonnberg the truth because Wise was fairly certain that he wanted to film there. But there was no way the Reverend Mother was going to let a film crew shoot inside her cloistered walls! Remember, these nuns hadn't even looked out of a window in 50 years. They certainly weren't about to mingle with movie folk. Wise did, however, talk the mother into letting them shoot in the abbey courtyard and right outside the building. So the scene where the children go to the abbey to look for Maria is actually filmed at Nonnberg, and the shots outside the nunnery, when Maria

leaves the abbey for the first time to travel to the von Trapp home, were filmed there. But the sequence in the abbey cloisters where the nuns sing "Maria" was filmed entirely at the Fox studio.

Boris Leven was also allowed to install a rope outside the abbey gates so the children could ring the bell when they came looking for Maria. The Mother Abbess liked this idea so well she had the company leave the rope when they were through.

Location scouting for films is not usually a dangerous assignment. It's certainly not the kind of job where one expects to end up in jail. But that's exactly where Maurice Zuberano found himself one day while looking for the locations to be shot over the title sequences. Zuberano was not only the sketch artist on the film;

he was also the second unit supervisor. The second unit is the film crew that is sent out without the director to shoot scenes in which none of the principals appear. The filming of the opening titles for *The Sound of Music* (which were actually shot after the rest of the company had completed filming in Salzburg and had flown back to Los Angeles) didn't require anyone but the supervisor, a cameraman, and one helicopter pilot.

"Our helicopter pilot was the greatest ace, a real daredevil," recalled Pia Arnold. "But he was too reckless. I heard that he was killed in 1968 working on some film."

"He was known as the 'cowboy' pilot, and he scared the hell out of me," said Zuberano. "I was choosing a spot to be filmed,

and I would say 'Oh, over there in the distance is a good shot.' Well then, he'd swoop down on it like an eagle. It was pretty frightening."

"He was told, 'Whatever you do, do not touch down!' recalled Arnold. "But they had to land the helicopter because they were running out of gas!"

"We didn't have a special permit to land in Germany," Zuberano continued. "Well, from up in the sky we didn't see any borders, so we landed. Along comes this officer out of nowhere who'd had nothing to do since World War II, and he jumped out and yelled, 'You are all interned! You are all interned!' So we went to jail!"

"I think they were hiding and just waiting for something like this," said Arnold. "So I went to

Sketch artist Maurice "Zuby" Zuberano.

S.O.M.

PRODUCTION NOTES

SCENES	
1-3-ETC.	DO WE SET UP THIS 2ND UNIT WORK TO SHOOT WHILE WE'RE THERE SHOOTING?
5-6 + 8	DISCUSS THE TOTAL NUMBER OF NUNS, NOVICES AND POSTULANTS WE USE HERE. ALSO THE NUMBER WITH "WORK OUTFITS".
4	IS THIS PLANNED 1ST OR 2ND UNIT? FEEL IT WOULD BE BEST TO HAVE TED SHOOT IT.
6	DO WE HAVE ALL THESE PROPS THAT NUNS CARRY CORRECTLY LINED UP?
7 + ON	HOW DO WE HANDLE OUR CASTING IN SALZBURG? DO WE BRING STU DOWN FROM LONDON? EXTRA EXPENSE — BUT WOULD IT SAVE US IN ANY WAY?
8	DISCUSS WITH SOLLY THE NUMBER OF NUNS INVOLVED IN "MARIA". MOTHER ABBESS, BERTHE, MARGARETTA, SOPHIA, CATHARINE, AGATHA — 6 —
9	WHAT IS THE SITUATION WITH THE PLANS FOR MOTHER ABBESS' OFFICE?
10	DO WE HAVE A PROPER GUITAR CASE FOR MARIA? WHAT ABOUT HER CARPET BAG?
10E	DO WE HAVE OUR PERIOD BUS? WHAT ABOUT OTHER

Wise made scene-by-scene production notes on all technical aspects of the picture—lighting, props, costumes, even the children's table manners.

the finance office and got through to the finance minister. It took hours, but I finally got them out!"

Maria von Trapp was not only concerned that the movie family had climbed the mountain into Switzerland and not Italy (where her own family had actually escaped). She was also alarmed when she realized that the mountain the film company chose for their escape actually led right into one of Hitler's camps! What she didn't realize, however, is that it was because of Hitler that they managed to shoot that scene at all.

While he was on the recce trip, Wise and his colleagues simply could not find the ideal mountain to use in the closing scene. The mountain had to look relatively untouched but also had to have roads leading up to the top to provide easy access for all the equipment, sets, cast, and crew. Frustrated with being unable to find the right place to shoot this important scene, Wise

CARS, ETC. FOR DRESSING?

10 & 11 CAN WE PROCEED WITH OUR WORK ON FROHNBERG?

D 12 BE SURE MARIA'S OUTFIT HAS GOOD SIZED POCKETS
FOR THAT TOAD BUSINESS.
DO WE HAVE TO HAVE SOMEONE TO "INSTRUCT" ON THE BOATSWAIN WHISTLE?

13 ANY SPECIAL "GRACE" WE SHOULD KNOW ABOUT FOR THIS SCENE?
ANY SPECIAL TABLE SETTINGS, SILVER, GLASSWARE THAT WE
SHOULD HAVE FOR AUSTRIA IN THIS PERIOD? MENU?
HAVE TO BE SURE CHILDREN LEARN TO EAT IN EUROPEAN
MANNER.

14 DO WE HAVE ALL PROPER INFORMATION ON ROLF'S OUTFIT
AND PROPS? -

16 DISCUSS WITH TED McCORD HOW WE CAN HANDLE THAT
START OF THAT RAIN IN DAY FOR NIGHT SHOOTING - ALSO HIS
THOUGHTS ABOUT THE LIGHT AT THE PAVILION, THE EVENTUAL LIGHTENING, ETC.

A16 PROCESS OR BACKING IN PAVILION HERE AT STUDIO?

16-17 A PLAYBACK ON SET WITH THUNDER TRACKS WHEN WE'RE
SHOOTING

17 HAVE TO HAVE BOLTS OF MATERIAL THAT SOME OF MARIA'S
LATER DRESSES ARE MADE OF.

17 IS THAT BEDROOM SET FIXED FOR RAIN AT THE WINDOWS?
AT LEAST THAT ONE LIESEL ENTERS AND MARIA LOOKS OUT OF.
WHAT KIND OF WINDOW IS IT THAT LIESEL ENTERS! THE POINT
IF FRAU SCHMIDT CLOSING THE WINDOWS

All these details added to the authenticity of the film.

decided to leave this decision until they came back to shoot the picture. Even then, it proved to be an impossible location to find. "I looked for that mountain day after day," remembered Zuberano, "but I couldn't find one that had a road to bring up all the cars and trucks. I was very discouraged. And then, finally, the last day before we were scheduled to shoot the scene, we were getting some gas in a gas station, and I saw some old guys sitting in the station swapping stories. We were very close to where Hitler had built the guest house he called 'Eagles Nest,' so I got someone to translate for me, and I started asking them about the camp. They mentioned that Hitler was going to build another residence in *this* area, but then abandoned it in favor of the higher mountain, which eventually became Eagles Nest. I asked if there were any roads leading up to the abandoned camp, and they said, 'Yes. There's a wide paved road that goes straight up there.'

"So we took this beautiful road going up. It was a four- or five-lane highway. We got to the top of the mountain, but there was nothing there. I don't remember if it was snowing or what, but I couldn't see a thing.

"So I said, 'I think we should shoot here, but Bob has to see it first.' Saul Wurtzel told me there wasn't time for Bob to check it out. I thought, my God, I didn't even get a good view of it!"

The mountain was named Obersalzberg and was located in Bavaria, Germany, near the small village of Rossfeld. The next day, on Zuberano's and Wurtzel's recommendations, the company drove all of its equipment and trailers up the mountain. "We got to the top of the mountain the next morning," Zuberano went on, "and it was raining. So I *still* didn't know what the damn thing looked like! And then, like magic, Julie came out of her trailer and the whole sky cleared up. You could see the rainstorm in the distance. The mountain was gorgeous."

"Sometimes you do things like that," said Wise when asked about taking a chance on a location that they hadn't even seen. "It's just a roll of the dice."

Another mountain, where the children had their picnic and began singing "Do-Re-Mi," was a place called Werfen, in the Salzach River valley of Austria. Zuberano recalled, "The glaciers on the side were beautiful, but when it came time to shoot, we couldn't get them in the picture. So Bob solved that by having the

kids throw up a ball. That way the camera pans up, and you could see the glaciers."

The mountaintop used in the famous opening scene was dubbed "Maria's Mountain" by the company. It proved almost as difficult to find as the Obersalzberg location, again because of the logistics of finding a site that had wide roads leading to the top. They found what they thought would be their ideal spot at Mellweg, a mountain near the Bavarian village of Schellenberg, about 10 kilometers outside Salzburg. They found out later that Mellweg, of all the locations used in the film, would be the most difficult to shoot.

The other sites were not as challenging to locate. The massive rock wall at Felsenreitschule (or Rocky Riding School) provided the perfect spot for the music festival scenes. Its imposing presence gave the impression of centuries of Austrian tradition; in fact, ancient Romans had dug the edifice into a mountain face so they would have a place to hold tournaments. The complexity of the structure, with its ornate niches and passageways, made it a very complicated spot to shoot, but it was so visually exciting that the crew could not pass it up.

Maria and the Captain's wedding was shot at the Church of Mondsee Cathedral. Although it is usually difficult to get permission to film in a place of worship, this site had been used many times by other film companies, and church officials were very cooperative. The

marketplace where Maria took the children during the "Do-Re-Mi" montage would be a set Leven and his German crew would create. A real marketplace was too hard to control, so they would build their own.

From its Mirabell Gardens, seen in "Do-Re-Mi," to stately Unterberg Mountain towering regally in the background, Salzburg proved to be very photogenic. Finally, with a very long list of location possibilities, Wise and company flew back to Los Angeles. Then began the arduous task of choosing which locations to use and acquiring the permission to use them. Saul Wurtzel stayed on in Salzburg for a few weeks to make the arrangements. Other tasks lay ahead for the rest of the group.

When Wise and his associates returned to the studio, Boris Leven began designing the sets he would be building both on location and at Fox. Leven, a Russian immigrant, had come to the United States when his brother declined a scholarship to USC. The brother had fallen in love and did not want to leave Russia, so Leven came in his place. It was a fortuitous move. Upon graduating from USC, Leven began working at Paramount Pictures, starting a film career that would last for decades. Leven had collaborated with Robert Wise before, designing the sets for his films *West Side Story* (which won Leven an Oscar) and *Two for the Seesaw*. He also worked on three of

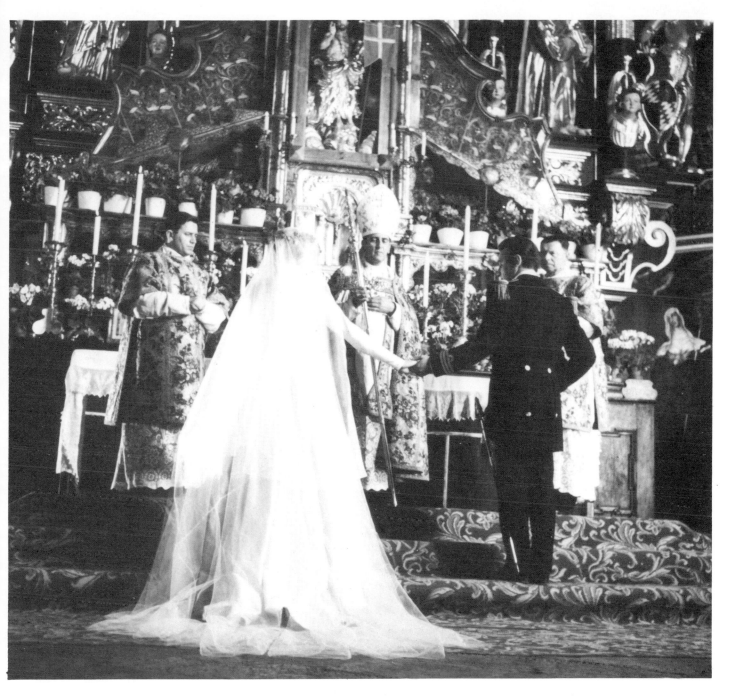

The Church at Mondsee.

Wise's later films, *The Sand Pebbles, Star!*, and *The Andromeda Strain*.

"I have a high regard for Boris's work," said Wise. "I feel the art director's work is as important as the cinematographer's. And Boris and Ted, our director of cinematography, had a tremendous rapport. That doesn't usually happen in films. More often there is a rivalry between the two. But when Boris would put his own lighting ideas into his scene sketches, Ted was thankful for his input and incorporated them into his own lighting design."

The entire interior of the von Trapp villa, including the ornate von Trapp ballroom, was built and shot at the studio. The ballroom was such a beautiful piece of film art that after the picture was completed Fox donated the set to the Hollywood Museum.

for the Holidays

and Wishing you happiness throughout the New Year

THANK YOU FOR YOUR THOUGHTFULNESS

Your Letter Carrier

Fred W Gromer

You never know when inspiration will strike. Boris Leven, doodling, sketched the von Trapp staircase onto a Christmas card he'd received from his mailman.

(Below) Set design paintings: graveyard (top); Mother Abbess's reception corridor (bottom). Artist: Ed Granes.

Leven also designed a reproduction of the abbey courtyard so faithful to the original, down to its cobblestones and stained-glass windows, that on *The Sound of Music* tour in Salzburg the guides actually believe that the cloister scenes were shot at Nonnberg Abbey. Another scene the tour guides erroneously describe as being filmed in their city is the graveyard scene, in which the von Trapps hide from the Nazis. Though filmed on a set on the Fox lot, the scene is so realistic that guides claim the scene was shot at St. Peter's Graveyard in Salzburg.

Where Leven was busy with the sets, Dorothy Jeakins was immersed in readying the costumes for a cast that included not only seven *growing* children but also hundreds of extras.

Jeakins was used to costuming large casts. She began her film career working with Cecil B. DeMille on *The Ten Commandments* (the 1956 version) and *The Greatest Show on Earth*. Over the years she became one of the most highly regarded costume designers in Hollywood and on Broadway. Perhaps her most famous Broadway design was Mary Martin's costume for *Peter Pan*. In Hollywood her films ranged from the musicals *South Pacific* and *The Music Man* to the dramas *The Way We Were* and John Huston's *The Dead*, her last film.

In keeping with Wise's desire for clear visual lines in the film, Jeakins was told to make sure her designs appeared as simple as possible. She had to check constantly to make sure that none of the dresses appeared too cloying.

Jeakins's designs, in all her pictures, were completely authentic. If a period piece did not use zippers, her costumes wouldn't use zippers. This not only added authenticity to the film but also helped the actors feel their parts. For her research into Tyrolean costumes Jeakins had Pia Arnold assist her from Germany. Arnold looked into everything from Austrian naval buttons to the carpetbag that Maria would carry to the von Trapp home. She even received some help from the film company that had produced the original German films. Nonnberg Abbey, once again, was not at all cooperative in giving any details about its order's habit. So Jeakins met with a Mother Abbess in a Los Angeles convent and was given guidelines for the veils and headdresses of the order.

Dorothy Jeakins discusses her costume sketches with Christopher Plummer and Robert Wise.

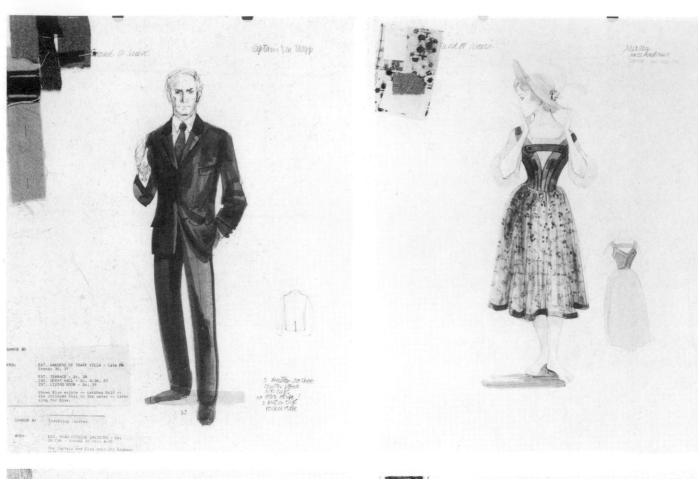

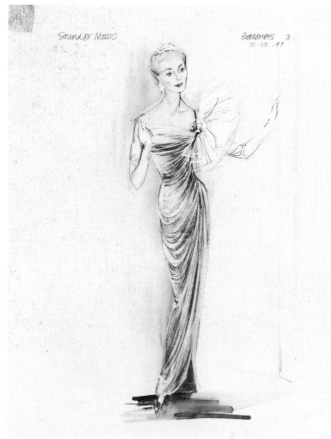

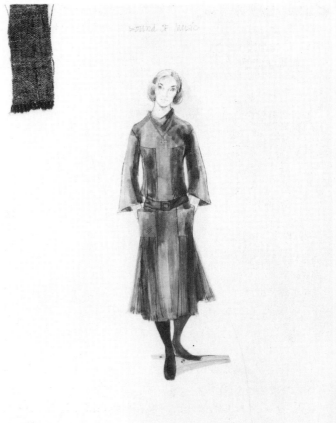

Some of Dorothy Jeakins's costume sketches.

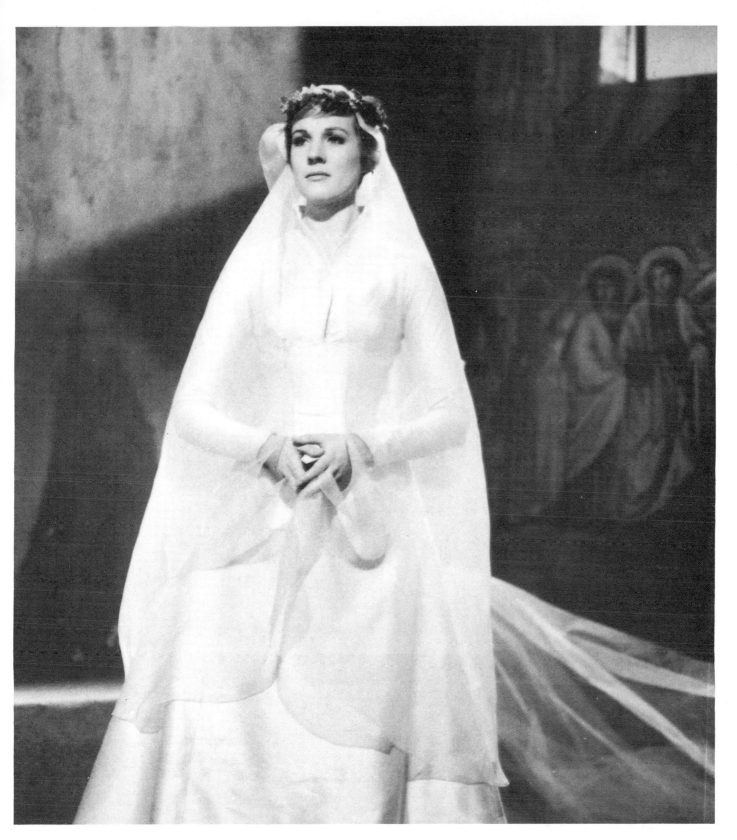

After she sketched a few costumes for the film's leads, Jeakins and Wise met with the stars, who offered their own suggestions. Andrews and Dorothy Jeakins were good friends, and Andrews had enormous respect for the designer's abilities. "I've never felt as beautiful as when I wore that wedding gown," said Andrews. "I've never felt prettier before or since. That dress was a miracle."

Dance rehearsal (from left):
Pamela Danova (leaning on
piano), rehearsal pianist Harper
MacKay, Richard Haydn, Robert
Wise, Saul Chaplin, Marc
Breaux, and children Debbie
Turner, Duane Chase,
Charmian Carr, and Nicholas
Hammond.

Rehearsals began in mid-February. The children started rehearsing on February 10, Julie Andrews was set for February 20, Christopher Plummer began on March 2, and the nuns started on March 19. There were no scene rehearsals per se; the rehearsal period consisted of learning the dance sequences, doing wardrobe and photographic tests, and prerecording the music.

The choreographers, Marc Breaux and Dee Dee Wood, were hired on February 3, 1964. They were the husband-and-wife team that had worked with Julie Andrews on *Mary Poppins*. Breaux and Wood had one week of preparation with Wise and Chaplin before rehearsals began. The four of them would meet and discuss the characters, then Breaux and Wood would go into the rehearsal room with a couple of assistants and start playing around with the music. Saul Chaplin would usually play the piano while they worked out the timing of the movements. "We

couldn't change the arrangements at all under Rodgers and Hammerstein's contract," said Breaux. "So we had to work within the confines of what music was already there."

Breaux and Wood didn't use the choreography that was in the play; the stage choreography was too restrictive. As Wise wrote later in his *Los Angeles Times* article, "On stage, the choreography is necessarily confined to the limits of the proscenium arch. We have no such strictures [with film] and can permit the dancing to flow out of the bounds of the other areas. It not only serves to broaden the scope of the number itself, it helps to serve as a bridge to the ensuing scene."

In "Do-Re-Mi," for example, Saul Chaplin wanted a strong finish for what would turn out to be one of the most popular sequences in the film. The song was already much less static than it had been in the stage version, since it was filmed with the snow-covered Alps and the city of Salzburg as backdrops and included footage of Maria and the children running, bicycling, and shopping. At one point in the song, Maria and the children are riding along in a horse-drawn carriage, and the children each sing a note of the scale when Maria points to them with the buggy whip; using their voices as an instrument, she creates a new melody. Chaplin and the choreographers, upon seeing the

steps at Mirabell Gardens, decided to take the metaphor even further and had the children jump up or down the steps—depending on whether their notes were higher or lower than the last note sung—as they sang the finale, so that their bodies, as well as their voices, echo the song's conceit.

Breaux and Wood did try to make the Laendler, the Austrian folk dance the children teach Maria in the garden the night of the ball, as authentic as possible. They researched the number and then integrated the authentic dance into their own choreography. The rest of the film's choreography was strictly their own, with Breaux and Wood taking their lead from the characters and the music. The

The Laendler.

Bil Baird designing the marionettes for "The Lonely Goatherd" number.

Andrews and the children spent three weeks rehearsing with the puppets.

couple even choreographed the puppets' dance sequences in "The Lonely Goatherd" number. Bil and Cora Baird, America's foremost puppeteers at the time, designed a new series of marionette characters just for the film. Breaux and Wood created the dance sequences and then showed them to the Bairds. They, in turn, would work the marionettes to copy the choreographer's steps. It then took three weeks of rehearsals with Andrews and the children to make it seem as if the actors were working the puppets.

Designing dance sequences where actors covered lots of ground, such as in the "Do-Re-Mi" number, was a bit tricky. That's where Zuberano's storyboards would come in. Breaux and Wood would judge the distances from the sketches. Then they would rehearse everything at the studio before going to Salzburg. For instance, to rehearse the sequence in which Maria and the children ride bikes down a tree-lined road, Andrews and the children would get on bikes and ride down a street on the Fox lot, timing the riding with the music.

Two weeks before the company was to travel to Salzburg to begin filming, Marc Breaux and Saul Chaplin flew to the city ahead of the cast to further perfect the timing of the dance sequences. (Dee Dee Wood stayed on in Hollywood to rehearse with the cast.) They took along a prerecording of "Do-Re-Mi" and "I Have Confidence in Me," the only two songs filmed on location. They had already rehearsed these complicated numbers on the lot at Fox, so they had an idea of how far the actors needed to go to get from, say, one end of the street to the other, and how many bars of music it would take for them to get there. Now Chaplin and Breaux had to see if they were right. If they weren't, Irwin Kostal could redo the tracks back in Los Angeles and get them ready before the company began location shooting.

It must have been a silly sight, the choreographer and associate producer pacing musical numbers in the middle of traffic. Chaplin stood on the street corner, poised with a tape recorder in hand, and as soon as the traffic light changed he gave it some juice and Breaux would take off down the street, his "dancing" becoming a mixture of his own choreography and his weaving as he dashed between the cars. Invariably the light would change again before the music ended and Breaux would then be stuck in the middle of the street. This happened again and again until finally a policeman stopped them and began questioning them in German. Since neither of them spoke fluent German, they couldn't readily explain what they were doing. But they were lucky. The policeman, realizing they were Americans, just shook his head and walked on, as if their nationality were explanation enough for their behavior.

Julie Andrews rehearsing with choreographer Marc Breaux.

Saul Chaplin and Marc Breaux (Dee Dee Wood in background).

On the Fox lot, timing the bike-riding scene from "Do-Re-Mi."

The children began rehearsals on February 10. All the children got along famously, right from the beginning. Heather Menzies and Angela Cartwright became inseparable. They were obsessed with the Beatles and spent any free time drooling over teen magazines. Kym Karath's first crush was Nicholas Hammond. They became such good friends, in fact, that Hammond later took Karath to her first prom.

The studio, in compliance with California law, had all the children except for Kym Karath, work just six hours a day. Because she was not yet six, Karath could

An American obsession, even for the von Trapp "children."

Lunchtime!

Kym Karath's sixth birthday party.

work for only four hours. She was always being teased by the others because not only did she work fewer hours, but her mother was required to accompany her every time she went to the bathroom. Karath's happiest memory of the picture was the day she turned six. "Oh, thank God!" she remembers saying. "Now I can finally go to the bathroom by myself!"

The children were also required to be in school three hours a day. Their "schoolhouse" was located in an office on the Fox lot, where they were tutored by veteran studio teacher Frances Klamt. A typical day for the children, before they began filming, would be:

8:00–10:00: School

10:00–12:00: Rehearse with vocal coach, Bobby Tucker

12:00–1:00: Lunch

1:00–2:00: School

2:00–3:00: Vocal coach again

3:00–4:00: Learn dance steps with Marc Breaux and Dee Dee Wood

4:00–5:00: Work with dialect coach Pamela Danova

Charmian Carr didn't have to go to school, so her day began at 9:00 with Pamela Danova, and she took guitar lessons from 1:00 to 2:00; she had to look convincing playing the guitar in the "Edelweiss" scene.

Danova worked on the children's dialects every day, even when they traveled to Salzburg. All cast members were given lists of commonly used words and how to pronounce them. Vowels sounding like a British *good* were *ful*fill and *look*, for example. Vowels sounding like the German *herr* were pr*ayer*, c*areful*, f*are*well. Vowels sounding like *few* were fort*une*ate, T*ue*sday, t*une*s. *Friedrich* was pronounced *Free*drik. *Georg* sounded like Gay-org. The list went on.

When the children weren't busy with these activities, they were in wardrobe fittings or makeup, or they were having their portraits taken.

Dan Truhitte and Nicky Hammond had to have their hair dyed for their parts. Both had dark brown hair, and it was no small task turning them into blonds.

"They had to bleach not only my hair but my eyebrows too," recalled Truhitte. "Then, in Salzburg, they ran out of whatever they usually used on my hair, and the wardrobe mistress used this European stuff. I should have known then that this would be a problem, because she looked very concerned when she put it on my hair. I don't know if that's what did it, but my hair never grew back right after that. I lost

Carr with instructor, learning how to play the guitar.

Julie Andrews and Pamela Danova.

half my hair, and it thinned out a lot. I had to start wearing hairpieces at twenty-one, and it hasn't been the same since."

Truhitte wasn't the only actor whose hair was damaged by the hair dye. Julie Andrews's hair was dyed blond for her role of Maria, but that was not the original intention. "I came in for the hair tests," recalled Andrews. "They always test your hair and makeup and wardrobe when you start a picture. I had natural blond highlights in my hair, but they said it was a little dark at the back of the neck. So they decided to put in more highlights to give it a blond effect. But the highlights bled, and my hair came out orange! We were all mortified! So to cover it up, they bleached my hair blond all over."

Prerecording was a major factor in preproduction. Prerecording songs is necessary in a musical film because there has to be a consistent tempo against which to shoot musical numbers. Every scene in any film is shot in pieces, called *takes*. One scene could literally have hundreds of takes. Sometimes one scene could take days or even a week or more to shoot. If a live orchestra was on the set, there would be no way it could keep the tempo exactly the same for each take.

When Irwin Kostal, the musical arranger, began the prerecording sessions on the music stage at the studio, he had both a large orchestra and the singers on the stage. He recorded them, however, on separate sound tracks, so the sound technicians would have ultimate flexibility in balancing the two when final dubbing was completed. The separate music track was also used later for dubbing in foreign countries.

The orchestra, with eight to ten microphones scattered through the various instruments, was recorded on several stereo sound tracks. The singer was in a

Though she was happy to have her hair cut short for the film, when they dyed her hair orange, Andrews said, "We were all mortified!"

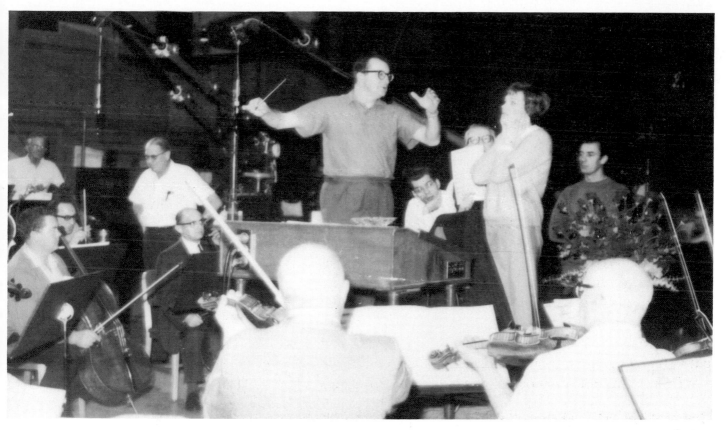

Julie Andrews rehearses songs with orchestra led by music supervisor and conductor, Irwin Kostal. Before going into the "remote box" to prerecord their numbers, the actors rehearsed with the orchestra so both parties could get a feel for the energy and nuances each one would bring to the song.

remote sound "box" at the side of the stage. The box had glass panels so the singer could see the orchestra and the conductor. Each singer's voice was recorded on a single, intimate microphone.

The songs were recorded in pieces. "It's almost impossible for an orchestra and a singer to go through a whole three- or four-minute number," said Wise. "So you may do bars one through twenty-eight, get that right, and then pick up with bars twenty-nine through fifty, and so on. You set all your tempos there. I used to be known as 'Ten Percent Wise.' I'd come into a rehearsal, and I'd listen to the recording, and often I'd say, 'Yeah, it's swell, but it needs to be ten percent

faster.' And usually it was better."

"It's hard to prerecord a song without knowing what you're going to be shooting," said Andrews. "Like in 'The Sound of Music.' It was hard to lay down that song definitively without knowing precisely what the movements were. I knew I wanted it to be joyous and thrilling, and to this day, when I sing it in my concerts, that song still gives me a thrill. But back then I had to try to outguess myself and project what I would be doing."

If prerecording a song was hard for the actor, it was even more complicated when using a voice double. Voice doubles were used when the real actor's voice

wasn't strong enough. "You always have the actor at the recording sessions," said Wise. "That way the actor's interpretation can be worked into the song. The actor doesn't sing along with the double, but he gives the double his input. He might say, 'I would play it this way.' The actor is there to help give the acting dimension to the singing."

Peggy Wood's voice was dubbed by Margery MacKay, the wife of the rehearsal pianist, Harper MacKay. Even with all the voice lessons and rehearsals, the children's voices had to be reinforced. "The voice lessons are really to teach the actors how to sing the songs in sync with the recording," said Harper MacKay,

Norma Varden,
*hair and makeup
tests.*

"It makes the singing more realistic."

Irwin Kostal used seven children and five adults to fill in the children's voices. "The only time the children actually sing alone," said Kostal, "is in the scene after Maria has left and the children are sad. They try to sing 'The Sound of Music' on their own. That is their real voices. That's the best they could do."

Coincidentally, one of the singers hired to dub the children's voices was Darleen Farnon, Charmian's younger sister. "They didn't even know she was my sister," Carr said in a 1964 interview with a Fox publicist. "The same agent who took me out on a date took her out. It wasn't until after they signed her that I told them she was my sister." Darleen too later changed her last name to Carr and over the years has acted in numerous television shows, including a recurring role as Karl Malden's daughter in "The Streets of San Francisco."

Production on *The Sound of Music* almost came to a complete halt before the movie even began filming when Christopher Plummer threatened to quit the picture. Plummer was determined to have his own voice recorded on the film, and to that end he took voice lessons every day with Bobby Tucker. But when Plummer was told that his voice was going to be dubbed, even in the prerecordings, he almost walked off the set.

"Plummer hadn't understood that they were going to prerecord his songs with a voice double," said Wise. "That meant that he would have to sing in sync with that 'dummy' voice as he was acting in front of the camera. Plummer wanted to do his own prerecording, with the chance to redo his singing, if necessary, after shooting was completed. He felt that by the time the picture was in postproduction he would have improved on his voice enough so that it could stay in the picture."

"No one wants to do voice dubbing," said Irwin Kostal. "You do it only as a last resort. Chris was very conscientious about his lessons. Bobby Tucker spent a lot of time working with him."

Different looks for Liesl.

Wise and Chaplin rehearse a song with Kym Karath.

However, no matter how much he rehearsed, Plummer's voice just wasn't strong enough.

When Plummer announced that he was going to quit, Ernest Lehman, who had already left the picture and was at work on *Who's Afraid of Virginia Woolf?*, was called back to talk to him. "He said he felt emasculated," said Lehman. "He said that knowing his voice would be dubbed destroyed his ability to play the role."

The case was taken all the way up to Dick Zanuck. Zanuck finally told Plummer that he could do the prerecordings. Then, after the shooting was completed, they would rerecord his voice for the picture if Plummer thought his voice was good enough. A clause to this effect was inserted in Plummer's contract, and he was led to believe that his voice could still be in the picture if he worked on it sufficiently. Wise also agreed to this plan of action, for

he thought it just might be possible that Plummer's voice would improve enough to go into the completed film.

"This has happened in a lot of pictures where the star doesn't have a strong enough voice," said Harper MacKay. "I've worked with Audrey Hepburn on *My Fair Lady*, Rosalind Russell on *Gypsy*. It's all the same. The stars work very hard on their voices, and everyone encourages them and tells them how well they are doing, and then they begin to believe it themselves. And when they are finally told that it's not good enough, there are a lot of hard feelings."

The prerecordings weren't completed before filming began, so extra recording sessions had to be fit into the shooting schedule. When the actors weren't required for a scene, they would be busy finishing the prerecordings. "It was a tense and edgy period," Wise recalled of those last few days before beginning production. "No matter how much preproduction preparation time one has on a film, and we had six months of it on *Music*, on that first day of shooting you feel like a high diver taking the plunge into a pool far below. The anticipation is very nerve-racking, and it's only when the plunge has been made and the shooting starts that the nerves settle down."

FINAL SHOOTING SCHEDULE

E RNEST LEHMAN MAY HAVE WRITTEN A FLUID, TIGHTLY
constructed story of Maria's early experiences with the von Trapp
family, but the film was not shot that way. As with all pictures, the film
was shot out of sequence. Following is the breakdown of the way the
film was actually shot, based on available daily production reports.

LOS ANGELES

March 26-April 1, 1964—Scene 17
Int. Maria's Bedroom—Night
Frau Schmidt brings in material . . . tells Maria that the Captain will
marry the baroness . . . As Maria prays, Liesl enters through the
window. Lightning and thunder bring in the other children. Maria
begins "My Favorite Things." They all join in. The Captain enters, and
the children all leave. The Captain has a few words with Maria, and
then he too leaves. Maria examines soon-to-be-replaced drapes and
conceives idea for playclothes. She begins the song again.

April 2, 1964—Scenes 5 and 6
Ext. Abbey Cloister—Dusk
Nuns walk to chapel as we hear the chant, "Dixit Dominus."

April 3-8, 1964—Scene 8
Ext. Abbey Cloister—Dusk
"Maria."

April 9, 1964—Scene 60
Int. Room Off Abbey Cloister—Day
Mother Abbess and others prepare Maria for the wedding. They escort Maria to cathedral gate. She goes through the gate while the nuns remain inside.

April 10, 1964—Scenes 8, 79, 81, and 83
Int. Maria's Room, Abbey—Night
(8) Maria is kneeling in prayer. Sister Margaretta comes to tell her that the Mother Abbess wants to see her. Maria and Sister Margaretta walk to the Mother Abbess's quarters. Maria is summoned inside.

(79) The Captain and his family hear Nazis. Mother Abbess leads them out of the abbey. She cautions Sister Berthe to be slow in opening the gate.

(81) Zeller and his men hear a car racing away and rush out as the sisters move to the window.

(83) The sisters confess they immobilized the Nazis' cars . . . show parts to Mother Abbess.

April 13-17, 1964—Scene 80
Ext. Abbey Graveyard and Crypt—Night
Mother Abbess leads the family to the abbey crypt. They hide from the Nazis. Rolf discovers them and tries to turn them in. The family escapes.

COMPANY TRAVELS TO SALZBURG

April 23, 1964—Scenes 59 and 61
Int. Mondsee Cathedral—Day
Wedding of Maria and the Captain.

April 24, 1964—Scene 7—St. Margarethen Chapel
Int. Chapel—Day
Nuns kneel in prayer.

April 25, 1964—Scene 9—Dürer Studios
Int. Mother Abbess's Quarters—Day
Reverend Mother tells Maria that she must go to the von Trapp home.

April 27-May 5, 1964—Scene 75
Int. Rocky Riding School—Night
Festival Scene.

Scene 8—"Maria."

May 4 and 6, 1964—Scene 66
Int. Rocky Riding School—Day
Zeller arrives at rehearsal and asks Max when the Captain will be coming home from the honeymoon.

May 7, 1964—Scene 67
Ext. Rocky Riding School—Day
Max and the children are rehearsing, and Liesl spots Rolf delivering a telegram. He ignores her.

May 8, 1964—Scene 53—Nonnberg Abbey
Ext. Abbey—Day
The children go looking for Maria.

May 9, 1964—Scenes 53, 78, 79, and 82—Nonnberg Abbey
Ext. Abbey—Day
(53) The children look for Maria.

Ext. Abbey—Night
(78) Nazi cars speed toward the abbey.

(79) The sisters open the door to Zeller.

(82) Zeller and his men cannot start their cars.

May 11, 1964—Scene 10
Ext. Path over Toscaninihof—Day
"I Have Confidence in Me."

Ext. Abbey—Day—Nonnberg Abbey
Beginning of "I Have Confidence," when Maria leaves the abbey.

May 12, 1964—Scenes 28 and 29
Ext. Mirabell Gardens—Day
"Do-Re-Mi" sequence.

May 13, 1964—Scene 24
Ext. Winkler's Terrace—Day
"Do-Re-Mi" sequence.

May 14 and 15, 1964—Scene 10
Ext. Kapitelplatz, Residenzplatz, Domplatz
"I Have Confidence" and "Do-Re-Mi."

May 16, 1964—Scenes 18 and 19
Ext. Marketplace and Footbridge—Day
"Do-Re-Mi" sequence.

May 19-21, 1964—Scenes 20 and 28
Ext. Horse Fountain—Day
(20) In the middle of the "Do-Re-Mi" montage, Liesl meets Rolf, who is out delivering telegrams. Liesl introduces him to Maria.

Ext. Mirabell Gardens—Day
(28) "Do-Re-Mi."

May 22, 1964—Scenes 10 and 28
Ext. Kapitelplatz and Residenzplatz—Day
(10) "I Have Confidence"

Ext. Mirabell Gardens—Day
(28) "Do-Re-Mi."

May 23–June 5, 1964—Scenes 36, 37, and 38—Bertelsmann
Ext. Trapp Villa—Day
The Captain shows Elsa the estate after they arrive at the villa. Elsa hints at marriage, and then Max emerges from the house. After the Captain exits to look for the children, Elsa and Max have a conversation about her strategy to win over the Captain. The Captain eventually finds the children in the middle of the lake in a canoe. The boat overturns, and everyone falls out. The Captain and Maria have heated words over her conduct.

June 6 and 7, 1964—Scenes 52 and 55—Bertelsmann
Ext. Trapp Villa—Day
(52) Elsa plays ball with the children. She then tells Max that she will send the children to boarding school. The children try to sing without Maria, but their hearts are not in it.

(55) The children come back after trying to visit Maria at the abbey. The Captain berates them for disappearing, but they tell him they just went berry picking. They start to sing "My Favorite Things," and then Maria comes back and joins in. The children tell Maria that the Captain will marry Elsa.

Angle on Maria as Captain comes down the steps and welcomes her back. She tells him she will stay only until he finds a new governess. She then walks up the stairs to go into the house.

June 9, 1964—Scenes 37k, 52, 38, 16, and 56—Frohnburg
Ext. Trapp Villa
Close ups of scenes listed.

June 10–13, 1964—Scenes 14 and 71–74—Frohnburg
Ext. Trapp Villa—Day
(14) Rolf delivers telegram to Franz.

Ext. Trapp Villa—Night
(71–74) The von Trapps silently push their car past their house. Zeller drives up and catches them. He offers to escort them to the festival.

June 15, 1964—Scenes 38, 42, and 55—Rear of Frohnburg
Ext. Trapp Villa—Day
(38) The Captain hears the children singing for the first time; they are singing "The Sound of Music" for the baroness. He walks inside the house.

(42) The Captain comes out onto the terrace. He is thinking about Maria. The camera moves up to reveal Maria, gazing out into the night from her bedroom window, thinking about the Captain.

(55) Rear angle of Maria after she tells the Captain that she will stay only until he finds a new governess. She walks up the stairs to go into the house.

June 16, 1964—Scene 55—Frohnburg
Ext. Trapp Villa—Day
Angle on Captain as Maria comes back from abbey. He asks her why she left but she has no answer. Elsa comes down the stairs and sees Maria.

June 17 and 18, 1964—Scenes 10, 38, and 68—Frohnburg
Ext. Trapp Villa—Day
(10) Maria first arrives at the villa. Franz answers the door.

(38) The Captain sees Rolf throwing rocks at Liesl's window.

(68) Maria and the Captain return from their honeymoon. The Captain rips up the Nazi flag.

June 19, 1964—Scenes 10 and 18—Frohnburg
Ext. Trapp Villa—Day
(10) Maria opens the gate as she arrives at the villa for the first time.

(18) The children run out in their playclothes—beginning the montage of "Do-Re-Mi."

June 20, 1964—Scene 27
Ext. Nonnberg Abbey—Day
Maria leaves the abbey and begins "I Have Confidence."

June 21, 1964—Rained Out
June 22, 1964—Scene 25
Ext. Tree-Lined Street—Day
"Do-Re-Mi" (rained; did not complete).

June 23, 1964—Scene 25
Ext. Tree-Lined Street—Day
"Do-Re-Mi" (rained; did not complete).

June 24, 1964—Scene 25—Werfen
Ext. Picnic—Day
(Rained out, so just rehearsed.)

June 25 and 27—Scene 25
Ext. Picnic—Day
"Do-Re-Mi."

CHILDREN TRAVEL BACK TO LOS ANGELES

June 28-July 2, 1964—Scene 2—Mellweg
Ext. Maria's Mountain—Day
Opening sequence. "The Sound of Music."

REMAINDER OF COMPANY TRAVELS BACK TO LOS ANGELES

July 6-8, 1964—Scene 13
Int. Trapp Dining Room—Night
Dinner scene, where Maria makes the children feel guilty for putting the frog in her pocket.

July 9-10, 1964—Scene 12
Int. Trapp Villa Ballroom—Day
Scene with Maria and Franz when she first arrives at the villa. Maria walks into the ballroom and begins to dance by herself. The Captain enters, and she runs out of the room.

July 13-14, 1964—Scene 12
Int. Trapp Villa Hall—Day
The Captain calls the children down with his whistle. They line up and announce their names to Maria.

July 15-20, 1964—Scene 45
Int. Trapp Villa Ballroom—Night
Party scene with "So Long, Farewell."

July 21-23, 1964—Scene 46
Int. Trapp Villa Terrace—Night
The Captain and Maria dance to "Laendler."

July 24, 1964—Scenes 49 and 69
Int. Trapp Villa Hallway—Night
(49) Elsa leaves Maria's room after telling her about the Captain's feelings for her.

(69) Maria, the Captain, Liesl, and Max enter after the couple returns from their honeymoon. Liesl hands the Captain the telegram telling him he has been ordered to join the German Navy.

July 27, 1964—Scene 57
Ext. Trapp Terrace—Night
The Captain comes out onto the balcony and looks down at Maria as she walks near the lake. Elsa joins him, and he breaks off their engagement.

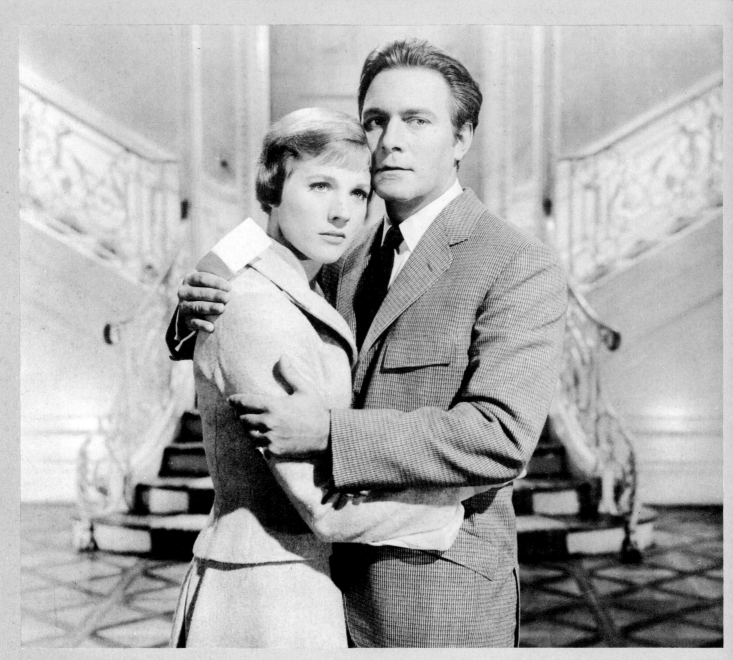

Scene 70

July 28, 1964—Scene 70
Int. Trapp Villa—Day
Maria and Liesl talk about love and reprise the song "You Are Sixteen."

July 29, 1964—Scenes 48 and 42
Int. Maria's Bedroom—Night
(48) Elsa tells Maria that the Captain is in love with her.

(42) Maria leans out of her window, wistfully looks out at the night, and thinks about the Captain.

July 30–August 3, 1964—Scene 41
Int. Trapp Villa—Day
"The Lonely Goatherd" puppet show.

August 6, 1964—Scene 41
Second unit works on the puppet show.

August 6-7, 1964—Scenes 39 and 40
Int. Trapp Living Room and Hallway—Night
The Captain enters the living room and watches his children sing "The Sound of Music." He moves in to join them and sings "Edelweiss." The Captain catches Maria moving up the stairs, and he asks her to stay.

August 10, 1964—Scenes 39, 40, 47, and 51
Int. Trapp Living Room—Night
(39) The children and the Captain finish singing "The Sound of Music."

(40) The Captain asks Maria to stay.

(47) Exiting, "So Long, Farewell."

(51) Maria moves down the staircase after her conversation with Elsa, places her going-away letter on the table, and exits.

August 11, 1964—Scene 58
Ext. Pavilion—Night
The Captain meets Maria down by the lake and tells her that his engagement to Elsa is off.

August 12-13, 1964—Scene 58
Ext. Int. Pavilion—Night
Maria and the Captain sing "Something Good."

August 14-19, 1964—Scene 16
Ext. Pavilion—Night
Liesl and Rolf meet and sing "You Are Sixteen."

August 20, 1964—Scene 31
Int. Ext. Car Process—Day
Process scene in car with the Captain, Elsa, and Max.

August 21, 1964—Scenes 12 and 13
Int. Trapp Villa—Day and Night
Insert scenes: Pinecone in Maria's chair and the frog running upstairs.

September 1, 1964—Scene 31
Int. Ext. Car Process—Day
Retake process car scene with the Captain, Max, and Elsa.

END OF PRINCIPAL PHOTOGRAPHY

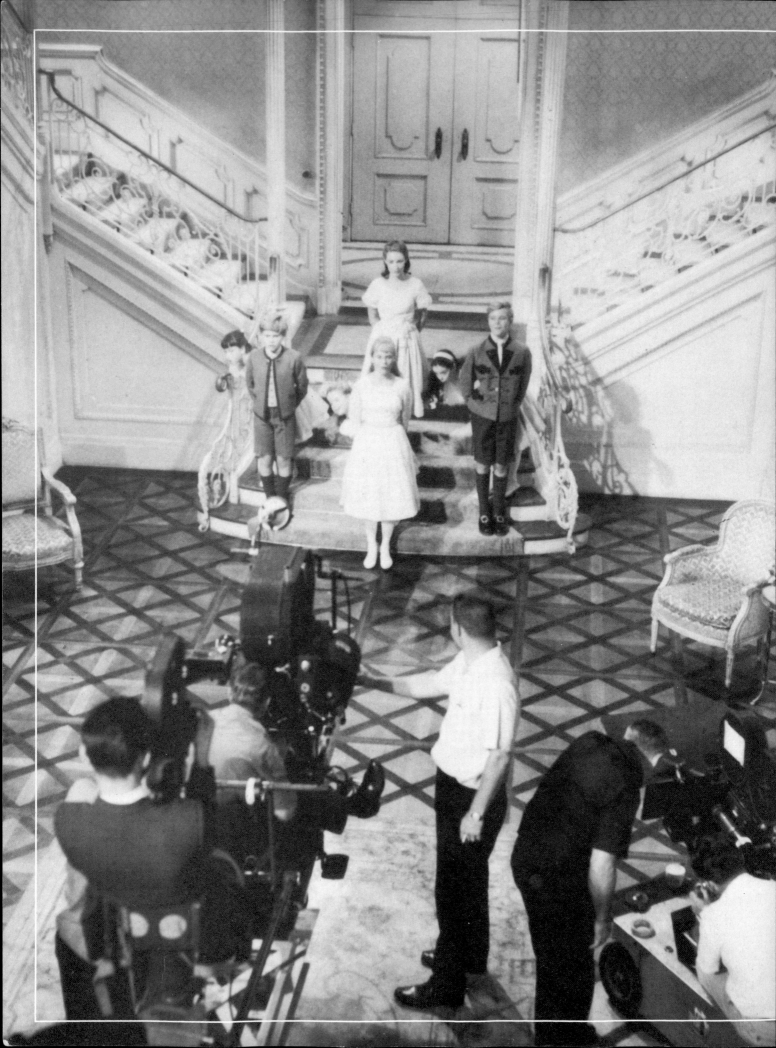

"Climb every mountain . . ."

PRODUCTION

ON THURSDAY, MARCH 26, 1964, Julie Andrews, Charmian Carr, and Norma Varden assembled on Stage 15 on the Fox lot for the first day of shooting *The Sound of Music*. The inaugural scene took place in Maria's bedroom, where the frightened children gather during a thunderstorm. It took five days to shoot the complicated scene, and by the end of that time they were already a day behind schedule.

The first day, Wise shot the exchange between Maria and Frau Schmidt in which the housekeeper enters carrying the bolts of cloth for Maria's new dresses and speaks to her about the Captain. He also began to shoot the scene between Maria and Liesl where the lovesick teenager enters Maria's room through the window after her meeting with Rolf.

This was Carr's first day acting in front of a camera. In fact, except for a small part in a high school play, this was her first day *acting*. According to a January 26, 1965, article in the *Hollywood Citizen-News*, Carr arrived at the studio brimming with expectations about the first day of her new career. But then

Good wishes sent to director Robert Wise from Dick Zanuck on the first day of filming.

WU MSC003 NL PD=TDL WUX WEST LOS ANGELES CALIF MAR 25=

ROBERT WISE= 20TH CENTURY FOX STUDIO

STAGE 15 LOSA=

DEAR BOBBY: TODAY WE LAUNCH "SOUND OF MUSIC" WHICH IS THE
MOST IMPORTANT PICTURE ON OUR PRODUCTION SCHEDULE AND I
COULDNT HAVE MORE CONFIDENCE IN THE TEAM OF TECHNICIANS
AND ACTORS THAT WE HAVE ASSEMBLED FOR THIS PICTURE BUT MY
GREATEST SATISFACTION IS THAT YOU ARE AT THE HELM AND I
AM SECURE IN KNOWING THAT WE WILL HAVE A GREAT AND
MONUMENTAL ACHIEVEMENT. SINCERELY=
DICK ZANUCK=

MAR 26 THE COMPANY WILL APPRECIATE SUGGESTIONS FROM ITS PATRONS CONCERNING ITS SERVICE

The first day of shooting.

"Mr. Rainstorm."

something happened to stifle her enthusiasm. "This is an easy shot," said Wise. "In this scene you climb in through this window seeking refuge. You'd been caught in a rainstorm. Now, meet Mr. Rainstorm."

With that, the prop man began spraying Carr with cold water. "Give it to her again," said Wise. "We've got to be able to see water on her face, and that dress has to be wet enough to cling to her."

When Wise was satisfied that Carr was "wet enough," he called for "action" and the camera started rolling. It took 15 takes to get the scene right with all the different angles, and between takes Carr was doused with water again. Finally, when the scene was finished, Carr went back to her dressing room, drenched and

shivering. "What girl doesn't dream of being an actress?" Carr was quoted as saying. "But an experience like this somehow seems to have dampened my ardor somewhat, along with everything else, including my dress and hair and makeup!"

While Carr may have been an acting neophyte, Julie Andrews had had years of acting experience under her belt. Yet she was just as anxious that first day as Carr was. "That first day, I was so nervous," remembered Andrews, "and all I could think of was 'I hope I'm doing this right.' I was still pretty new at film acting, and those first few days I was searching around, trying to figure out how to do it. Sometimes it takes a day or two to feel comfortable."

Her director helped to calm

her nerves. "Bob taught me a great deal about film acting. For example, he told me that when I have a close-up I should find a spot on someone's face to look at and not dart my eyes like one usually would if looking closely at someone. It seems like a small thing, but those techniques helped a great deal."

The rest of the children spent that first morning in wardrobe, sitting for pictures, and continuing their classes. This was to be the children's basic routine during the period the film was being shot. Every moment was put to use; when there was spare time, the children would work on their lines or rehearse dance numbers.

The children's first appearance in front of the camera was on day two. They were to enter

Robert Wise explaining a scene to Andrews.

Rehearsing "My Favorite Things" and building a rapport with the children.

118

Shooting "Maria."

Maria's room frightened, jump onto her bed, and eventually join her in singing "My Favorite Things." "The first day with the children on the set I concentrated on getting to know them and building a good rapport with them," Andrews recalled. "I tried to help Bob. I made them laugh, tickled them, helped them with their close-ups. I wanted to quickly build a relationship."

"She put the kids at ease and made them easier to work with," said Wise. "She even taught them to sing 'Supercalifragilisticexpiali-docious.'"

Andrews also used this first scene to show how even warm and loving Maria could find seven children a bit unnerving. "I tried to make her very real," said Andrews. "I did simple things. I wanted to show that sometimes they exhausted me." In her biography, Andrews explained that, in the song, when the kids kept asking what kinds of "favorite things" they should be thinking about, she tried to show her frustration by thinking "Oh my God! Children always do ask questions like that!"

They finished the "My Favorite Things" scene on April 1 and spent the next six days at the set of the "abbey cloisters," where they filmed the number "Maria." It was in this scene that Marni Nixon made her film debut, as Sister Sophia. Everyone expected a big rivalry between Nixon and Julie Andrews because Nixon had been chosen to dub the voice of Eliza in the film version of *My Fair Lady* after Andrews had lost the coveted role to Audrey Hepburn.

Nixon recalled, "We were meeting in the anteroom of Bob Wise's office. All the nuns were sitting around, and in walks Julie Andrews. They introduced us, and everyone held their breath, expecting a big

SCRIPT SUPERVISOR'S REPORT

Betty Levin

DATE OF REPORT: Thursday, April 16th, 1964

PAGE NO. 1

WORKING TITLE: "THE SOUND OF MUSIC"

CREDITS

	SCRIPT PAGES	SCRIPT SCENES	ADDED SCENES	RETAKE SCENES	TOTAL SCENES	DAILY MINUTES	SETUPS	TAKES
PICTURE NO. G-09					9	45	9	40
TODAY	5/8	1	8		165	23'23	145	
PREVIOUSLY TAKEN	21-3/8	25	140		174	24'08	154	
TOTAL TO DATE	22	26	148					
TOTAL TO BE TAKEN								
TOTAL IN SCRIPT	155-1/8	128						

ADDED SCENE NOS.
RB80D, RB80E, RD80
RM80, RQ80, RS80,
RY80
SA80, SB80

SCENE NOS. S-80

SCENE NO. S-80

S-80 EXT. CRYPT & GRAVEYARD ✻ NITE –
LONG DOLLY – ROLF & CAPTAIN – overlap for
his taking away gun – Rolf runs f.g.
Lt. b.g exiting 1 – CAPTAIN runs f.g.
down steps to car – and family, drives
out.

1/532 – Inc. 13"
2/533 – Comp. 18" HOLD
3/534 – Inc. 10"
4/535 – Inc. 13" HOLD
5/536 – Comp. 15" PRINT

SA-80 TIGHT GROUP IN CAR – THEN CAPTAIN
VON TRAPP enters, gets inside, starts
car.

1/537 – Comp. 5" HOLD
2/538 – Comp.06" PRINT

SC. SB-80 LOW FULL SHOT – TO CAR –
(SPEED:18)
MED LOW LONG SHOT TO FAMILY as Captain
Von Trapp runs to car and drives family
out.

1/539 – Comp. 06"
2/540 – Comp. 04"
3/541 – FS
4/542 – Comp. 04" PRINT (END SLATE)

SOUND TRACK 543 FOR SCENE 80
Dialogue, running footsteps, the slamming
of a car door (and the shouting-whistling
of Rolf)

RB-80-D EXT.GRAVEYARD – REV LONG SHOT TO
MED – TO CRYPT as spotlights hits Maria,
then Captain, then Liesl – Captain moves
forward, unclocks gate – family exits r
CAPTAIN moves forward.

1/544 – Comp. 51"
2/545 – Comp. 51"
3/546 – FS

SC RB-80D (CONTINUED)

4/547 – Comp. 45"
5/548 – Comp. 53" PRINT

RB-80-E MED – CAPTAIN & FAMILY – they
exit – he startw to move f.g.

1/549 – FS
2/550 – Comp. 45" PRINT
3/551 – Inc. 20"
4/552 – Comp. 45" HOLD

RD-80 MED CLOSE – MARIA AND CHILDREN
as flashlight hits first Maria then
Lisl – they move to f.g. open gate.

1/553 – Comp. 08"
2/554 – Comp. 11" PRINT
3/555 – Comp. 13"
4/556 – Inc. 06"
5/557 – Comp. 13" PRINT

RM-80 MED – GROUP IN CRYPT – move b.g.
to f.g. open door – PULL BACK as Maria
and children run out and down steps
and out.

1/558 – Comp. 26"
2/559 – Comp. 30" PRINT

RQ-80 LONG DOLLY MED CLOSE OVER ROLF
TO CAPTAIN – Captain moves closer to
Rolf,removes gun, both run out.

1/560 – Inc. 21"
2/561 – Inc. 1'19" HOLD
3/562 – Comp. 1'25" HOLD
4/563 – Comp. 1'25" PRINT
RY-80 CLOSE OVER ROLF TO CAPTAIN
he takes gun, both run out.

1/564 – SEE PAGE TWO

blowup. But Julie just strode across the room, reached out her hand, and cried, 'Marni, I'm such a big fan of yours!' We all breathed a sigh of relief."

Nixon and Andrews had another encounter later that week. Nixon was planning to audition for a revival of *My Fair Lady* at the City Center Theater in New York, and she was having trouble with a scene from the play. Andrews found out and went looking for Nixon. "I'll bet it's the slipper scene," Andrews told her. That was the very scene that

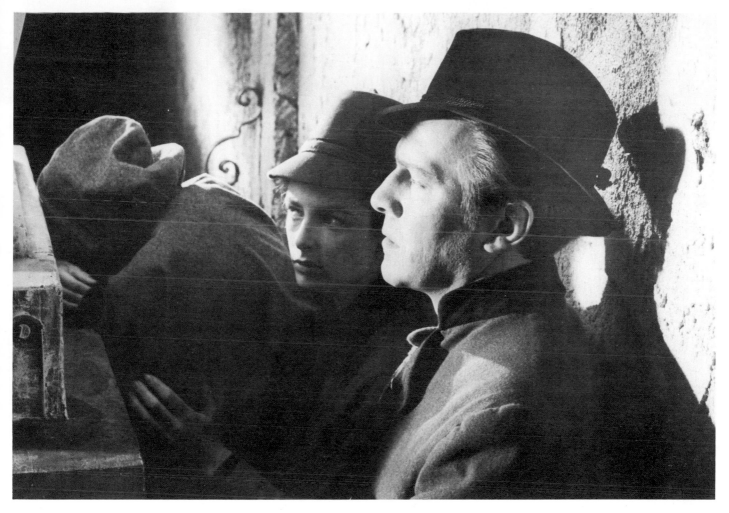

Hiding from the Nazis.

confounded Nixon, so Andrews took her into her dressing room and, as she changed costumes, helped Nixon through the scene. "I'll never forget Julie, standing there in her underwear, telling me how to throw that slipper!" Nixon remembered with a laugh.

The company then worked for another week, this time on the graveyard escape scene, before going off to Salzburg.

Wise intended to spend six weeks shooting in Salzburg. He and Saul Wurtzel had carefully planned every detail of the schedules because when filming on location, the company could not waste even a single day. "Location shooting is very expensive," Wise recalled. "All the costumes and the sets to be used on location were shipped over. You have a whole crew you have to fly over. You have to house them, give them per diem [daily expenses]. We had scores and scores of people we flew over. Apart from the actors, we had twenty-five to thirty crew members. And then we had to house and feed all the German technicians who came down from Munich."

But the cost of a foreign location shoot proved to be nothing compared to the one insurmountable obstacle that continued to plague the company throughout the entire 11 weeks spent in Salzburg: the rain.

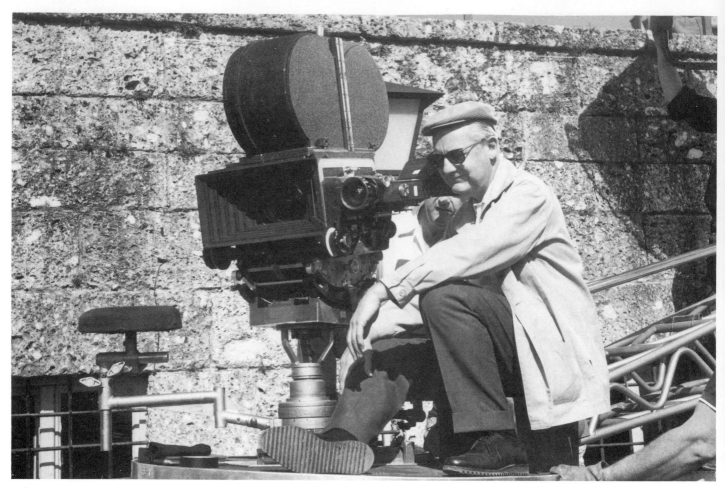

Robert Wise.

"Salzburg is more than just a city where this story took place," Wise said. "It is an atmosphere." Certainly, Salzburg's natural beauty and ancient architecture became an additional character in the movie. But it wasn't always a willing participant.

In September 1963, even before they decided to shoot in Salzburg, Saul Wurtzel had sent to Austria for a survey on the weather conditions in the city. The survey showed how many sunny days, clear days, and overcast days there would be, on average, in the summer months, when they planned to be in the city. Wurtzel even had pictures taken. The results of the survey claimed "beautiful foliage, flowers, beautiful sunny days . . . that go along with the months of May and June in Salzburg."

The survey was wrong.

"We always get those surveys before we do a picture," Wise said, laughing, "and then we get to the location, and the weather is terrible, and the locals all say, 'But this is the first time this has happened!' It never fails. We always bring bad weather with us, and they say it's never happened before."

"I told Bob one time he should quit the picture business entirely and make his fortune as a rainmaker," said Assistant Director Reggie Callow, interviewed by Rudy Behlmer for the *American Film Institute Film History Program*. "I have never gone anywhere with any director in the world who has had so much trouble with weather as Bob Wise."

Anticipating that there might be problems, Wise sent a memo to Callow listing three different "calls" each day. First was the basic call for ideal weather; second was an alternate call to be used in case of overcast conditions; and third was a "cover set," an alternate set to be used in case of bad weather.

Wise and company had provided themselves two cover sets. One was St. Margarethen

Chapel, which was used in the beginning of the film, where the nuns are seen praying in the chapel. The other cover set was at Dürer Studios in nearby Parsch. The crew shipped the entire set for the Mother Abbess's office over to Salzburg and set it up in the studio. This way, even if the weather became too miserable, they knew they could at least get in half a day's work at the studio.

Wise had even changed his plans to avoid weather problems. He had originally intended to start shooting in Salzburg, rather than Hollywood, but realized that he would have to wait for the Austrian snow to melt and so postponed the trip.

Weather would be a problem throughout the entire shoot. The cast finally flew to Munich, then chartered a flight to Salzburg over the weekend of April 18 and 19. The entire company was housed in four hotels. Wise and

Dan Truhitte.

Andrews stayed at the Osterreichischer Hof, the children and their parents at the Park Mirabell, Plummer and the "nuns" at the Hotel Bristol, and various crew members at the Winkler. They set up the production office at Dürer Studios; makeup and hairdressing were based at the Hotel Bristol. All those who weren't staying at the Bristol traveled the short distance to the hotel each morning to prepare for the day's shoot. Every evening, each company member received a call sheet listing the next day's schedule.

Early production reports for the first few days in Salzburg are sketchy, but one of the first scenes shot on location was the wedding scene at Mondsee. It was filmed April 23 and took only one day to complete. The company hired about 600 extras, all brought down from Salzburg. Wise sent extra electricians there a day ahead of schedule to prelight the cathedral, and all went very smoothly—nothing out of the ordinary.

But there was one cast member who admits that April 23 was the most extraordinary day of his life. That was the day Dan Truhitte, Rolf, met his future bride. "I met Liesl's stand-in at the wedding scene," remembered Truhitte 27 years later. "I think that was the only scene she stood in for. Gabriele Henning. She was an actress from Salzburg. We spent the next three months together. In fact, one of the posters that promoted the movie

showed a picture of the kids playing together in the foreground, and I was sketched somewhere in the background riding up to the mountains on my bike. That kind of described me then. The kids were always going everywhere together, and I was always running off to the mountains with Gabriele."

The Truhittes were married for 20 years, and then a few years ago they divorced. But they are still close friends. "What was really weird," said Truhitte, "was that Gabriele's parents were named Liesl and Rolf. It was like a premonition."

The romance and beauty of Salzburg touched other hearts as well, for there were two other marriages whose courtships began that spring. Kym Karath's sister, Francie, who had come to the location with her mother and sister, fell in love with Alan Callow, the son of Reggie Callow.

"I met Alan on the plane," recalled Francie, "and he just swept me off my feet." Francie Karath was then 21, and Alan Callow was 22. Callow, who had come on the trip with his father, was put in charge of organizing the children and making sure they got to the set on time. "Salzburg was in its prime back then, and we went all over. We double-dated with Dan and Gabriele and with Charmian and an Austrian assistant director she was going out with."

Callow and Karath were married about a year and a half later in Las Vegas, but the

marriage lasted only a year. "I was brought up that after high school you get married," said Karath, "and we were just too young."

But there was one marriage that began on location of *The Sound of Music* and is still going strong. Betty Levin was hired as Wise's script supervisor on the film, and she just loved chamber music. So when she arrived in Salzburg, she called the Austrian tourist bureau and found out when they were having concerts. On her free nights, she made plans to go. When Saul Chaplin heard that he and Betty shared the same passion for music, he invited himself along.

"Everyone saw Saul and Betty's romance developing," said Pia Arnold. "The whole company saw them fall in love, I think before they even saw it. They were both shy in realizing what was happening to them. But we saw the intensity of their feelings." Saul and Betty spent all their free time in Salzburg together, and four years later they married.

But Salzburg wasn't all fun and romance. It was a lot of hard work. The company stuck to a rigorous six-days-a-week schedule. And no one worked harder than Robert Wise. Reggie Callow, in his interview with Behlmer, remembered, "Bob Wise is the most prepared director I've worked with. He retires early. He gets up at five o'clock in the morning and prepares his work for the day." Every morning Wise would meet Callow, and they would compare notes. Did they have to set up 12 shots that day or 17? "Whatever it was," said Callow, "Bob would know precisely what he was going to do all the time."

"I'll never forget," recalled Dee Dee Wood, "Bob had this pocket watch, and he'd look at it every five to ten minutes to keep on schedule. But he never got impatient."

"Bob was a real commander," Portia Nelson reminisced, "but you didn't feel directed. It was effortless."

Wise had begun his career as an editor, so, armed with that experience, he covered his scenes from as many angles as he could. "People think that because you were an editor, you know in your head exactly how each scene is going to play," said Wise. "It's just the reverse. You want to cover as much as you can with as many angles as possible. That way you have more flexibility. And then in the previews, if a scene doesn't work, you can go back to the editing room and pick and choose from other angles to make the scene work. So much can be done in the editing room."

As discussed earlier, all the scenes were shot in pieces and edited together later. As with any film, a number of takes were required for each scene. And retakes are especially common when filming a musical. The actors have to sing along to a playback of the prerecording they made earlier at the studio. During filming, the microphone is turned off, so the quality of their voices as they walk or dance does not matter, but their mouths have to move in perfect synchronization

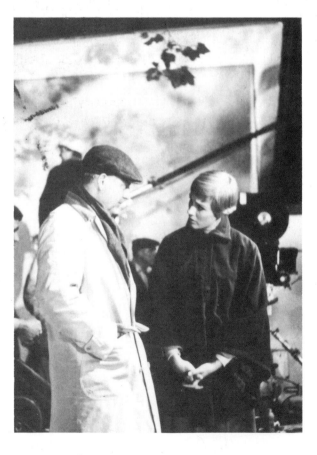

The director and star.

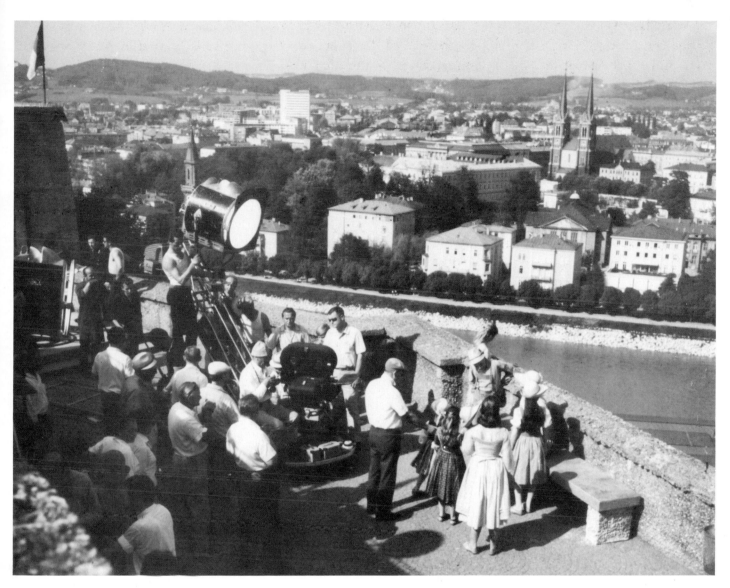

with the playback. If they are off, even a fraction of a second, the shot
has to be retaken. Wise, who had also been a music editor, was a master
at spotting something even half a frame out of sync.

"We had three of us watching very closely all the time for that
sync," said Wise. "You do take after take. You might have a perfect take
up to the end, and then suddenly you go off." The actors had tapes of
their prerecordings and would practice. Andrews was already a master at
synchronization, and the children also became very adept.

Wise remembers one amusing incident that happened when they
were shooting the "Do-Re-Mi" sequence up on Winkler's Terrace. "We
were up high, looking out over the city," he recalled. "The terrace
overlooks the whole main part of Salzburg. We had our playback up
there with these big speakers. You play these songs very loud so your
actors can sing back to it. My wife, Pat, was below, in the city, and she
said the music came flooding down from up in the hills, and all the
passersby kept looking around, wondering where the music was coming
from!"

They shot "Do-Re-Mi" all over the city, but in the other Salzburg locations Wise had more control over his environment. "When we were shooting Julie and the kids in the carriage," he said, "we had our own extras and everything, so we didn't have a problem with people looking into the camera, and we didn't have to worry about our loud music disturbing anyone."

Rehearsing "Do-Re-Mi" in the studio at Fox . . .

Setting up the shot on location in Salzburg . . .

"Do-Re-Mi."

Running off camera . . .

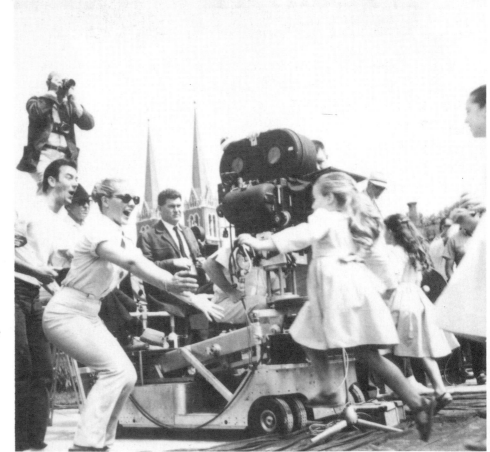

. . . and into the arms of choreographer Dee Dee Wood.

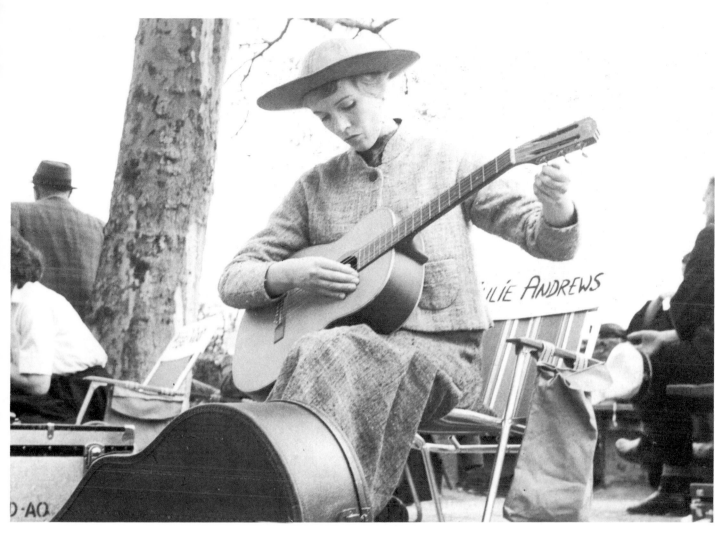

Reggie Callow got a surprise one evening when he found out that he was going to be the carriage driver in that sequence. According to Behlmer, Callow recalled, "We had hired a Norwegian actor to drive the buggy. We were shooting, I think, on a Saturday. On Friday night, very late, the actor called me up at the hotel and said, 'Look I can't work tomorrow morning because my sister just died and I have to leave for Norway immediately.' I called Bob and he told me not to worry. I was fat at that time, so he said to me, 'You're the only man in the company who will fit his wardrobe. You drive the coach!' "

One sequence of "Do-Re-Mi" drove Julie Andrews crazy; she had to learn how to play the guitar for the scene that was to be filmed on the mountaintop. "For some reason I just couldn't play the guitar and sing at the same time," Andrews related with a laugh. "Saul and Marc and Dee Dee kept on me to practice, but I kept putting it off and putting it off. Finally the big number was coming up, and Saul got very angry with me. 'You better get with it,' he yelled at me. So one of the farmers, up near the area we were shooting, made the best schnapps. It was pure one-hundred-proof liquor. I remember one day it was so cold and I was in such a bad temper about the guitar, I had a glass. It was firewater! But oh, it was heaven. I finally practiced the guitar, rather sulkily."

"For some reason I just couldn't play the guitar and sing at the same time."

A director is always part "commander," part psychiatrist, and as such Wise had to deal with the diverse personalities of his actors. Andrews and Plummer, for instance, had two completely different acting styles. Andrews was often a perfectionist, but she could also be very silly at times. And she tried everything, from classic vaudeville tricks like stepping out of the bus and having her guitar get stuck in the door to dancing the flamenco—partly to see what would work for the character and partly to relieve stress on the set. Wise nixed some of her routines, but she didn't give up trying to get a rise out of her director. She finally won in the puppet-show sequence. "At the end of the puppet show, I came around the corner and showed how exhausted Maria was," Andrews said. "Bob at first said not to do it, but I said 'Come on, Bob, I've just done a whole puppet show, with seven children, singing "The Lonely Goatherd!" ' He let it go."

After about five weeks of intense nonstop filming Andrews finally had a couple of days off and decided to celebrate. She hired a bus and took a group of 30 company members to the Royal Ballet Theater in Munich, leading a chorus of show tunes along the way.

Christopher Plummer, on the other hand, was intense. "His style was more 'Let's see what can explode out of me today,' " said Dee Dee Wood. "He was dark."

But, according to Andrews,

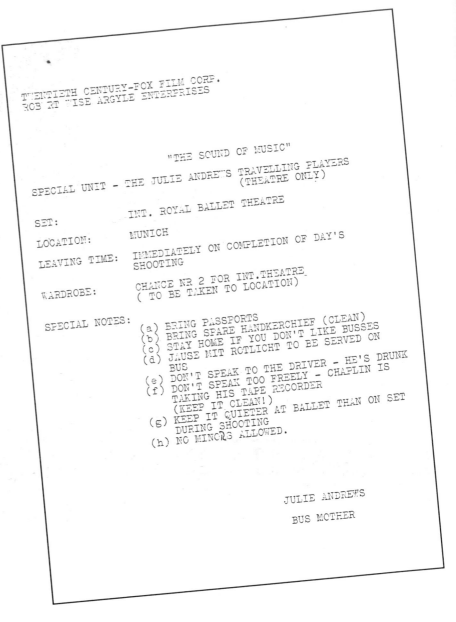

these two diverse styles were exactly the right mix to create the chemistry between her and her costar. "His intensity was just right for his part," said Andrews. "I didn't find his style at all threatening. In fact, in the canoe scene where we come out of the water and have a big fight—Chris worked with me a lot on that scene. We rehearsed it a number of times to build it up. As far as I'm concerned, he couldn't have

been nicer or more professional."

Not everyone shares that view. Plummer, who wasn't too thrilled with doing the film in the first place, became even more disenchanted while on location. He began calling the film *The Sound of Mucus*, although he swears that everyone, including Julie Andrews, used that phrase.

"I never called it *The Sound of Mucus*," said Andrews.

Plummer's sour attitude was

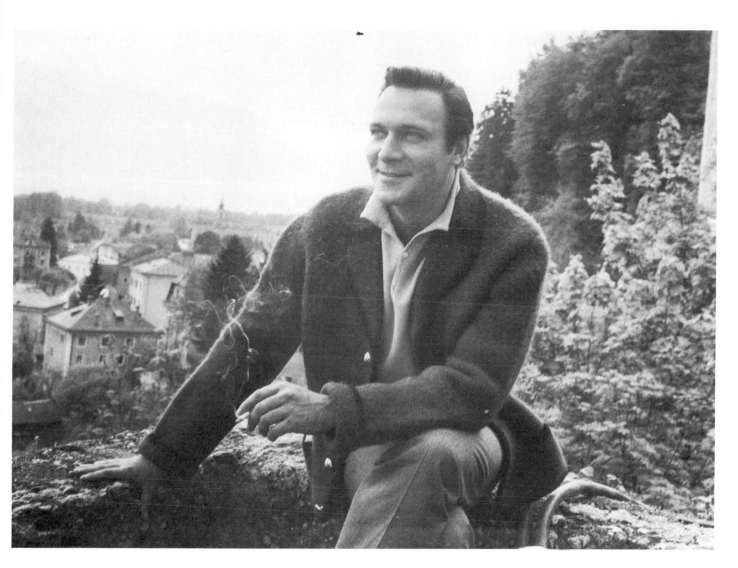

A rare moment of relaxation for a very intense actor.

not lost on the rest of the company. Saul Chaplin remembered, "His relationship with the other actors left a lot to be desired. He behaved as though he was a distinguished legendary actor who had condescendingly agreed to grace this small, amateurish company with his presence."

"I remember absolutely nothing about Christopher Plummer," said Kym Karath. "He stayed *so* far away from us."

Even Wise admits that Plummer's relationship with the kids was not very close, but he is adamant about his professionalism. "Chris was marvelous to work with because he never came into a scene where he didn't add something. Not that he was trying to take over, but more in a creative way. Even in the scenes with the kids, he always had good ideas or suggestions on how to improve the scene. He's a very intelligent guy."

Everyone, even Plummer, agrees that when the cast was shown the rushes (unedited footage of the days of shooting) of the opening scene, his attitude changed. "I was staggered by that opening," said Plummer.

"He was very impressed and for a few days forgot who he was," said Chaplin.

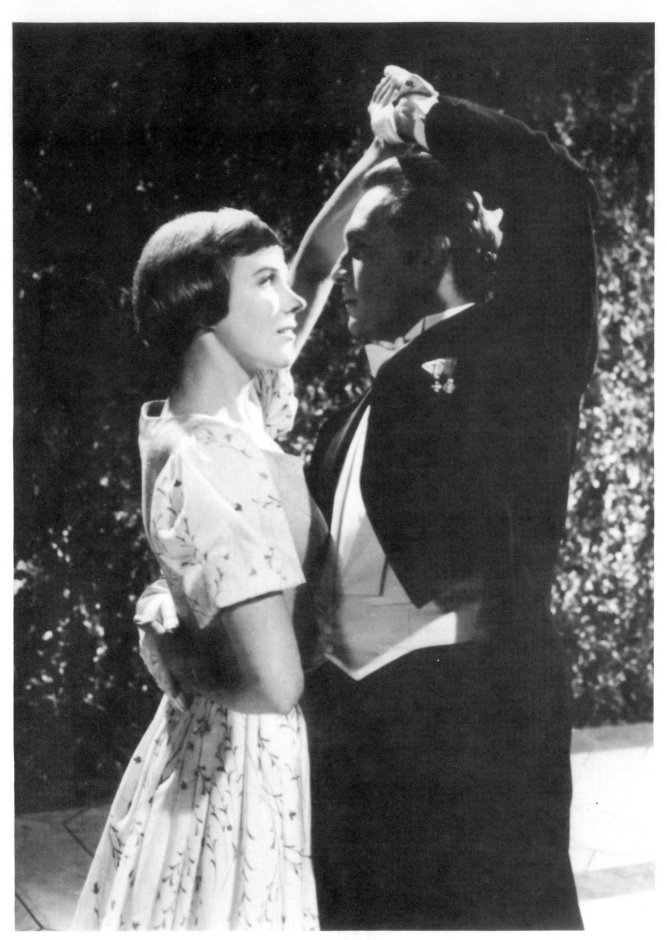

"I suppose you always fall a little in love with your leading man."

"No one realized what we had until we were shown the rushes and saw how beautiful it was going to be," said Anna Lee. "We were awestruck."

But even with all the tension, Plummer and Andrews got along famously. "She threw herself into the part with four times the effort," said Plummer. "Julie was great fun. Terribly professional, with a healthy attitude. We were great pals."

"We had some lovely scenes," Andrews reminisced. "One of them was the scene after Chris sings 'The Sound of Music' with his children. I'm going up the stairs, and he comes up and asks me to stay. I thought that was a nice scene. I suppose you always fall a little in love with your leading man. Nothing went on between us, but I adore him to this day."

Wise also had to contend with another strong personality when an unexpected visitor arrived one day and announced that she wanted to be in the movie. Maria von Trapp was visiting Austria with her 13-year-old granddaughter and dropped by the set. She told Wise that one of her secret ambitions was to be in a movie and asked if that was possible. Wise had dealt with von Trapp earlier, through phone calls and letters, when she wanted him to change the film character of the Captain. The outcome had not been pleasant, but Wise decided to use her anyway, as an extra in the scene where Andrews walks down toward the fountain in the square singing "I Have Confidence."

Wise recalled, "We got her a costume and everything, but like in every film, we had to do a number of takes, and it took, I think, three hours. She didn't know you have to do it again and again."

Maria von Trapp was so exhausted when the scene was finally over that she declared, "That's one ambition I'm giving up."

How did "Maria" react when she met Maria? "She was instantly friendly and easy," said the fictional von Trapp. "Years later I brought her onto my musical series, and she sang with me. Even then she was always easy and pleasant."

Christopher Plummer first met Maria von Trapp that day she visited the set, and he couldn't help comparing the real von Trapp with her movie counterpart. "I couldn't put the Maria of the story and the real Maria together," said Plummer. "[von Trapp] was the antithesis of Julie, physically. Maria was this big, athletic woman, and Julie seemed so slight by comparison. Julie gave the part lots of spunk, which of course Maria had. But Maria was a big version of Queen Victoria!"

Plummer met Maria von Trapp a couple more times over the years, and they grew very fond of each other. He even remembered that, as a child, he used to ski at her lodge in Stowe, Vermont.

One day, Plummer recalled, he was visiting a friend in Nassau when his host announced that he had invited a surprise visitor over

for tea. "In walks Maria von Trapp," said Plummer, still tickled by the memory. "She had just swum the Nassau Channel! She must have been in her late sixties by then, but she bounced in, after *swimming the channel*, changed her clothes, and was ready for tea! When she saw me, she ran up to me shouting, 'My husband! My husband!' "

Plummer crossed paths with von Trapp again years later in Hollywood. "I was playing the piano onstage for something or other, and she sat beside me at the piano. I played 'My Favorite Things,' and she sang with me. It was very sweet. I miss that jolly face."

After an intense 12- to 14-hour day on the set, nerves were a little frayed, and each company member had his or her own routine for unwinding and letting off a little steam.

"My favorite memory of the picture was what I called 'magic hour,' " Pia Arnold recalled. "That was when Bob invited a select group of people over for a martini after the day's shooting. He created a special warmth."

While Wise's group met each evening over martinis, another, somewhat noisier group met at the Hotel Bristol. The Bristol was to become the major night spot for many of the cast members. "It was run by an American general," Portia Nelson reminisced, "or so he called himself. I think his name was General MacCrystal. He was a big fan of mine, so he turned part of the bar of the hotel into the 'Blue Angel' after the

"Maria" meets Maria.

This is a publicity shot photographed the day Maria von Trapp visited the set.

club in New York where I used to perform."

"Gretl Hubner was the general's wife, and I think she owned the hotel," said Christopher Plummer. "Every night she had opera stars and musicians coming in. A real bohemian bunch. She even employed the local aristocracy. They worked as bellboys and waiters."

"We called it the 'Crunch Bar' because of a joke that Marc

[Breaux] told us," said Larri Thomas, Julie Andrews's stand-in. "Chris played the piano. Sometimes he'd stay up all night and then go to work from the bar, but he never forgot his lines."

Plummer's nights at the "Crunch Bar" became legendary, but they never affected his work. In fact most everyone that stayed at the Bristol and even those who were booked into one of the other hotels ended up at the Bristol night after night. Peggy Wood,

Saul Chaplin, Pat Wise (Mrs. Robert Wise), Dorothy Jeakins, Marc Breaux, Pamela Danova, and Richard Haydn.

Eleanor Parker, Larri Thomas, Marc Breaux and Dee Dee Wood, Portia Nelson, Anna Lee, and Pamela Danova would all drink Dom Perignon and sing around the piano while Plummer played.

"The more he drank, the more beautiful his music was," recalled Anna Lee. "The music just poured out of him."

Julie Andrews participated only occasionally in the nightly festivities at the Bristol. This was her first long separation from her husband, set designer Tony Walton. He was doing back-to-back shows in New York and couldn't travel with her on the shoot. She did bring along her 19-month-old daughter, Emma Kate, and preferred to spend the evenings with her.

Even if she had wanted to go

out at night, it would have been difficult. "I was in every scene," explained Andrews, "and my schedule was exhausting. I'd start work at six or seven in the morning, and the day would end about seven at night. You can't imagine how exhausting it was to be out in the fresh air all day long, either baking in the sun or, more often, drenched in the rain. When I got back to the hotel room, I felt grubby and filthy and dusty and dirty. Then I'd take my makeup off, and it just didn't make any sense to put it back on and go out again. Instead I would eat in the hotel room and put my feet up."

Still, watching everyone going out on the town every night made her a bit lonely. "I felt fairly isolated. Oh, there was a lot

of socializing on the set and a lot of fun, and everyone invited me to go along with them. But at night I had a responsibility for my daughter, whom I hadn't seen all day. So the nights were fairly quiet."

The city itself seemed to contribute to her solitude. "Salzburg gives you the feeling of isolation. You're surrounded by a ring of mountains. It's a private, magical place, and I adored it, but it does give you a lonely feeling."

Working with six children might have posed a serious problem, but surprisingly the children were very well behaved. Oh, they had their little pranks. "We were awful," said Heather Menzies in a 1990 *Los Angeles Times* interview with Libby Slate. "We played tricks on people. We baby-sat each other in the hotel when our mothers went out, and we'd throw things like wet toilet-paper pieces out the window to the cars below."

Even the hotel guests became unwitting victims of the children's mischief. Every evening the patrons would place their shoes outside their doors to be polished. One night the children gathered all the shoes from the

Sightseeing.

137

Children with their Salzburg teacher, Jean Seaman. When the youngsters were not traveling all over the city, a trailer was set up to substitute for a classroom.

second floor and took them up to the third. Then they took the third-floor shoes down to the second. It took quite a while for the guests to sort them out.

When the hotel proprietors had finally had enough, the children were asked to leave. That's when Robert Wise stepped in. "Bob Wise had to sit us down and read us the riot act," continued Menzies. After that, the children calmed down and the hotel allowed them to stay.

The children united into a loving, supportive family. On the Fox lot an office building had been their schoolhouse; in Salzburg their schoolhouse was the city itself. They traveled all over with their teacher, Jean Seaman (who filled in for the Fox teacher, Frances Klamt). They had two minivans at their disposal, and they went to puppet shows, a children's production of *The Magic Flute*, the salt mines, and museums. They did science projects and art projects. Seaman taught them all to speak some German, and at times the children even acted as interpreters for the grown-ups.

"Salzburg was a fun place to be as a little kid," remembered Kym Karath. "There were all kinds of interesting cultural events." One of

her funniest memories was that of a castle they visited. "The castle belonged to someone named 'Mad Something-or-other,' who happened to be a practical joker. Apparently he had a lot of popes and dignitaries visiting him, and he designed a special banquet table outside that had jets of water shooting up through the middle of the chairs. So during dinner he would have a servant turn them on, and everybody would get their pants wet. Now *that's* hilarious to a kid!"

Charmian Carr spent her time more with the adults than the children and passed her leisure time working on a travelogue about filming the movie in Salzburg, entitled *Salzburg, Sight and Sound*. This documentary was aired on television just before the movie was released and was also used as a trailer in the theaters to advertise the picture.

All six of the younger children brought their mothers to Salzburg (Carr was already 21 years old and came by herself), and it seems the mothers had a good time as well. Karath remembered, "The mothers would meet in the room late at night and drink various brandies that they'd picked up at the stores. They'd sit around and gossip. Sometimes they'd go to the casinos. I think they had as much fun as we did."

A few headaches arose from having six children on a long production. Though none of them got sick, the children, like all youngsters, kept growing. But the problem was that one or two would grow more than the others and so, to keep the continuity, some of their shoes had to have special lifts.

"All the children kept growing, except me," Carr recalled in 1990 for the British "This Morning." "By the end of the film I was standing on apple boxes."

"I grew six inches in six months," said Nicholas Hammond in the same interview. "I started on lifts and ended up in my bare feet!"

Kym Karath not only grew taller; she grew rounder. "I gained so much weight during the filming," said Karath, "that they had to keep adjusting my costumes. I didn't like any of the German food, so the only things I would eat were bananas, rolls, and

Kym Karath gives a kiss to her "first crush," Nicky Hammond, at his birthday party.

fried artichokes."

A supply of junior baby teeth was also brought along in case a child lost a tooth or fell and cracked one. Debbie Turner, who lost some of her baby teeth during shooting, had to have them replaced with false ones and then found she had difficulty singing. "I had a lisp because I couldn't get used to the dentures," she told Tracey Morgan in a 1990 *Us* magazine interview. Turner wasn't the only actor to have trouble with his or her teeth. Larri Thomas, Julie Andrews's stand-in, recalled, "Richard [Haydn] came downstairs one morning with his hand over his mouth, embarrassed. He had lost his false teeth down the toilet, and he didn't have an extra set. So my husband, Bruce, saved the day. He reached down into the toilet and rescued his dentures!"

The children became such

close friends that they reunited for a *Sound of Music* party every year on Kym Karath's birthday until she turned 13. In fact the production went so smoothly for the children that, when filming was completed, Reggie Callow received a letter from the local Board of Education. The letter stated that, in all of its years in the picture business, no filming had ever had as few problems in handling children as *The Sound of Music*.

Virtually every exterior scene in the film was shot in Salzburg. There were a few exteriors, however, that Wise and Director of Photography Ted McCord realized simply could not be shot outside. Wise had had Boris Leven build the glass-enclosed gazebo down near the lake at Bertelsmann but then found that they couldn't shoot inside the

gazebo for the "You Are Sixteen" and "Something Good" numbers; the eight-sided glass made the light bounce into the camera from eight different angles. Furthermore, so many visual effects were required in these scenes—rain, lightning, and night lighting—that it would be too costly to shoot the scenes on location.

So they decided to duplicate the entire gazebo on the Fox lot and shoot the scenes at home. Weighing the difficulties and expense of shooting "day for night" (the process of shooting a nighttime exterior scene in the daytime) on location in Salzburg, they also elected to duplicate at Fox the rest of the set that Leven had built down near the lake at Bertelsmann. Thus every bit of the "You Are Sixteen" and "Something Good" numbers was shot on a soundstage back at the

Ted McCord and Robert Wise.

Saul Chaplin

TWENTIETH CENTURY-FOX FILM CORP.
Robert Wise Argyle Enterprises

"THE SOUND OF MUSIC"
7th Shooting Day

Date Thurs. Apr.30,1964

Shooting Call 7:30 PM

Set	Scenes	Location
INT.ROCKY RIDING SCHOOL (N)	75,76,77	Felsenreitschule, Salzburg

Playback: "Do Re Mi",
"Edelweiss", "So long,Farewell"

Phone: 2441, 2021

Cast	Character	P/U Hotel	Makeup & Hair	Leave	Set Call
			5:15 PM	6:45 PM	7:30 PM
			5:45 PM	6:45 PM	7:30 PM
1. Julie Andrews	Maria				
2. Chris.Plummer	Captain	NC			
3. Eleanor Parker	Elsa		6:15 PM	6:45 PM	7:30 PM
4. Rich.Hayden	Max	5:30 PM	5:45 PM	6:45 PM	7:30 PM
5. Charmian Carr	Liesl	6:30 PM	6:45 PM	7:15 PM	7:30 PM
6. Nicholas Hammond	Friedrich	6:30 PM	6:45 PM	7:15 PM	7:30 PM
7. Heather Menzies	Louisa	6:30 PM	6:45 PM	7:15 PM	7:30 PM
8. Duane Chase	Kurt	6:30 PM	6:45 PM	7:15 PM	7:30 PM
9. Angela Cartwright	Brigitta	6:30 PM	6:45 PM	7:15 PM	
1o. Debbie Turner	Marta	7:15 PM	ON SET	6:45 PM	7:30 PM
11. Kym Karath	Gretl		4:30 PM		
12. Peggy Wood	M.Abbess	NC			
13. Portia Nelson	S.Bertha	NC			
14. Anna Lee	S.Margaretta	NC			
15. Daniel Truhitte	Rolf		ON SET	6:45 PM	7:45 PM
16. Ben Wright	Zeller	NC		6:00 PM	
17. Gil Stuart	Franz				
18. Larri Thomas	Dance-In				

Bits - Standins - Extras at Felsenreitschule

10 Standins	6:00 PM	At Riding School Makeup & Hair:
40 Orchestra	7:00 PM	4 Extra - 5:30 PM
1 Leader	7:00 PM	
16 SA Men	6:00 PM	
2 SS Men	6:00 PM	At Riding School Wardrobe:
5 Judges		3 Extra - 5:00 PM
75 Singers		1 (At Studio)
50 Women (To Fit)	6:00 PM	
25 Men (To Fit)	6:30 PM	
355 Men	7:00 PM	
325 Women	7:00 PM	
Toby Reiser	8:30 PM	
~~Frl. Schweiger~~	~~8:30 PM~~	

Special Notes:

Advance Schedule:

Saturday, May 2nd:
INT.ROCKY RIDING SCHOOL

Monday, May 4th:
EXT.ROCKY RIDING SCHOOL

All Calls in PM except where noted.				6:00	2nd Unit	
		Props		6:00		
Director	6:00	Art.Dir.		6:30		
Asst.Directors	6:00	Costume Des.		4:00		
Script	6:00	Men's Wdrb.		4:00	Durer & Wien-Film	
Cameraman	6:00	Women's Wdrb.		5:00		
Operators	6:00	Makeup		5:00	Elect.	5:00
Asst.Cam.	7:00	Hairdressers		7:00	Grip	5:00
Stills	6:00	Dial.Coach		6:00	Painter	5:00
Sound Mixer	6:00	Music Cutter		6:00	Sound Bus	6:00
Sound Recorder	6:00	Choreographers		8:00 AM		
Boomman(W-F)	5:15	Illustrator		6:00		
Electric (US)	5:15	Spec.Effects		NC		
Grips (US)	5:00	Chapman Crane Op.		5:00		
Gen.Men		Mole-Persons				
Playback						

Call sheet.

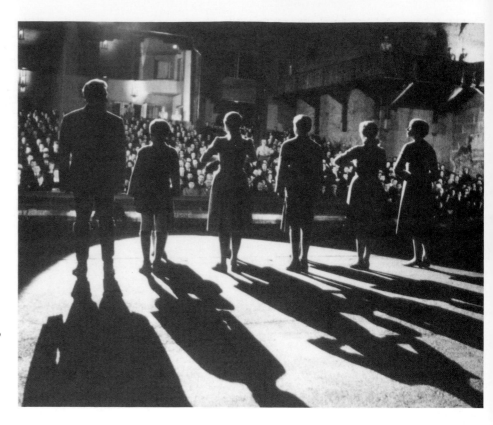

"So Long, Farewell."

Twentieth lot. Even the scene where the Captain comes down from the house, meets Maria on the bench, and tells her he's not engaged anymore was shot in Los Angeles. Leven's Bertelsmann gazebo was still used; they needed it for "point of view" scenes. For example, when the Captain stands on the balcony (actually a Hollywood set) and stares down at Maria walking along the lake—that scene was shot from the Captain's "point of view" onto the actual *location* set.

Another difficult scene for McCord to shoot was the nighttime scene at the Rocky Riding School. They had to pull in lights and generators from all over Europe to light the hundreds of archways carved into the mountainside. The extras weren't thrilled with the location either. One thousand Salzburg residents were hired to play themselves in

the festival scenes—and they all had to wear summer clothes even though the scenes were filmed from 8:00 P.M. to 4:00 A.M. and the temperatures were hovering just above freezing.

Everyone was uncomfortable, even the star. "The Riding School was cold and dank, and we seemed to be there forever!" said Julie Andrews.

But Kym Karath loved every minute of it. "I got to stay up all night and play gin rummy with the Nazis," she recalled with a laugh.

One of the most frightening memories for Karath was the canoe scene. "We all had to fall off the boat," she remembered, "and I couldn't swim. They were going to use a double, but they really wanted to use me. Mr. Wise took me aside and talked me into doing the scene by telling me that Julie was going to catch me. I did

the first take, but it was no good. So I screwed up my courage, and we did it again. But this time, when the boat rocked, Julie went off in the wrong direction, so she couldn't catch me. The water was very murky, and I went down. Luckily Alan Callow was there, and he actually jumped in and caught me."

But that wasn't the end of Karath's troubles. "We had to go in again, just to get a take of us as we were struggling out of the water. But by that time I'd had enough! Poor Heather was supposed to carry me out of the water, and I threw up on her shoulder!"

Divers standing near the boat. They would go underwater and rock the boat so that the actors could topple over (right).

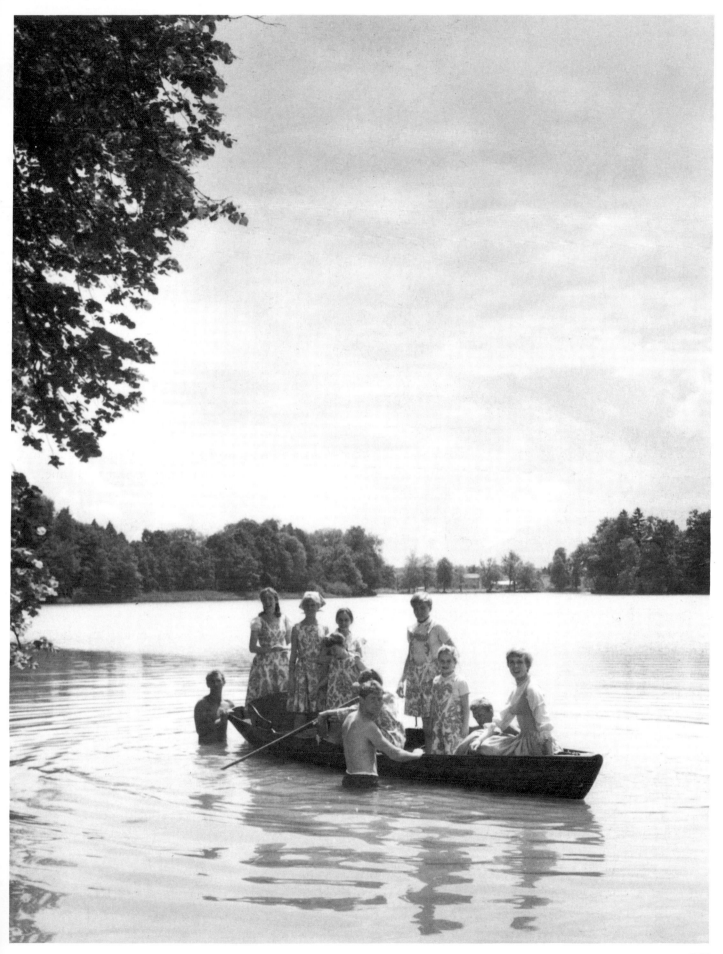

Alan Callow, Kym Karath's future brother-in-law, saves her from drowning.

It wasn't enough to fall off a boat into a murky lake; the actors had to be sprayed with water until they really looked, and felt, soaked.

The City of Salzburg was very cooperative with the film crew and even went as far as issuing a *The Sound of Music* postmark commemorating the picture. But there was one scene in the movie that the town elders did not support—the depiction of the Anschluss, where Nazis march across the Residenzplatz and take over Austria.

One of the requirements for this scene was that swastika banners hang from the sides of the buildings. "Pia Arnold went to the town fathers and told them we needed to hang up swastikas in the square," recalled Zuberano. "They said, 'Oh no, you can't do that, because the people of Salzburg were not sympathizers.' I insisted, but they wouldn't budge. Then I remembered the newsreels of Hitler marching into Austria and seeing all the people out there with their little flags, cheering him on. So I told Pia to go and tell the fathers, 'Never mind, we'll use the newsreels.' Well, they were cornered. They didn't want us to use a newsreel showing the Austrians cheering Hitler, so they gave in. But they insisted that we take down the banners as soon as the shot was over. The only thing we still weren't allowed to do was use a crowd cheering, but I think we made our point without it."

By far the scene that caused the most difficulty was the last scene filmed on location. Ironically, it was the first and, later, most famous scene in the picture. And the one reason that scene was so much trouble was the one sticking point for everyone on location in Salzburg. "Someone told us it rained a little," said Wise. It rained a lot. And it was an especially frustrating rain; a day that started out beautiful and sunny would gradually turn cloudy and gray until, at the time the shoot was scheduled to start, the rain would finally come. Frequently, by the time it cleared up, the sun was on its way down.

"The problem with this kind of weather on any location," Wise explained, "is, even if the weather forecast says it's going to rain all day, you can't sit around in your hotel. You have to move your troupe out to some location, and some of these locations were thirty to forty minutes away. And

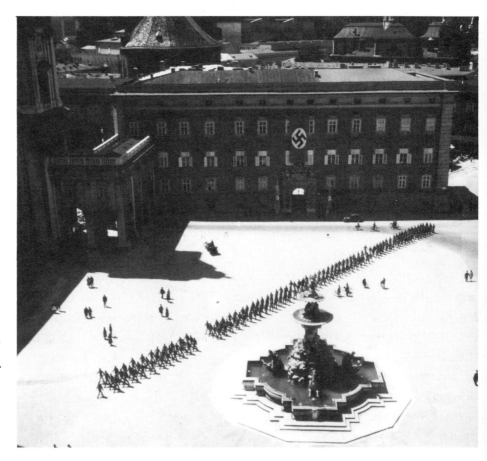

Nazi banner hanging on the buildings of the Residenzplatz.

When the rain on the mountaintop became too heavy during the filming of the "Do-Re-Mi" sequence, the cast would escape to a barn, where they would rehearse the song.

if you do stay in the hotel and then it breaks unexpectedly, it takes you forever to get the whole company out in time to use the good weather. You may leave the actors in the hotel because they can get out faster, but you need the crew to set up."

If it was early enough in the day that rain would be a problem, the company would move to a cover set. If not, they would sit around and play cards, play backgammon, do crossword puzzles, or rehearse the dances. But time is money, and every wasted minute made Wise more nervous.

"I can't tell you how long we sat around," Wise continued, "in buses and in cars, reading, sleeping, whatever, waiting for the rain to let up. Sometimes, if it was just overcast, you still couldn't shoot because you had started the sequence in the sunlight and you needed the

continuity. The guys used to go out and play baseball and whatnot, but the minute the sun came out, we'd rush out and get going."

If they had time to rush to a cover set, the company would transport everything to the Dürer Studios. All the scenes with Peggy Wood in the Mother Abbess's office were shot on location at Dürer, including her most memorable number, "Climb Ev'ry Mountain."

But even though this was to become one of the most beloved songs in the picture, Wood had trouble with the number. "Peggy felt the song was too pretentious," said Portia Nelson. "She wanted to speak the first words before going into the song."

Even Robert Wise admits, "This was the one scene in the play that embarrassed me."

Nelson, on Wood's behalf, went so far as to ask Saul Chaplin

if Wood could speak the lines first. But Chaplin said that he couldn't change it because Richard Rodgers, in deference to the late Oscar Hammerstein, wouldn't allow any changes in the lyrics. So Wise had the idea of filming Wood in dark shadows, with her head turned away from the camera. That way the pretentiousness would be diffused.

There were only so many scenes with the Reverend Mother and Maria, and after the company had completed them all they ran out of cover sets. A director knows he's really in trouble when he runs out of scenes to do on a cover set. "When you don't have a day when you can do an insert [a shot of an object that is later edited into a scene], anything," said Wise, "that's terrible."

When the weather was bad in the outdoor scenes, a tarp would be set up over the scene and they would use artificial light. This

Don't let that nun's habit fool you! Julie Andrews takes a break between scenes to fling some industry buzzwords at her daughter, Emma Kate. The Reverend Mother clearly approves.

Maria and the Reverend Mother. Filmed in a "cover set."

THESE ARE A FEW OF MY FAVORITE SCENES

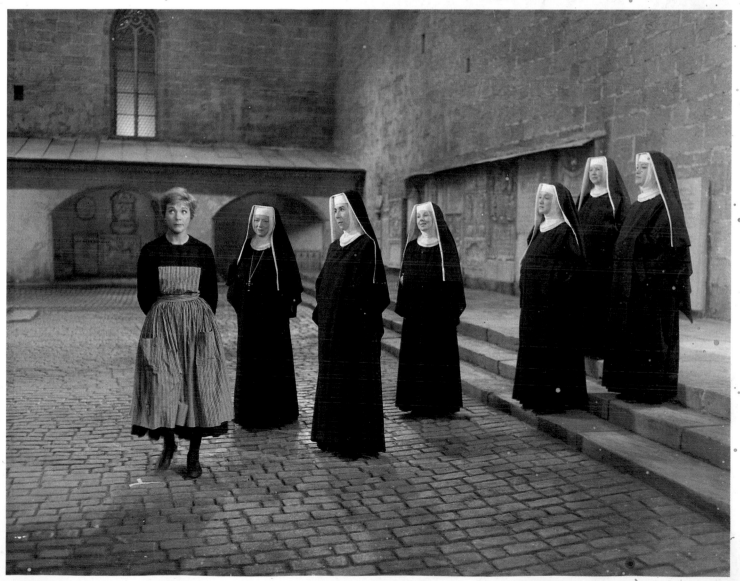

Shooting under a tarp.

setup was used in the scenes on the terrace, where Elsa played ball with the children, or in the scene where Max ate his three pieces of strudel. But shooting under the tarps required extra time, and time was a precious commodity.

The original location schedule called for the company to shoot in Salzburg from April 20 to June 11. On June 28, 22 days behind schedule, they finally started filming the opening number, in which Maria bursts onto the screen and begins singing the title song.

"Maria's Mountain" was located outside Salzburg, about 10 kilometers into Bavaria. The crew set up camp at an inn at the bottom of the mountain. Their plan was to transport the equipment, cast, and crew up the mountain by Jeep, but the constant rain had washed out the roads. So they were forced to resort to a more old-fashioned method of transportation—the ox cart.

"One of my favorite memories of Julie," recalled Wise, "is when she traveled up that hill in the ox cart with her fur coat wrapped around her against the cold."

If traveling in an ox cart seemed primitive, it was nothing compared to trying to maintain some decent hygiene. "Filming on the mountaintops was the hardest," said Andrews. "We were miles away from any toilets. So when we had to go, we'd just say, 'I'm going to the woods now.'

Everyone understood what you meant."

To film what is one of the most famous openings in movie history, a helicopter swooped down just as Maria rushed up to her beloved mountain. The timing on that shot had to be perfect. So, to make sure Andrews came up the hill at the moment required, Marc Breaux hid in the bushes nearby. As the helicopter ascended, Breaux, using a megaphone, cued Andrews and she rushed up the hill and began singing.

"The funniest memory I have of the movie," said Breaux's wife, Dee Dee Wood, "is of Marc hiding in the bushes yelling '*Go, Julie*!' "

"The helicopter was a jet

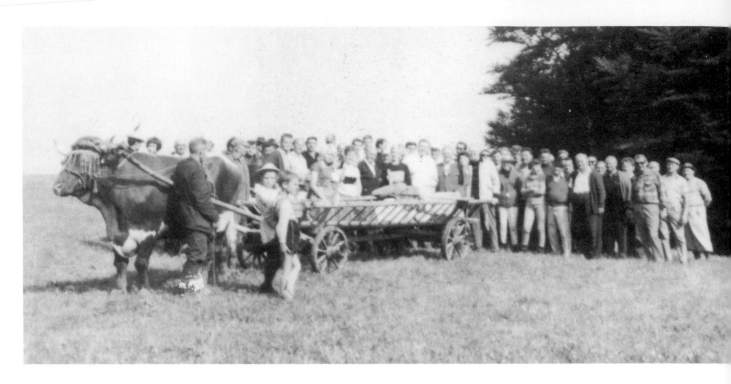

The company (and friend) on top of "Maria's Mountain."

helicopter," Andrews recalled. "The cameraman was strapped onto the side of the helicopter, hanging out so he could get the shot, and he came at me sideways. I'd start from the end of the field, and I'd hear Marc yelling 'Go!' from a bullhorn. The helicopter would come at me, clanking away, then it would go around me to get back to the beginning to repeat the scene. But when it circled around me, the downdraft from the jets was so strong that it would literally knock me over. I couldn't stay up. They had to do this shot about ten times, and finally I got so angry I yelled, 'That's enough!' "

The rain was a constant frustration throughout the filming of the opening sequence. But they were stuck. Not only was Maria's Mountain across the Austrian border and into Bavaria, but to get to it the company had to travel *around* the Untersberg Mountain and drive up the other side; they couldn't easily travel to another location when it started to rain. And by this time they had only this one scene left to shoot. All the actors but Andrews had already returned to Los Angeles.

The June 29 production report states, "Mountains clouded and fogged in—unable to shoot." July 1: "Attempted one scene—rain, Rain, *Rain!*"

Wise described, "We had designed that whole number to be shot in about six or seven sections. Julie walks up the hill and twirls, she walks through the field, she dances around the trees, etc. I kept chewing away at them. We would line up our shot, we'd have the playback ready, and maybe we'd get one section. Then we'd come out the next day and set up for another section. But then it would start to rain, and it would be no good. We'd sit up there under the tarps and wait. You don't want to go down the hill, because it's such a big deal to get everything down there and then up again."

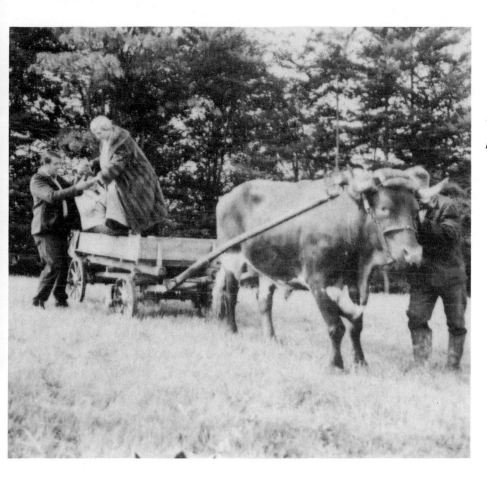

The star descending from her carriage.

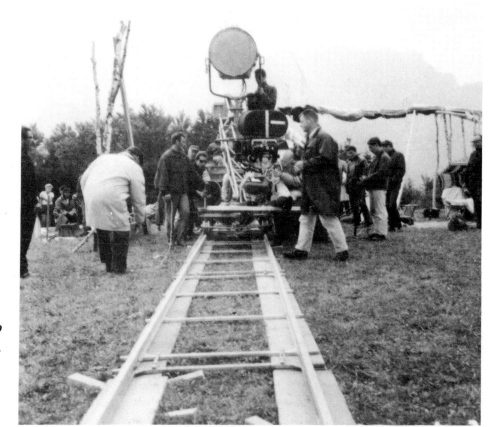

Setting up a tracking shot to follow Julie Andrews.

151

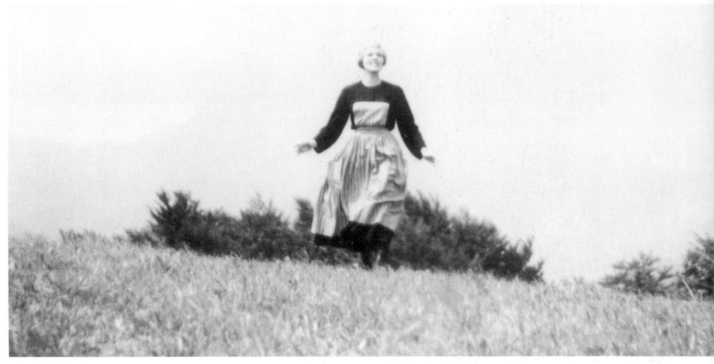

*"I remember running out to sing
'The hills are alive . . .' and
shivering in my boots."*

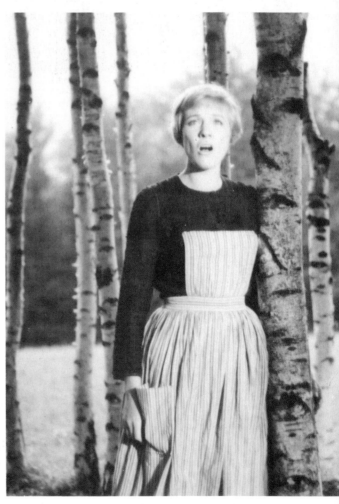

**Planting birch logs to suggest that Maria
is at the edge of a forest.**

Singing among the "trees."

Saul Chaplin.

"The rain was awful," Andrews remembered, "and it was freezing cold. I remember running out to sing 'The hills are alive . . .' and shivering in my boots." But as usual, Andrews tried to make light of a tense situation. As the company sat on Maria's Mountain, waiting for the rain to let up, she, Marc Breaux, and Saul Chaplin would sing songs on the rainy hillside for hours. As described in Robert Windeler's biography of Andrews, they dubbed their group The Vocalzones, their main selection being the "Hawaiian War Chant." She also sang such operatic numbers as "The Bell Song" from *Lakme* in perfect pitch, but she'd counter by singing the "Indian Love Call" slightly off-key.

But the rain wasn't the only problem. When the company first looked at the meadow on top of the mountain, they were impressed by the high fields of hay and grass. Wise paid the farmer for the use of the field and told him not to mow the hay. Yet when they finally returned to shoot the number, the farmer had cut down the vegetation until there was nothing left but short stalks of grass!

The meadow's young birch trees, which Maria grasps, swinging from trunk to trunk, were all brought in and planted a few days before the shoot, and the crew hung a large piece of canvas over the area to create shade. The crew also created the brook into which Maria throws stones. The crew dug a ditch, lined it with plastic, and filled it with water.

But the same farmer who had cut the grass got very angry with the company. It seems the longer they stayed, the more their presence interfered with his cows, who suddenly refused to give milk. So he grabbed a pitchfork, stabbed it into the brook, and drained the water!

Wise certainly had his hands full. Finally, after four frustrating days of rain and headaches, the director had all but one piece of the puzzle completed. But that one piece of film happened to fall right in the middle of the number. At this point Wise started getting pressure from Dick Zanuck back at the studio. Zanuck had spoken to Wise about the situation before, but now the film was 25 days behind schedule and $740,000 over the $7,995,000 budget.

"I'd called Bob about two or three times before," recalled Zanuck, "and he'd convinced me that he would be done soon and everything would be great. I was enormously pleased with the film that was coming back, so I'd kept backing him. But there had to be a time when the company would eventually have to come home."

"Bob, you've got to get the troupe out of there!" Zanuck had urged. "It's just costing too much, and we're so far over!"

Wise pleaded, "Dick, I've still got this one piece I have to get, and I don't know how we'll do it!"

But Zanuck was adamant. "You've got to get them home."

Wise responded, "I'll tell you what. If I don't get this missing piece by Thursday, I'll come home Friday whether we have it or not, and I'll figure out a way to shoot it at the studio." He later confided, "How in the world I was going to get it I didn't know."

Thursday began as another dreadful day. "Everyone was sitting around under the tarps sweating it out," Wise continued, "because they knew I had a deadline. We had the shot all lined up, the dolly tracks were down, the lighting ready. All the equipment was covered with tarps. It was about midafternoon. Then, suddenly, the weather broke for about half an hour. We ran out, zipped off the tarps, and finally

got the last shot. That's one of the tightest situations I've ever been in."

Wise finally did move his troupe home on Friday, July 3. By Monday, July 6, they were all back at the studio shooting the dining room scene, in which Maria scolds the children for the "precious gift" they left in her pocket. All the interiors in the Trapp villa and the outdoor scenes that couldn't be shot on location still had to be filmed.

The production ran much more smoothly now that the company was home and didn't have to worry about outdoor elements. Oh, there were a few complications. For instance, in the song "So Long, Farewell," Carr

"By the time we got back [to Los Angeles], I was so tired and nervous that I couldn't keep going."

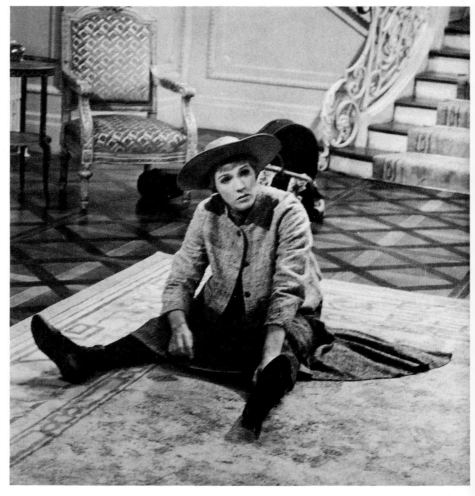

had so much trouble carrying Kym Karath up the stairs at the end of the number that she got a backache. It seems Karath's three-month diet of bananas and fried artichokes had had an adverse effect on her little figure.

Director of Photography Ted McCord had trouble shooting inside the gazebo where they filmed the numbers "You Are Sixteen" and "Something Good." He didn't have "day for night" to contend with, but he still had the problem of the lights reflecting off the glass. Besides taking extreme care to set the camera up in such a way as to minimize glare, he resorted to having the stagehands actually lie on the floor so that their images would not be reflected in the gazebo walls.

Half of the number "Something Good" was shot in silhouette, a daring technique that wasn't used much in film. Actually, it may not have been used in this picture either if its stars had been able to control themselves.

Back on the set at Fox. Behind Andrews is Script Supervisor Betty Levin. Levin married Associate Producer Saul Chaplin, one of the three marriages whose courtships began on the set in Salzburg.

155

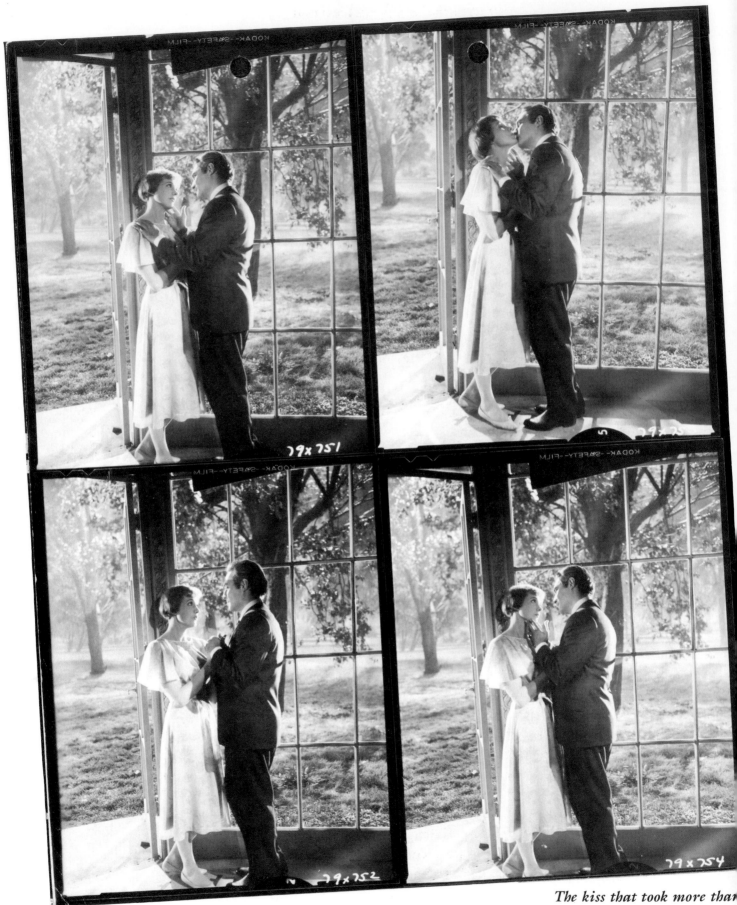

The kiss that took more than
dozen takes.

156

By the time the company returned to the studio, they were all exhausted. They'd had only one weekend to catch up and recover from their jet lag before they had to be back at the studio to begin work again. "By the time we got back, I was so tired and nervous that I couldn't keep going," recalled Andrews. "And when I get nervous, I get very giggly."

It all came out when they filmed "Something Good." Ted McCord lit the gazebo with a powerful photo floodlight hung from rafters and tipped downward to suggest a shaft of moonlight. These huge arc lights, which are not used anymore, worked by having two pieces of carbon come into contact. But when the carbons got worn down or old, they would make a terrible noise, like a groan or, more often, a "raspberry."

"Chris and I were standing very close," explained Andrews. "We were face to face, about an inch away from each other, looking into each other's eyes. We were just getting to the point where we would say 'I love you,' or we'd start kissing . . . and then those old arc lights would let out a loud 'raspberry'! It was like a comment on our scene! Well, Chris and I would start laughing. We couldn't help it. Then we'd go back to the scene again, and those lights would start groaning at us again! Our giggling got even worse. In fact, it got to the point where we couldn't get through the scene!"

After almost a dozen takes, there still wasn't any film of the kiss worth saving, so Wise finally called a break, sending everyone out for lunch.

"I was in a high state of nervousness by now," recalled Andrews. "I walked around the studio . . . talking to myself, trying to calm myself down."

But when the actors returned to the set, it happened again. They just could not stop giggling.

Wise finally got fed up. "Shoot 'em in the dark!" he yelled. "Then no one can see them laughing!"

"I, for one, was very grateful," said Andrews. "Otherwise I could never have gotten through that scene."

Andrews and Plummer completed filming on August 13. The only scene left to do was "You Are Sixteen." One of Charmian Carr's most vivid memories of the film was shooting that number with an Ace bandage wrapped around her sprained ankle. "They made special dance shoes [for the number]," Carr told the Fox publicist, "and they forgot to put the rubber on the heels so I wouldn't slip. I did a step where I jump up on the bench, turn around and kick, and instead of turning and kicking, my feet slipped and I went right through a windowpane and flopped on the floor. Nothing serious happened, but I got a few cuts and sprained my ankle. The number goes by so fast that you don't even notice."

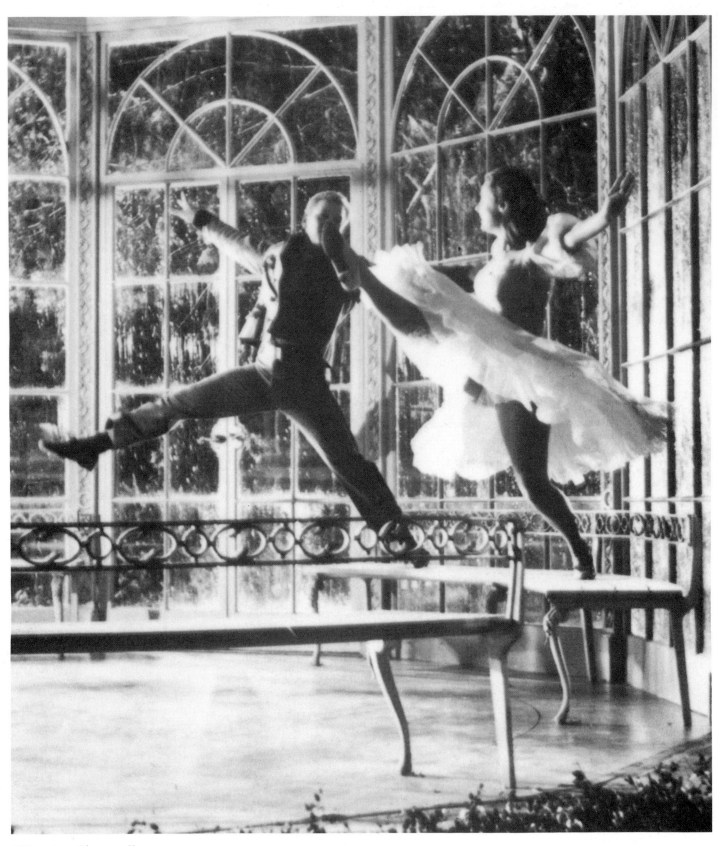

"*You Are Sixteen.*"

They finished that scene on August 19. The following day, Plummer, Eleanor Parker, and Richard Haydn were called back to reshoot a scene, inside a car, where they react to the children hanging from the trees. This was a processed scene, using a rear projection of the children, to make it seem as if the actors are riding past the trees. With that scene finished, principal photography was officially completed.

The next day was spent doing inserts; for instance, a shot of the pinecone sitting in Maria's dining room chair or the frog hopping up the stairs. Plummer, Parker, and Haydn were then called back a second time, on September 1, to retake the car scene again. Unofficially, that was the last scene shot in the movie.

Although the cast and crew had completed *shooting* the movie, work was far from over. There was still a tremendous amount of postproduction work to be done on the film. Because of the constant rain in Salzburg and the extraneous noises of planes, cars, or pedestrians, much of the sound quality was lost and had to be corrected through dialogue looping. Wise explained, "You always hope to use the original track, but if there are interferences you go back into the studio, and you take a section, and you run it and run it, and then you redo the

Eleanor Parker and Richard Haydn.

dialogue. It's very time consuming, and you have to be careful about the sync." So the cast spent hours in the looping room dubbing the dialogue.

As Wise and Dick Zanuck had promised months before, Christopher Plummer was now given the opportunity to redo his singing with the hope that his new voice tracks would be good enough to use in the picture. Plummer spent two days in the dubbing room with Wise, Chaplin, and the technicians, resinging his numbers. Wise and Chaplin were concerned not only with the quality of Plummer's singing but also that his new voice tracks would synchronize with the rest of the picture.

Then came that fateful day when Christopher Plummer would listen to his own voice on tape and decide whether or not it was good enough for the film. Chaplin already knew it wasn't. So did Wise. But they had agreed that Plummer could make the final decision. Wise ran three songs for Plummer—"The Sound of Music," "Edelweiss," and "Something Good." He let him listen to the songs alone.

After listening to them four times, Plummer came into the looping room where Wise was waiting, and they walked out into the hall together. Plummer told Wise that he was surprised that he wasn't embarrassed by his singing, and Wise said that he shouldn't be. He had made big improvements in his voice since the beginning of the film. Then Plummer asked Wise what he thought of his voice. Wise was honest.

"I don't think it's good enough for our picture," Wise told him. "I don't think it's up to the standard of the rest of the picture, and the fact that your voice isn't that good will bring down the level of the marvelous performance you gave as the Captain."

Plummer listened carefully and then said, "I know exactly what you mean. It's just not musical enough."

Bill Lee was hired on October 1 to dub Plummer's singing in the film. Plummer later reflected, "If I had been singing with someone else other than Julie, my voice might have been OK to use, but Julie's voice is so perfect, there's just a difference in quality. But I learned a lot from the film."

Irwin Kostal not only orchestrated the musical numbers; he also underscored the entire film, providing the background music for every scene. Kostal could not create his own music to suit the needs of the film: all of the music had to be variations on Rodgers and Hammerstein's original songs. "The scoring couldn't be foreign to the general texture of Rodgers and Hammerstein's original music," explained Kostal.

The orchestrations for the stage version, by Robert Russell Bennett, added a Viennese feel to Rodgers's melodies. Kostal took these out in every scene except for the one where the Captain and Maria dance the traditional Laendler, and instead used the action of the picture to

"THE SOUND OF MUSIC"

SCHEDULE

Tuesday August 25	Portrait Gallery 9:30 a.m.	JULIE ANDREWS CHRIS PLUMMER 7 CHILDREN
	2:00 p.m.	CHRIS PLUMMER ELEANOR PARKER

Looping Stage
10:30 a.m.-12:30 p.m. 7 CHILDREN
3:30 p.m.- 6:00 p.m. 7 CHILDREN

Stage #1
2:00 p.m.-3:30 p.m. 6 CHILDREN
(ex. Nick Hammond)

LUNCH - 12:30 p.m. to 2:00 p.m.

Wednesday
August 26
Stage #15 - Process - Retakes
9 a.m. CHRIS PLUMMER
ELEANOR PARKER
RICHARD HAYDN

Golf Course - Portraits
2:00 p.m. JULIE ANDREWS

Looping Stage
2:30 p.m. CHRIS PLUMMER

Thursday
August 27
Friday
August 28
Looping Stage
9 a.m.-6 p.m. CHRIS PLUMMER

Note: Any unfinished loops of NICK HAMMOND
to be fitted in here.

Hairdressing Dept.
Friday 8/28 NICK HAMMOND
(Restore hair to normal color)

*Postproduction
schedule.*

-2-

THE SOUND OF MUSIC - SCHEDULE

Looping Stage 7 CHILDREN
DAN TRUHITTE
BEN WRIGHT
"WOMAN"

Monday
August 31
through
Friday
September 4

Looping Stage
Stage #1 JULIE ANDREWS

Tuesday
September 8
Wednesday
September 9

Looping Stage
Portrait Gallery PEGGY WOOD

Wednesday
September 16

dictate his use of note sequences, tempo, and phrasing. For the escape scene, for instance, he used what he calls "Nazi and nun music." Saul Chaplin had asked for "wisps of wind" for the opening sequence on the mountain, and Kostal complied with an underscore that conveyed just that.

With his score, Kostal amplified or added nuances to Wise's visual image. "Postscoring was all fixing," recalls Kostal. "You have the music editor in the screening room with you, and you time every piece of music. You're looking through a moviola; you count the frames to see how long it runs: 40 seconds; two minutes. Before 'Something Good' I had five minutes of underscoring before it meets the bar of music that's prerecorded. I used a flute solo for Julie. For the camera shot of Chris I used a cello."

Before Kostal could do his musical fine-tuning, of course, the film had to be edited. Wise and film editor William Reynolds had to decide which of several camera angles to use for each scene, what order the shots should be in, when to end each image and begin another. They also had to be sure that the action was seamless, that scenes shot on different days or in different locales seemed to have been shot chronologically and in one place.

After the dubbing, looping, editing, and scoring were somewhat completed, the film was ready to preview. Wise felt that the audience reaction in the previews would help direct them to other areas that needed work. "I'm a very strong believer in the value of a 'sneak' audience," Wise wrote in a memo to Dick Zanuck. "We spend years, much effort and millions of dollars getting a picture on film, and then, so often, we don't spend the additional time and effort to give it the proper acid test before a non-professional audience."

They chose Minneapolis and Tulsa as sites for their two sneaks. Minneapolis was chosen because *West Side Story* had tested very well in its preview there. They picked Tulsa because Wise asked the Fox sales department where the film would find its toughest audience.

On February 1, 1965, at 8:15 P.M., the film previewed at the Mann Theater in Minneapolis. "Minneapolis was the most incredible preview I've ever been to," said Dick Zanuck. "It was about thirty degrees below zero, blizzard weather. Yet people were standing in line outside to see the show. The response was incredible. They even gave us a standing ovation at the *intermission*!"

After the preview everyone went back to the hotel to review the critique cards the audience had been asked to fill out. "We all sat around having a beer," Zanuck continued, "and started looking at the cards. Every single one of them read 'excellent.' All except three. Those just read 'good.' Suddenly we were all focusing in on those three 'good' cards, trying to figure out what we did wrong!"

```
                                    JANUARY 17, 1965

DARRYL ZANUCK
ZANUCKS, PARIS

     PREVIEWED SOUND OF MUSIC FRIDAY IN MINNEAPOLIS AND SATURDAY
IN TULSA AND BOTH REACTIONS WERE NOTHING SHORT OF SENSATIONAL.
ALMOST INCREDIBLE CARD BREAKDOWN OF 223 EXCELLENT, 3 GOOD AND
NO FAIR IN MINNEAPOLIS AND 137 EXCELLENT 2 GOOD AND NO FAIR IN
TULSA stop AUDIENCE APPLAUDED THROUGHOUT FILM AND OVATION AT
FINISH stop THERE IS NO QUESTION IN MY MIND BUT THAT WE HAVE
GREAT COMMERCIAL HIT OF THE SMASH CATEGORY.

                                              DICK

CC:   BOB WISE  ✓
      JONAS ROSENFIELD
```

Unfortunately, the Tulsa screening did not go as smoothly, because the audience was angry before they even walked through the theater doors. It seems the theater managers opened the building late, and the audience had to stand waiting in freezing weather. So this was an audience with an *attitude*.

Then they ran the film, which began with no dialogue and no music—just beautiful mountain scenery—and the audience went crazy. They thought there was something wrong with the theater's sound system, and they responded by stomping their feet all the way through the opening credits, calming only when Andrews sang the opening number. As the movie progressed, however, the audience settled down, and to everyone's surprise the movie was received as favorably by this crowd as it had been by the audience in Minneapolis.

Still, when Wise got back to the studio, he did more touch-ups on the dubbing and the editing. He trimmed a shot here, balanced the music there. Then, finally, the big day came when the movie would get its premiere. While Wise and company should have looked forward happily to the world's reaction to their masterpiece, no one breathed easily. Chaplin remembers only one person who had no doubt that the movie would be a success. That was Mike Kaplan, the movie's publicist.

"But it was his job to be optimistic," said Chaplin, "so no one believed him."

Telegram from Dick Zanuck to his father relaying the exciting results of the previews.

FROM THE *MUSIC* PHOTO ALBUM

Nicky Hammond and Duane Chase letting off a little steam between takes.

Andrews, Parker, and Carr rehearsing lines.

Wise showing off his technique.

Kym Karath and her "big sister."

Charmian Carr may have been 21 and an adult, but she was not above playing patty-cake with "Herr Dad."

Looking for postcards to send home.

Saul Chaplin, Julie Andrews, and Pamela Danova.

Julie Andrews, Dorothy Jeakins, and Charmian Carr.

It seemed everyone was taking
pictures of the kids but the kids'
own mothers. They finally got
their chance.

Peggy Wood
in-"habit"-ing
her role.

She can juggle, too!

Anna Lee instructing her "Mother" on how to take a "Superior" snapshot.

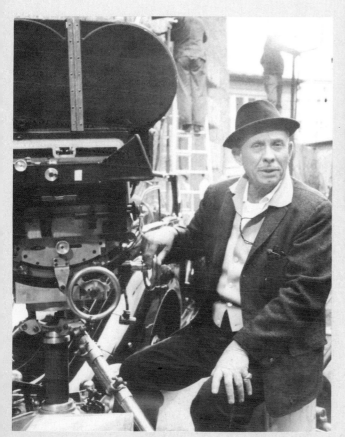

Director of Photography Ted McCord.

Relaxing between takes with Emma Kate.

A few more directions given during lunch break.

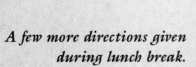

"We were great pals."

Karath shows off her
wounded finger.

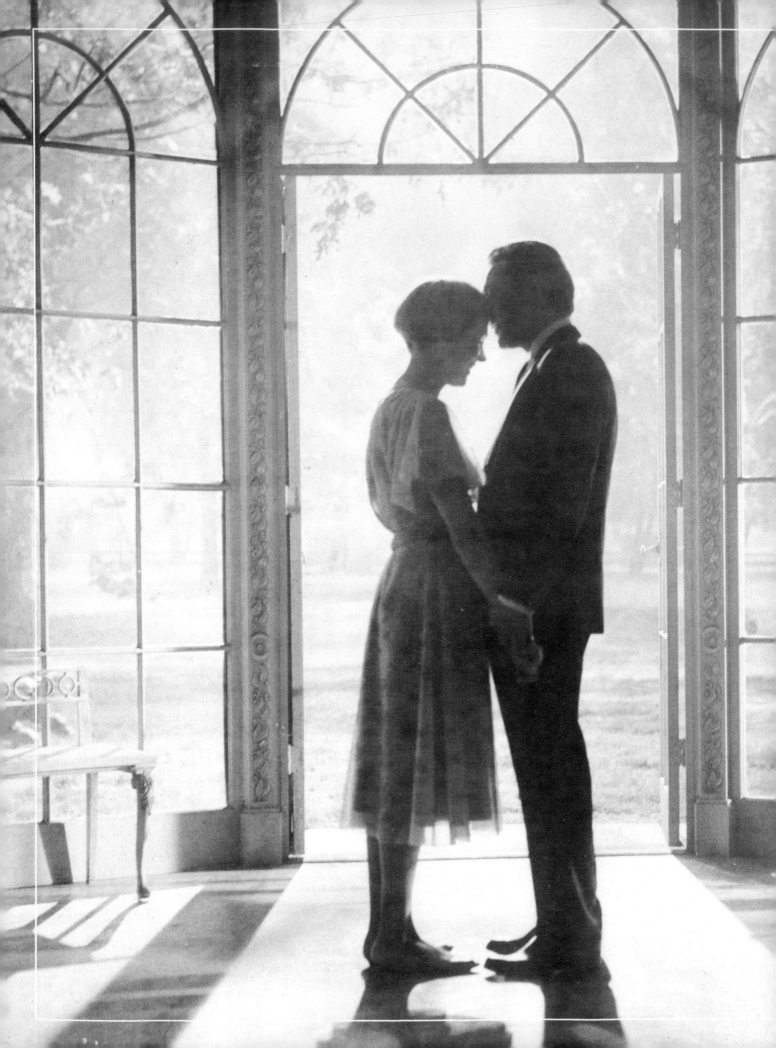

"I must have done something good . . ."

THE SOUND OF MONEY

*". . . THE GREAT-BIG COLOR MOVIE MR. WISE HAS MADE FROM [THE play] . . . comes close to being a careful duplication of the show as it was done on the stage, even down to its operetta pattern, which predates the cinema age . . . Julie Andrews . . . provides the most apparent and fetching innovation in the film . . . [her role] is always in peril of collapsing under the weight of romantic nonsense and sentiment. . . . The septet of blond and beaming youngsters who have to act like so many Shirley Temples and Freddie Bartholomews when they were young do as well as could be expected with their assortedly artificial roles, but the adults are fairly horrendous, especially Christopher Plummer . . . staged by Mr. Wise in a cosy-cum-corny fashion that even theater people know is old hat. . . . *The Sound of Music* repeats, in style—and in theme."*

—Bosley Crowther
New York Times
March 3, 1965

That was the first review Robert Wise read of his film version of *The Sound of Music*. The movie had its first opening premiere in New York

on March 2, 1965, at the Rivoli Theater. (The second premiere marked the opening of the movie in Los Angeles and was held on March 10, 1965.) During the New York screening, Wise and Jonas Rosenfeld, Fox's vice president of publicity, sneaked out into the theater lobby. They had obtained an advance copy of the next morning's *New York Times*, and they were eager to read the first major critique of their picture. As the crowd inside the theater cheered and applauded the film, Wise and Rosenfeld were left holding the copy of Crowther's review and wondering where they had gone wrong . . .

> . . . *everything is so icky sticky purely ever-lovin' that even Constant Andrews Admirers will get a wittle woozy long before intermission time. . . . There is nothing like a super-sized screen to convert seven darling little kids in no time at all into all that W. C. Fields indicated that darling little kids are—which is pure loathsome. . . . The movie is for the five to seven set and their mommies who think their kids aren't up to the stinging sophistication and biting wit of Mary Poppins. . . .*
>
> *Judith Crist*
> New York Herald Tribune
> *March 3, 1965*

That was the review that greeted Robert Wise the following morning.

Ernest Lehman, who had read both Crowther's and Crist's reviews from his home in California, immediately dialed Wise's New York hotel. Wise's wife, Pat, answered the phone.

"Let me speak to Bob," Lehman said urgently.

"He's not here," Pat Wise said. "He's taking a walk in Central Park.

"I know he's there," Lehman insisted. "Put him on."

Wise finally took the phone from Pat. "How could they do this to us?" he cried.

Judith Crist's review was even more damaging than Crowther's because she was also the movie critic on the "Today" show, which broadcast from coast to coast. Darryl Zanuck was so enraged by Judith Crist's review that he wrote a confidential memo to Seymour Poe, Fox's executive vice president of distribution. Crist "has built her reputation with a knife and the evil skill of an abortionist," he railed. She "uses the tactics of a concentration camp butcher!"

Poe answered Zanuck's memo by stating that "an industry effort should be made to dislodge Crist from her spot on the 'Today' show."

But Zanuck was not in favor of taking any retaliatory action against the critic. Instead, he confided in another memo to Poe, "While I would thoroughly enjoy the pleasure of inserting the toe of my ski boot in Miss Crist's derriere, I prefer to leave the job to movie-goers who, in due time, will take good care of her."

The "movie-goers" did get their revenge, but not against Judith Crist. Pauline Kael, another prominent movie critic, wrote in a review for *McCall's* magazine that *Music* was "the sugar-coated lie that people seem to want to eat . . . and this is the attitude that makes a critic feel that maybe it's all hopeless. Why not just send the director, Robert Wise, a wire: 'You win, I give up.' " Soon after the review was published, the publishing offices at *McCall's* were flooded with mail from readers vehemently protesting Kael's review of the film. So the magazine fired the movie critic! The editors felt that Kael was not in touch with their readership and that her review might eventually lose them subscribers. (Of course, Kael went on to great success as movie reviewer for the *New Yorker*.)

"The East Coast, intellectual papers and magazines destroyed us," remembered Robert Wise, "but the local papers and the trades gave us great reviews."

They have taken this sweet, sometimes saccharine and structurally slight story of the Von Trapp Family Singers and transformed it into close to three hours of visual and vocal brilliance, all in the universal terms of cinema. They have invested it with new delights and even a sense of depth in human relationships. . . .

> Philip K. Scheuer
> Los Angeles Times
> *March 7, 1965*

. . . one of the top musicals to reach the screen . . . a warmly-pulsating, captivating drama set to the most imaginative use of the lilting R-H tunes, magnificently mounted and with a brilliant cast . . . bears the mark of assured lengthy runs, and should be one of the season's most successful entries. . . .

> Daily Variety
> *March 1, 1965*

Music opened in 131 American theaters. It began as a "road show," a "hard-ticket" concept that the studios phased out with 1970s inflation. A road show was a 70mm movie with six-track stereophonic sound, released in a limited number of selected theaters. Fashioned after Broadway musicals, road shows featured reserved seats, two showings a day, and an intermission, making the film seem more of an "event" than a general-release picture, which opens in more than one theater per city, shows several times a day, and is more moderately priced.

Fox opened two other road shows around the same time that year: *The Agony and the Ecstasy* and *Those Magnificent Men in Their Flying Machines*, both of which had been filmed in Europe at the same time as *Music*. No other studio had as many road shows playing in the same

year, because these "event" movies were usually big pictures and were too expensive to produce. Fox gambled everything it had on these three pictures; its risk paid off handsomely.

In only four weeks, playing in just 25 theaters, *Music* quickly jumped to number one at the box office—and that was with only 10 performances per week. What put the film over the top were the average moviegoers, who thought the picture neither "sugar-coated" nor "a lie." To the contrary, the movie touched a nerve, and the public began spreading the word.

The original release, both as a road show and in general release, lasted an unprecedented 4½ years in the United States. By December 1965, just nine months after the movie opened, *The Sound of Music* had been number one 30 out of 43 weeks and had already amassed $50 million in worldwide box-office receipts—after taxes. Considering that the movie cost a total of $20 million to produce, promote, and market, it was already showing a substantial profit. Soon *Music* replaced *Gone With the Wind* as the number-one box-office champion of all time. *The Sound of Music* was quickly renamed "The Sound of Money."

Opening Premiere in Los Angeles, March 10, 1965. Host: Lorne Greene.

Greene interviewing the stars.

Arriving at the premiere in grand style.

Gregory and Veronique Peck.

Andrews and date, Roddy
McDowall.

Mia Farrow showed up at the
premiere even though she had
been passed over for the role
of Liesl.

Mr. and Mrs. Groucho Marx.

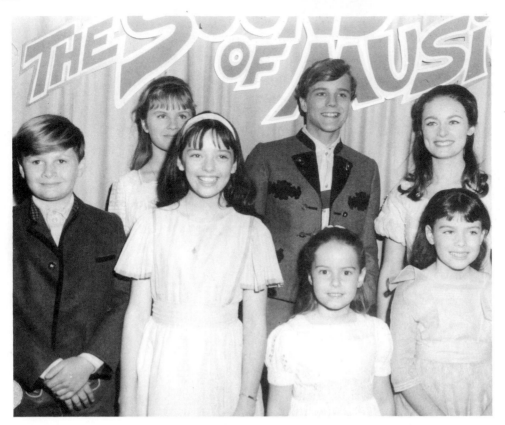

From left (back row): Duane Chase, Heather Menzies, Nicholas Hammond (with dark hair), and Charmian Carr. Front row: Angela Cartwright, Kym Karath, and Debbie Turner.

Patricia Lewis Plummer, Christopher Plummer, Julie Andrews, and Roddy McDowall.

One of the reasons for the film's large grosses was the legion of loyal *Music* fans who went to see the film over and over again. In some cities around the United States, the box office exceeded the total population of the area! In 40 weeks, Salt Lake City, with a population of 199,300, had a box-office attendance of 309,000. In Albany, New York, population 156,000, 176,536 people saw the film in 27 weeks. In Orlando, Florida, with only an 88,135 total population, reports recorded 105,181 admissions in 35 weeks.

The Sound of Music, which opened in 261 theaters overseas just a few months after the U.S. openings, was the first American film ever to be totally dubbed in a foreign language. Before *Music*, only the dialogue of American musicals was dubbed in the language of the specific country showing the film; the music remained in English. Foreign exhibitors then placed subtitles on the screen when the songs were sung. But the producers wanted to change that pattern with *Music* and chose to dub both the dialogue *and* the music in the languages of its main foreign markets: French, Italian, Spanish, and German.

Andrews makes handprints in cement at Grauman's Chinese Theater, March 26, 1966.

Madame Alexander Dolls made replicas of the children. They sold for $12 each.

Saul Chaplin, who was put in charge of handling the foreign dubbing, oversaw the translation of the lyrics. While dubbing in a foreign language is never easy, "Do-Re-Mi" gave the translators real trouble. For example, *do*, which is the first note of the scale in all languages, means a female deer (doe) in English, but does not have the same meaning in any of the other four tongues. The same held true for *re*, *mi*, *fa*, and on up the scale. Translators had to search for appropriate rhyming words for each note, all the while keeping the words similar enough that the new words the foreign singers were singing would look in sync with the way the original actors were moving their mouths.

As listed in the *New York Times Magazine* in 1966: In Egypt, the movie is entitled *Love and Tenderness*; in Portugal, it's called *Music in the Heart*; in Thailand, *Charms of the Heaven-Sound*; in Spain, *Smiles and Tears*; in Argentina, *The Rebellious Novice*; in Germany, *My Song, My Dream*; in Hong Kong the movie is known as *Fairy Music Blow Fragrant Place, Place Hear*.

Ironically, the movie was a box-office smash everywhere it was released except the two countries where Maria's story had originated—Germany and Austria. In Salzburg the movie ran exactly three days before the theater owners pulled the plug, and it has never been reissued. There are numerous theories as to why the film did so poorly in the one city that gained so much from its production.

Wise's film crew spent a total of $900,000 in Salzburg during the three months they shot in the city. The figure covers the accommodations for the cast and crew, payroll for local labor, and the cost of various services and equipment. After the movie became a hit, American Express began the "Sound of Music" tour, which bused tourists all over the city, showing them locations that were used in the film. There is a "Sound of Music" Dinner Theater and a "Sound of Music" record store. Yet Salzburg and many Austrian citizens actually harbored disdain for the film.

A typical response from the Salzburg residents who dismissed the movie was that it wasn't authentic. Austrians take great pride in their native dress, and they felt that the costumes in the movie did not reflect their style. They objected to the use of split locations—such as when the von Trapp house was shot at Frohnburg and its property was shot at Leopoldskron/Bertelsmann. The Salzburg residents resented this "Hollywoodization" of their city. They also wanted some authentic Austrian songs in the film and objected to the almost purely American score. But these reasons seem petty and subjective compared to the two underlying issues that seemed to truly influence their opinions of the film.

"The Austrians and the Germans just couldn't get over the fact that you were doing a remake of two of their favorite movies," said Pia Arnold.

Die Trapp Familie and its sequel, *Die Trapp Familie in Amerika*, were as popular in Austria and Germany as *The Sound of Music* was in the United States. The two leading actors, Ruth Leuwerik and Hans Holt, were beloved stars in the region. In fact, even though *Music* was never reissued in Austria, *Die Trapp Familie* was reissued in 1985 and did quite well. (Despite the feeling many Austrians have for the movie, they do appreciate the publicity the city has received from the movie. Wise has heard from consul generals and other officials over the years that *Music* has done more to bring attention to their country than any other form of publicity.)

Another reason for the movie's unpopularity, especially in Germany, was its Nazi theme. After the movie opened, a banner headline in a local German paper, *National-und-Soldatenzeitung*, declared, "Will Hollywood's Hate of German[y] Never End?" Saul Chaplin was in Germany shortly after this story ran in the newspaper and met with the Munich branch manager of Twentieth Century Fox, Wolfgang Wolf. They were riding in a taxicab together when Wolf

Wise, Shocked By Munich's Nazi Cuts, Questions 'Power' of Branch Offices

Hollywood, June 7. Robert Wise termed as "incomprehensible," "arbitrary," and "high-handed" the actions of a Munich branch manager of 20th-Fox who, as reported in the last week's VARIETY, trimmed the Nazi footage out of "The Sound of Music." Cutting has since been overruled by 20th-Fox toppers in N.Y., but Wise now is pondering the question of "spelling out more clearly" the relationship between a producer, his distrib and the distrib's employees.

Reportedly on the insistence of a Munich exhib, the cutting of "Music," mainly in the last section where Nazi oppression is prominent in pic's climax, was to appease latterday Nazi elements in Munich, Hitler's original hotbed. A prominent newspaper there talks in terms of "anti-German" emphasis when picture stresses "anti-Nazi."

Wise scored the action, taken without consultation with either 20th-Fox Continental distribution chief, or sales chief, or operating head of the company, or "above all," with "the man who made the picture in the first place."

"Music," a b.o. blockbuster, has had "disappointing" initial reaction in Germany, Wise said, adding that "we always felt that the anti-Nazi aspects of the final portion of the picture would not be wholeheartedly received in Germany." It is understood that, prior to release, there had been some talk about eliminating the Nazi heavy image from plot, but this was rejected.

Now "grateful" that pic is again being shown in full form, Wise intends to find "just what sort of powers are vested in the various (distribution) branches to make sure this sort of thing doesn't happen again." He concedes some "local situations" where "certain trims must be made" to conform to diverse censorship laws or custom, but adds that "even these are subject for discussion and not left to the arbitrary decision of a branch manager."

Wise continued with the observation that "producers are having enough trouble now with cuts being made in old pictures when released to television," without being faced with the "threat of high-handed cuts being made in current product by those to whom the prospect of an extra bit of revenue outweighs any ethical or artistic considerations."

He further said that "if a producer cannot have a reasonable assurance that his work won't be mutilated in first-run situations, then the time, apparently, has come" to more clearly define the "contractual relationship" between producer, distrib and latter's personnel.

The studio was enraged when Fox's German theaters cut the last third of the movie.

casually suggested to Chaplin that maybe the movie should be cut after the wedding scene. It seemed to be a logical place to end the picture, and the Nazi theme would then be less overt. Chaplin was shocked at such a suggestion and told him that he was definitely not allowed to edit the film in any way. But Wolf did not heed Chaplin's advice. He cut the picture after the wedding scene, eliminating one-third of its running time.

When Wise and the studio found out what had happened, they were aghast, not just because the picture had been cut but because of the political implications. The fact that any U.S. company would bow to neo-Nazi demands (which is how they viewed the situation) was unconscionable.

Wolf explained his actions by saying he was only "testing" the audience. If they didn't come to see the picture, even after the cuts, he would restore the movie to its original length. The home office did not buy Wolf's explanation, and he was immediately fired.

Wise, who was incensed by Wolf's escapade, was quoted in *Daily Variety* as saying, "Producers are having enough trouble now with cuts being made in old pictures when released to television without being faced with the threat of high-handed cuts being made in current product by those to whom the prospect of an extra bit of revenue outweighs any ethical or artistic considerations."

The film was eventually restored as originally intended—and it bombed in Germany.

There were, however, some segments of the movie that Wise approved of cutting when they seemed out of sync with the sensibility of foreign audiences. "Climb Ev'ry Mountain," for example, did not play well in some foreign markets. Foreign audiences seemed to get restless during the number, and Wise felt it slowed the pace of the show. So he cut it out. "Something Good" was also cut in some countries.

Wise also kept on top of theater exhibitors in the United States. Fans from all over wrote letters to Wise when a theater's print was damaged or the film was cut. Wise took care of all these complaints immediately. "I abhor any kind of cut made in my film by an exhibitor since he is, in fact, setting himself up as judge of my work," Wise was quoted in *Variety* at the time.

The Sound of Music won practically every major film award. Wise won the 1965 Outstanding Directing Achievement Award from the Directors Guild of America. He won the first annual David O. Selznick Producers Guild Award.

The picture won the Golden Globe for Best Picture, and Julie Andrews won as Best Actress. *Music* won the Federation of Motion Picture Councils' Best Family Film Award. It won Best Foreign Film in Peru, Italy, and Japan. It won many other international awards, and numerous religious and women's groups bestowed their own Best Film awards on the movie.

The soundtrack album on RCA records went gold and then platinum and has, to date, sold more than 10 million units worldwide. RCA has also released the sound-track in Spanish (*Sonrisas y Lagrimas*), German (*Meine Lieder, Meine Traume*), French (*Le Melodie du Bonheur*), and Italian (*Il Suono della Musica*), using foreign artists.

And then came the Oscars.

The Sound of Music was nominated for 10 Academy Awards: Robert Wise—Best Director and Best Film of the Year; Julie Andrews—Best Actress; Peggy Wood—Best Supporting Actress; Boris Leven—Best Art Direction (along with Walter Scott and Ruby Levitt for set decoration); Ted McCord—Best Cinematography; Dorothy Jeakins—Best Costume Design; Irwin Kostal—Best Music Adaptation; William Reynolds—Best Film Editing; and James Corcoran and Fred Hynes—Best Sound.

After everything Ernest Lehman went through to get *The Sound of Music* on the screen, and after the tremendous job he did in adapting a

somewhat static stage play into a vivacious and witty screen musical, Lehman did not get nominated for an Oscar. When Wise found out, he sent Lehman a letter. "All I can say is 'you wuz robbed,' " he wrote.

But Lehman was philosophical. He wrote back to Wise:

The enormous success of the picture all over the world and my own realization that I had guessed right in believing that that play could become a very rewarding and very popular film, and that I did have an important role in getting it from stage to screen . . . all these things, as I say, make it very difficult for me to have any unhappy feelings about anything connected with the picture. When you stop to consider what we achieved—this miracle that comes only to a very few once in a lifetime, and to us it has come at least twice [Lehman also wrote the Oscar winner West Side Story*]—well, out with the champagne!*

A record shop window display.

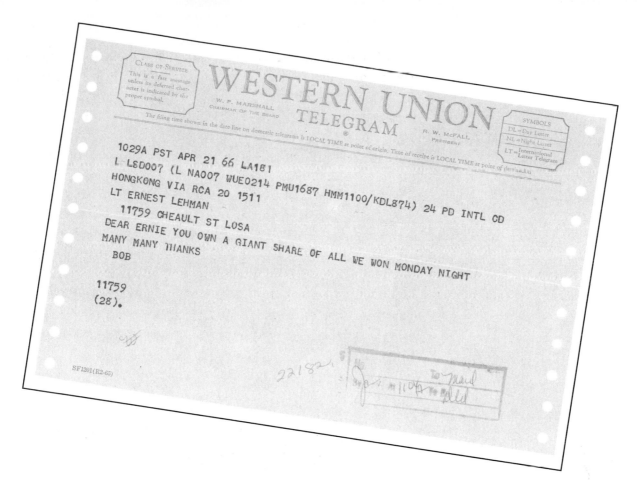

WESTERN UNION TELEGRAM

1029A PST APR 21 66 LA181
L LSD007 (L NA007 WUE0214 PMU1687 HMM1100/KDL874) 24 PD INTL CD
HONGKONG VIA RCA 20 1511
LT ERNEST LEHMAN
11759 CHEAULT ST LOSA
DEAR ERNIE YOU OWN A GIANT SHARE OF ALL WE WON MONDAY NIGHT
MANY MANY THANKS
BOB

11759
(28).

SF1201(R2-65)

Wise was in Hong Kong shooting *The Sand Pebbles* when the Academy Awards ceremony was held, so he could not attend the awards show at the Santa Monica Civic Auditorium. He asked Julie Andrews to accept the Oscar in his place should he win for Best Director, and he chose Saul Chaplin to represent him if they won Best Picture.

Chaplin arrived at the awards show with Julie Andrews, and they were both nervous wrecks. Andrews wore a bright red gown designed by Dorothy Jeakins. It was a red wool Japanese-style dress that Andrews felt was unflattering and made her uncomfortable. But she and Chaplin put on their best smiles and waded through the crowd of fans that greeted them at the theater.

"There was such an ear-shattering screech from the fans the moment they saw Julie," remembered Chaplin, "that I was literally stunned motionless. I don't believe I've ever heard a more terrifying sound in my life!"

The major Oscars were not awarded until the end of the program; the seven other awards for which *Music* had been nominated were spaced throughout the evening. Peggy Wood lost the Best Supporting Actress Award to Shelley Winters for her work in *A Patch of Blue*. But the next award was for Best Sound, which *Music* won. Then came Best Costumes; *Doctor Zhivago* took that prize. *Zhivago* also won for Best Art Direction and Best Cinematography, categories in which *Music* was a strong contender. But Irwin

Kostal won his award for Best Music Adaptation, and then the Best Editing award came up. *Music* won again. When William Reynolds took the podium to accept his award, he explained his method of film editing. "When in doubt, cut to Julie Andrews," he said.

Among others, Julie Christie had been nominated for Best Actress along with Julie Andrews, and there was a lot of hype during the promotion of the awards show about the expected rivalry between the two Julies. It was just Andrews's luck that the actor to hand out the Best Actress award was to be her old costar Rex Harrison, who had a perverse sense of humor. Harrison took advantage of the situation: after he opened the envelope that revealed the winner of 1965's Best Actress

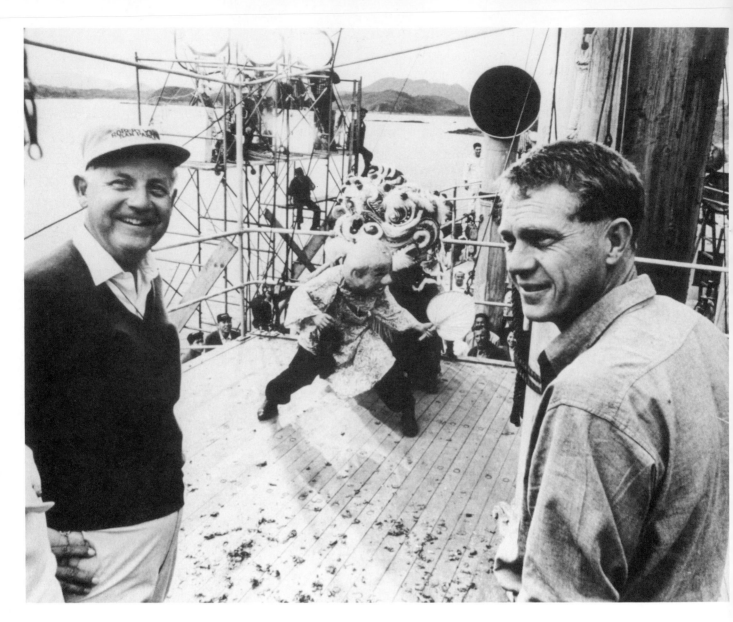

Robert Wise with Sand Pebbles *star Steve McQueen on the gunboat in Hong Kong during the surprise Oscar celebration.*

award, Harrison read, "Julie . . ." and then he stopped for a dramatic pause. ". . . Christie, for *Darling*," he announced.

If losing the award dampened Julie Andrews's spirits, she didn't have time to show it, because the Best Director award was up next, and Robert Wise won. Wise had asked Andrews to accept his award if he won, and, as she moved to the podium, she was hailed with enthusiastic applause by the audience, which seemed to want to make up for her not winning the coveted Best Actress Oscar.

When Jack Lemmon announced that the Best Picture of the Year was *The Sound of Music*, Chaplin ran onto the stage. He accepted the award on Robert Wise's behalf and then, from his heart, added a few words of his own. "I'm going to take this opportunity to thank [Robert Wise] for making the filming of *The Sound of Music* such a rewarding and stimulating experience."

Julie Andrews let out a yelp and fell into the arms of publicist Mike Kaplan. They both began to cry.

At the exact moment that Andrews and Kaplan clung to each other backstage at the Santa Monica Civic, Robert Wise stood on a gunboat off the coast of Hong Kong shooting a scene from *The Sand Pebbles* (while it was Monday night in America, it was Tuesday afternoon in China). The *Pebbles* crew wanted to make sure that Wise didn't miss any news of the festivities, so the local newspaper in Hong Kong had a hookup to radio reports from the Oscars show, and arrangements were made for the paper to phone the results to a crew member stationed on shore near the gunboat. The crew member would then send the news, by radio, to the gunboat as the winners were announced.

Although shooting did not stop during the initial reports from Hollywood, cheers went up from the film crew every time a win was announced for *Music*. Finally, when Wise won the Oscar as Best Director and *Music* was announced as the winner of Best Picture, filming stopped and all hell broke loose.

"I didn't know it at the time, but the Chinese crew had secretly strung the entire mast on the boat with big firecrackers," Wise recalled. "Ted Taylor, my public relations man on the picture, had also smuggled aboard a troupe of Chinese dragon dancers and had hidden them in the hold."

When the final award was announced, the firecrackers exploded, and the dragon dancers came charging out of the hold, banging their drums and dancing all over the boat!

So, even though they were thousands of miles away from home, on the other side of the world Wise, Reggie Callow, and Saul Wurtzel—his associates on both *Music* and *Pebbles*—had their own way of celebrating their good fortune.

HOW THEY SOLD
THE SOUND OF MUSIC

Moviemaking has changed drastically in the three decades since *Music* premiered. In today's market films open on a continuous performance basis in several theaters with as much ballyhoo and advertising as possible. In the sixties, developing an audience for a film was a much more subtle affair. From the inception of the project, *The Sound of Music* was intended to be a road show, a vision reflected in the decision to film in Todd-AO, a wide-screen process to which, at that time, relatively few theaters had been converted.

Months before the start of shooting, at the suggestion of mutual friends, Robert Wise discussed the project with publicist Mike Kaplan, who had just finished a year-long production and distribution campaign on *It's a Mad Mad Mad Mad World*. In one 30-minute

interview, the two discovered they had similar philosophies about the care and feeding of an important film project, and Kaplan came aboard.

The publicity campaign began in February 1964, before the first scene of the movie was shot. Most publicity directors of the era started work by creating a "campaign analysis"—a blueprint detailing the steps to be taken to make the public aware of the project. The publicists analyzed which publications and which journalists would be interested in specific elements of the picture. In the case of *Music* the elements might be the property's success as a Broadway show, the rising star of Julie Andrews, the challenge of Robert Wise to equal or top his success with *West Side Story*, or the heart-tugging elements of the story. Because the project was designed as a road show, for

which exhibitors in individual cities might bid against each other, Kaplan's plans also included a heavy concentration of ads in the show business trade papers *Daily Variety*, *Weekly Variety*, and *The Hollywood Reporter*. Exhibitors who read these "trades" were thus aware that something special was only a year away.

The first order of business was to give the film a cachet (a special ad line or slogan) and create a logo, which, the publicist hoped, would have such an impact that anyone seeing them would know immediately what film they represented. After rereading the script, Kaplan came up with the ad line "The Happiest Sound in All the World" and began the tedious process of creating artwork that would complement the line and be a memorable visual asset. He enlisted the help

Mike Kaplan (publicist), Robert Wise, and Saul Chaplin.

of outside creative agencies to work with the Fox advertising staff, and more than a dozen good pieces of art were rejected before the creation of the key art: Julie Andrews, carpetbag in hand, bursting over a hill with the seven children in the background.

Because of the road show concept, Kaplan avoided the usual broadside publicity campaign, preferring instead to draw up a list of 40 key cities that, he was certain, would be among the first to book the film. From the first day of production the publicity campaign was geared toward those cities; even more specifically, to encompass the personal interests of media personalities in those cities. For instance, if one city had three major newspapers, Kaplan would write three separate stories about the movie, tailoring each story to an individual newspaper.

Midway through the Salzburg location shoot, the *Music* company became the first stop on a three-city press junket launched by Twentieth Century Fox to publicize the musical and its other big European location productions, *The Agony and the Ecstasy* and *Those Magnificent Men in Their Flying Machines*. The stay was short, but with the cooperation of Wise, Saul Chaplin, and the stars, the 120 American journalists wound up with stories and pictures of the production, and all of them could boast at least one exclusive interview with the principals involved. The junket also paid off later, after the film opened; while other critics wrote unflattering reviews of the movie, the journalists who had gone on the trip wrote only sterling critiques.

THE HAPPIEST SOUND IN ALL THE WORLD

20th CENTURY FOX presents

RODGERS and HAMMERSTEIN'S

A ROBERT WISE Production

THE SOUND OF MUSIC

COLOR BY DE LUXE

Starring JULIE ANDREWS · CHRISTOPHER PLUMMER

AND ELEANOR PARKER as The Baroness

Co-starring RICHARD HAYDN

With PEGGY WOOD, CHARMIAN CARR, THE BIL BAIRD MARIONETTES

Associate Producer SAUL CHAPLIN

Directed by ROBERT WISE | Music by RICHARD RODGERS | Lyrics by OSCAR HAMMERSTEIN II

Additional Words and Music by Richard Rodgers

Screenplay by ERNEST LEHMAN

Production Designed by BORIS LEVEN

Produced by Argyle Enterprises, Inc.

When the company returned to the studio for interiors, the publicity campaign continued, with weekly feature mailings to the newspapers in the key cities. The buildup achieved such penetration that, when the film was completed and taken out for preview, it drew turnaway crowds despite minimal publicity regarding the screening itself.

The public's reaction convinced Kaplan that the company had a megahit on its hands. At a midnight snack session after the Tulsa preview, he told Wise and Chaplin, "You could get rid of me tomorrow and you'd still have a smash. Just open the doors and get out of the way." Less than 11 months later, Kaplan's optimism was justified when *Music*, despite its limited road show run, became the most popular picture to date.

By then a new campaign was under way—an effort to win Academy Award recognition for the picture and all the talents involved. The word *campaign*, of course, makes it seem as if potential Oscar candidates are on a political drive to snare votes. Actually the purpose of such a campaign, whether it be through advertising in the trade papers or arranging special screenings for academy members, is to make sure that everyone who has a vote has at least seen the picture.

In the sixties the usual process at Academy Awards time was for the major contenders to advertise heavily in the trade papers, usually taking a number of "double truck" ads—that is, two facing pages—extolling the appeal of the film, quoting the reviews, and listing its box-office records. In the case of *Music*, studio support was not completely enthusiastic. The film had opened the preceding March, and the general theory was that, since the awards are given out in March of the following year, the films released the year before are already forgotten and the big pictures that open at Christmas have a leg up in the academy voting. This seemed particularly true in the early spring of 1966, when most of Hollywood was convinced that *Doctor Zhivago* could not be beaten. To make matters even more difficult, a musical (*My Fair Lady*) had won the previous year, and Julie Andrews had won Best Actress for her role in *Mary Poppins*.

Clearly the drive for academy recognition would need something other than routine advertising; but since screenings and trade paper advertising were the only methods employed, some new wrinkle had to be found. The easiest deviation was in the area of screenings, where traditionally academy members and one guest were invited. For *Music*, Kaplan set up special Saturday screenings at the studio and invited academy members *and* their families—as many people as they wished—and made it clear they could come to more than one screening if they so desired.

The turnout was tremendous, as expected. But what was not anticipated was the reaction from the Fox sales department, which, despite the fact that the film was already established as the all-time box-

office champion, was outraged at the number of people seeing the film for free!

Finding a variation in the print advertising routine was a bit more difficult. But Kaplan drew on a long-standing theory of his own: Hollywood's movers and shakers, he insisted, did not read the trade papers; they had secretaries who scanned the papers and marked those items they thought would interest the boss. The executives did not stop to read the ads and did not bother reading anything that wasn't marked. So to get around this problem, Kaplan devised a series of 1½-page ads, the half-page being the left-hand page. In an unusual deal with the trade papers, he paid for two *full* pages with the understanding that the papers would use the top half of the left-hand page for legitimate news stories. Kaplan shrewdly calculated that if serious news stories appeared there, the executives would not pass over that page as they would have if it had contained only an advertisement. Thus the *Music* ad would draw the executives' attention, if only momentarily.

Obviously there is no way of proving how much these innovations meant to academy voters, but the results speak for themselves.

I saw it four times. I was ecstasied
SCHOOLBOY IN MALAYSIA
... When it finishes its run here, we
shall have lost something wonderful
FARMER IN MONMOUTHSHIRE, ENGLAND
... People who don't like it must be hard-
faced, with wrinkled foreheads and fore-
boding frowns ... without a doubt, the
HOUSEWIFE IN MALAWI
finest film ever—a legend in its own time
TEACHER IN PITTSBURGH
... I have seen it 70 times and could see
it 1,000 more ... I'm a James Bond fan
SAILOR STATIONED IN PUERTO RICO
but this is the best movie I've ever seen
ACCOUNTANT IN NEW JERSEY
... I only saw it three times as I live miles
from the cinema and don't get much
pocket money ... I'm worried—it's
SCHOOLGIRL IN NEW ZEALAND
cheaper than therapy ...
PSYCHIATRIST IN CALIFORNIA

(EXCERPTS FROM LETTERS ON FILE AT STUDIO)

The happiest sound in all the world!

20th
CENTURY-FOX

THE SOUND OF MUSIC

10 Academy Award Nominations

BEST PICTURE
——

BEST DIRECTION
ROBERT WISE

BEST ACTRESS
JULIE ANDREWS

BEST SUPPORTING ACTRESS
PEGGY WOOD

BEST CINEMATOGRAPHY (COLOR)
TED McCORD A.S.C.

BEST ART DIRECTION (COLOR)
BORIS LEVEN

BEST COSTUME DESIGN (COLOR)
DOROTHY JEAKINS

BEST SOUND (IN ALL THE WORLD)
JAMES P. CORCORAN & FRED HYNES

BEST SCORING (ADAPTATION)
IRWIN KOSTAL

BEST EDITING
WILLIAM REYNOLDS A.C.E.

"What will my future be, I wonder . . ."

LIFE AFTER MUSIC

IT'S BEEN NEARLY THREE decades since *The Sound of Music* opened, and the film changed not only movie history and the fortunes of one of Hollywood's major studios but also the lives of the people who made the picture.

Robert Wise became a member of an exclusive Hollywood club consisting of director/producers who have won two double Oscars (he had also won Best Picture and Best Director, the latter Oscar shared with Jerome Robbins, for *West Side Story*). After *Music*, Wise went on to produce and direct *The Sand Pebbles* (1966), *The*

Andromeda Strain (1968), *Star!* (1971), *Two People* (1973), *The Hindenburg* (1975), *Audrey Rose* (1977), *Star Trek—The Motion Picture* (1979), and *Rooftops* (1989).

He served as president of the Directors Guild of America from 1970 to 1974 and held the same title for the Academy of Motion Picture Arts and Sciences from 1985 to 1987. He is still very active in Hollywood business and the community and has a number of independent films in development.

Julie Andrews, of course, became a major star after *Mary*

Robert Wise.

Poppins and *The Sound of Music* and went on to achieve acclaim in many other films as well. The year after *Music*, she starred in the movie adaptation of James Michener's *Hawaii*, another popular road show, and *Thoroughly Modern Millie* in 1967 was the most successful movie at Universal Studios to that date. She collaborated with her second husband, writer/director Blake Edwards, on many films, two of which were the highly successful *10* in 1979 and *Victor/Victoria*, which came out in 1982 and won her an Academy Award nomination for the third time.

In 1987 Andrews returned to Salzburg to star in the television Christmas special "The Sound of Christmas." They filmed the special in many of the locations used for the motion picture, including Mondsee Church and Leopoldskron Castle (this time they were allowed to use the building). In 1988 Andrews performed in her first concert tour, playing to sold-out crowds throughout the U.S.; for a while she was the country's top concert attraction. In 1989 she was the first recipient of the British Academy of Film and Television Arts Lifetime Tribute Award. Andrews continues to perform in film and television and is

planning another concert in Japan. She performed in the Stephen Sondheim revue *Putting It Together* in New York and is in the middle of developing a stage musical version of *Victor/ Victoria*, slated to open in 1994. Yet, despite her hectic schedule, she still finds time for charitable work. Andrews is now the goodwill ambassador for UNIFEM, an organization dedicated to the advancement of women all over the world, especially in developing countries. Of her experience on *The Sound of Music*, Andrews, interviewed by Libby Slate for a 1990 *Los Angeles Times* article, said, "To be

Julie Andrews.

part of something that's still around, that's brought happiness to so many people, is an honor."

Christopher Plummer is another actor who never stops working. He has made more than 40 films, including *The Man Who Would Be King*, *The Pink Panther*, *Inside Daisy Clover*, and *Eyewitness*. His character portraits on film range from Archduke Franz Ferdinand to Rudyard Kipling. He works continually in film, on television, and onstage all over the world and is currently writing a novel about his career.

"*Music* was the highlight of my life!" claimed Dan Truhitte,

who never did another movie. After the film, Truhitte joined the Marines. By the time he returned home, realism had replaced movie musicals as the new wave in film, and the song-and-dance man was out of work. So Truhitte opened a dance studio in Sacramento, California, where one of his pupils was actress Molly Ringwald. After he closed the school, he worked in Las Vegas performing in the revue *Hallelujah Hollywood*. Then Truhitte moved to North Carolina, where he now runs another dance studio.

Portia Nelson has had two bouts with throat cancer so does

not sing anymore, but she continues to write music and act. She also published a book of poetry, *There's a Hole in My Sidewalk*, that has developed quite a cult following.

Music was Anna Lee's last picture. After the film she concentrated more on television and has played Lila Quartermaine on "General Hospital" for the past 15 years.

Marni Nixon continues her quest to "bring people into the concert world" by performing classical chamber music in concerts all over the country. In addition, she still performs in plays in New York.

Some of the cast members have died. Peggy Wood passed away March 18, 1978, from a cerebral hemorrhage. Ben Wright died on July 2, 1989, at the age of 74. His last film was Disney's *The Little Mermaid*, where he lent his voice to the character Grimsby. Gil Stuart died in 1977. Richard Haydn died on April 25, 1985, and Norma Varden in February 1989.

Eleanor Parker continued to work in television after *Music* but then retired to Palm Springs. "I was the so-called heavy in *The Sound of Music*," she reminisced in an article for the *Los Angeles Times* in March 1990. "Little children would look at me as a nasty lady who didn't like

children, though Bob Wise and I looked at her as a baroness whose way of life was that children went off to school. I'm very proud to have been in the film. If anyone asks me what I've done, I look to see how young they are and say, 'There's one film you will know'—and they've always seen it several times."

"If there's one thing we hold special in life, it is *The Sound of Music*," said Debbie Turner in a 1990 interview for *Us* magazine. But while making *The Sound of Music* was a highlight in the lives of the actors who portrayed the von Trapp children, the years since the film opened have not always been as pleasant. The *Music* "children" have all become

symbols, and they have found it very hard to live up to that image.

Kym Karath, who was a regular on "All My Children" before taking time off to have a baby, explained: "We went to London in 1990 to promote a new release of the video, and there were these mobs of people waiting outside the theater door. It was a little weird. They still expected me to be six years old! Then, when we were taping the TV interviews, the producers kept calling us 'the kids.' Now we're all in our thirties and forties, yet they wanted us to sing 'So Long, Farewell' with the same positions and the same mannerisms as in the movie. They practically wanted Charmian to carry me

Christopher Plummer.

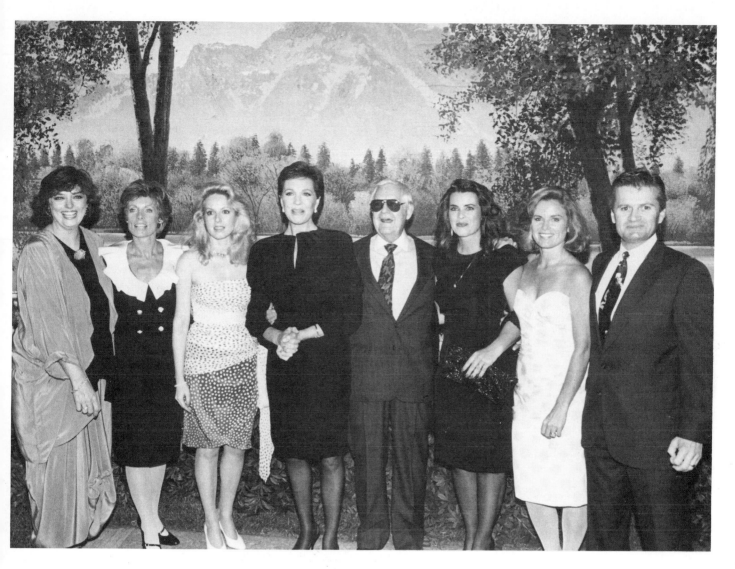

up the stairs again. I think people want us to be frozen in time!"

The actors have all remained very close. "It's like being members of a private club," described Heather Menzies in the 1990 *Los Angeles Times* article. Menzies, who is married to actor Robert Urich, starred in a few movies (she even played Julie Andrews's sister in the 1966 *Hawaii*), and she starred in the "Logan's Run" television series before giving up her acting career to be a full-time mother to her two children. She is also godmother to Karath's little boy.

Charmian Carr also gave up her acting career for marriage. She was a big hit after *Music* opened and did a number of television pilot episodes under her contract with Fox. She also acted in numerous commercials. But when she married Jay Brent, an Encino dentist, he gave her a choice. "My husband is sort of old-fashioned," she told one interviewer at the time. "He gave me a choice of marriage to him or an acting career and I chose marriage."

Carr and Brent are now divorced, and she runs her own interior design business in Encino. One of her most famous clients is Michael Jackson. "He loves *The Sound of Music*," Carr related in a 1990 interview for *People* magazine. "I got the job because he loved Liesl."

At the 25th anniversary party in Los Angeles. From left: Angela Cartwright, Charmian Carr, Kym Karath, Julie Andrews, Robert Wise, Debbie Turner, Heather Menzies, and Duane Chase.

The Urichs are another of Carr's clients; her company is now busy designing the Urichs' new home in Utah. And after their years of friendship and the story of how it began, it seems especially fitting that, just a few years ago, Carr and Menzies discovered they are distantly related!

Another actress in their close circle of friends is Angela Cartwright, who, after *Music*, signed on for the TV series "Lost in Space" and did a few movies. But when she turned 20 the roles dried up. "It was actually kind of a nice break," Cartwright told Lisa Bernhard in a 1988 article for *Us* magazine, "because I had worked all my life and wanted to play." She and her husband, Steve Gullion, started a gift shop, Rubber Boots, that she still runs in Toluca Lake, California.

Duane Chase, who lives in Washington State and tests computer software for oil and mining companies; Debbie Turner, who lives in a small town in Minnesota with her husband and four children; and Nicholas Hammond, who lives in Australia, where he still makes his living as an actor, doing stage shows, all keep in touch with their screen siblings.

While some people only dream of the kind of adulation and notoriety with which the seven *Music* "children" have been honored, the actors have sometimes found the attention a burden. Many times over the years they have been called on to do promotional appearances for the movie, including TV shows and radio interviews, effectively extending the job for which they were hired almost three decades ago, and they now feel they have had enough. "I had the time of my life [working on *Music*]," said Menzies in the 1990 *Us* magazine interview, "but it's a chapter in my life that's over."

Ironically the fictional von Trapp children are not the only ones to feel the frustrations of being "frozen in time." The real-life von Trapps have had a similar experience. When guests visit their lodge in Vermont, it seems they expect each of the von Trapps' lives to have been as pristine and happy as those of their movie counterparts. This is far from the truth.

In the Austrian documentary *And Edelweiss Is Also Just a Flower; Myth and Reality of the Trapp Family*, by Degn Films, the von Trapp children try, for the first time in their lives, to tell their side of the story.

While the von Trapps feel no animosity toward the film, they do resent the fact that, in the play and film versions, Maria is the one who is put on the pedestal while their father is given little credit for inspiring his children's talents and ideas.

"Part of the problem was that the Broadway play was written to be a vehicle for a star, Mary Martin, and so the character was made to be more important," said Johannes, the youngest of all Maria's children and president of the Trapp Family Lodge, in recent interviews with the author of this book.

Father Wasner, who played such a large role in the family's history, was left out of the play version entirely, to which the family also objected. But they were even more incensed when his character turned up again in the film as Max Detweiler. The priest and his film character, Max, couldn't have been more different.

The von Trapps all realize that the play and movies are *fictional* accounts of their lives, and on some level they even enjoy the movie. But they are all adamant about the fact that this is not their story. In fact, the children have a somewhat darker view of their family history, as compared to their mother's portrayal in her books.

According to the children, the von Trapp story began in 1910, when a distinguished naval commander, Georg von Trapp, met Agathe Whitehead at a ball. It was love at first sight and, in society's eyes, almost a royal match. Captain von Trapp was as distinguished a war commander as, say, Eisenhower was in America after World War II. The marriage between von Trapp and Agathe Whitehead, whose father had invented the torpedo, had the same mythical trappings as John and Jackie Kennedy's. And they were very rich. Whitehead had inherited money from her family, and the von Trapps lived off the interest.

The first blow to the Captain's way of life came when the Austro-Hungarian Empire broke up after World War I. Austria no longer had an ocean, so naturally it no longer needed a navy, and the Captain lost

The von Trapps in 1983 at the reopening of their lodge after a 1980 fire destroyed the property. From left: Werner, Lorli, Johannes, Maria von Trapp, Rupert, Rosmarie (seated next to her mother), and Maria.

A Von Trapp Update (Oldest to Youngest)

RUPERT: Medical doctor until the mid-1980s. He died in 1992 at the age of 80, leaving six children and ten grandchildren.

AGATHE: Lives near Baltimore, Maryland, where she helps run a kindergarten.

MARIA: Spent 30 years as a missionary in New Guinea. Now lives in Vermont.

WERNER: After leaving the family group he became a dairy farmer. Now retired, he has six children and thirteen grandchildren.

HEDWIG: Worked at the lodge until her death in 1972.

JOHANNA: Married in 1948, she left the family group to live in Vienna. She has six children.

MARTINA: Sang with the group until 1952, when she married. Died in childbirth the same year.

ROSMARIE: Lives in Stowe, Vermont, and is a companion for a 100-year-old woman who was a friend of her mother's.

ELEONORE (LORLI): Mother of seven children. Stopped singing in 1952. Now spends time with her children and ten grandchildren.

JOHANNES: Graduate of Dartmouth, with a master's degree in forestry from Yale, he is now president of Trapp Family Lodge, Inc., and has two children.

his post. Then, when the Captain's wife died, he was devastated. But Johannes von Trapp thinks the end of his naval career was as severe a blow to his father as the loss of his wife. "My father's forte was the navy," explained Johannes. "He was uncomfortable doing anything else. He was sort of lost."

After their mother died, the children had a number of governesses. One would be hired for the older children, one for the younger, and one to run the household. The children wanted to have just one governess, and Maria seemed to be perfect.

But, while Maria brought madrigals and other complicated music into the family, the children were far from musical novices. They sang all the time. And the captain encouraged them to sing. He even joined them, playing the guitar, mandolin, and violin.

When the Captain lost his fortune after the Austrian national bank folded, the children had to learn how to work, doing laundry and other household chores. They looked at their misfortune as an adventure, but the Captain was hit hard by the loss. He had nine children to support and suddenly had no money.

When his family began to earn money by singing onstage, the Captain faced another blow. "It wasn't singing onstage that bothered my father so much," said Johannes. "It was that they were getting *paid* to sing onstage. In his position in society working on stage for money was déclassé."

Maria, along with Father Wasner, brought a level of sophistication to the family's singing, but according to Johannes, the Captain's naval stature helped the family forge their careers. Even before they began singing the Captain was very well known, and his name lent a certain air of importance to their singing group.

But even with his name attached to the group, the Captain sat by himself backstage while his family performed. As head of the family he would come out and introduce the group after they had performed a few numbers, and then at the end of the show he would come back out onstage and take a bow.

Then Hitler invaded Austria. The Captain pulled his family to his side and said, "We are standing at the open grave of Austria." He asked them if they wanted to stay or to leave. They made their choice.

It was a terrible blow to leave their home and all their belongings behind, and then, when they learned that Himmler had taken over their house, the grief was almost unbearable.

The von Trapps arrived in America in 1938 and until 1956 spent their entire lives on the road, giving tours. But because they traveled so much, the children basically had to put their personal lives on hold. "Those years that we sang were not easy," said Johannes. "We traveled around the world and gave many concerts. But at each stop, my mother always made sure we went to this nunnery and that nunnery. So, with every concert we gave, there was often a free concert that we performed afterwards. I didn't think it was so hard. I was ten, twelve years old

The von Trapp family photographed in 1941. From left: Rupert (sitting), Hedwig, Johannes (on mother's lap), Maria von Trapp, Johanna, Captain Georg von Trapp, Rosmarie with her arm around Maria, Martina, Werner, Agathe (petting dog), and (sitting) Eleonore (Lorli).

at the time, but for my older brothers and sisters it must have been difficult."

Maria would never hear of any of them leaving the family to go out on their own, even after some of them married and had a family. "My mother had tremendous strengths," said Johannes, "but she had characteristics that also made her very difficult. She wanted us to perform a hundred ten percent of our capacity all the time, but she demanded that of herself as well."

Maria also seemed to have violent opposing forces inside of her that would sometimes cause her to lash out at her family. Some of the children think this stemmed from the fact that Maria had a hard time trying to subjugate her own interests to God's will. She tried to do what she felt God wanted her to do, but she also wanted what was important to her.

When the Captain died on May 30, 1947, the children started to rebel. They were tired

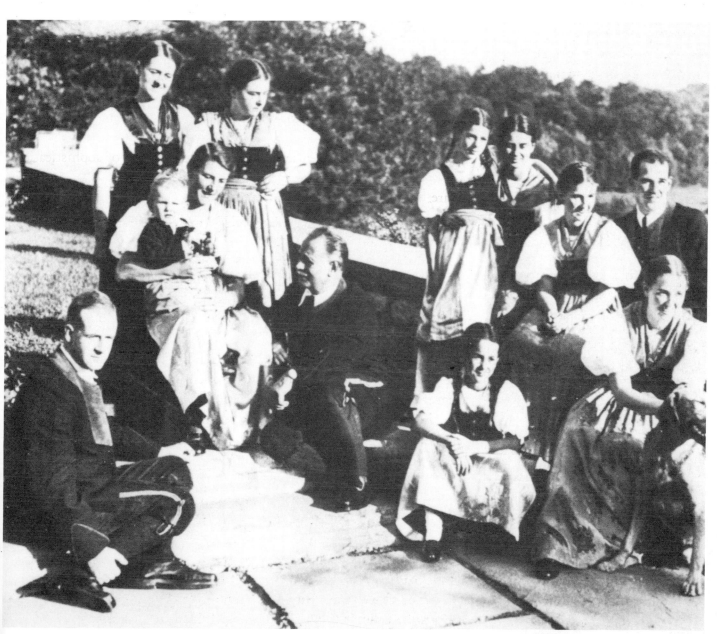

of living their lives on the road. They wanted to start families and settle down. Rosmarie, the eldest of Maria's own children, ran away from home at the age of 18. She was brought home by Father Wasner but never traveled with the family again. Johanna, the second to the youngest of the original children, ran away and got married, against Maria's wishes. The other children eventually broke away, and the family stopped touring in 1956. Then the family corporation bought a ranch in Montana. Johannes is the only one who ever stays there.

The siblings seem to communicate more now that Maria is gone. In fact they are finding, for the first time, that they share the same feelings. Yet, despite all the problems the family had to overcome, they were and still remain very loyal. Each of them, individually, is also very talented; they sew, knit, weave, sketch, play music, and have their own careers. They all feel that their father, not just Maria, fostered their talent. Yet Johannes remembers one moment when Hedwig, who died in 1972, came up to her brother and quietly admitted, "You know, Johannes, if it weren't for mother, we'd have all been cooks and maids."

Maria was a very complex woman. "She had a very unhappy youth," explained her youngest son. "It pained her to talk about her childhood." In a film that is shown at the Trapp Family Lodge, Maria reveals a little of that pain. She recalls, "I grew up without being kissed. It was just not a habit in [my foster mother's] house. And then I came here to this house, and one of the little ones, Johanna—she was seven years old—she spontaneously came up to me one day, put her hands around my neck, and kissed me. I remember the sensation very well. It was the first conscious kiss of my life."

Maria's ruthlessness sometimes stemmed from her own generosity. "My mother has helped thousands of people," said Johannes, "and if mountains had to be moved to help someone, she would move them. That's partly what caused people to have a strong reaction toward her. But she never did any of that selfishly. Her positives were as extreme as her negatives."

A small example of Maria's generosity was the Trapp Family Austrian Relief Fund. After the war Maria arranged for hundreds of tons of food and clothing to be shipped overseas.

"I was in Austria a few years ago," said Johannes. "We were sitting in a restaurant, and the owner, an older lady, came up to me and said, 'You know, if it weren't for your mother, I wouldn't be alive today.' "

Yet Maria never spoke of her own benevolence. "My mother believed that when you did a good deed you shouldn't talk about it." said Johannes.

Maria died in 1987 at the age of 82 and now rests alongside her husband on their property in Vermont. That young woman who rang a magical steeple bell and wished that she could express her faith and love on paper ended up writing five books about her life and her family. And, along with running the family hostel in Vermont, she also lectured around the world.

Maria and Georg.

Maria's life was complicated. She wasn't as pure as Julie Andrews's version of her, nor as pious as the nuns she had once hoped to emulate at the Nonnberg Abbey. She was, like the rest of us, just human. But she leaves a legacy of love and hope and family loyalty—traits to which we can all aspire. And finally, she will always be remembered as that will-o'-the-wisp whose story inspired *The Sound of Music*, a timeless motion picture about the remarkable faith and love that created a courageous and extraordinary family.

"... *till you find your dream* ..."

MUSIC-MANIA

ONE FAN FROM OREGON SAW the movie so many times he sent the producers a copy of the script he'd written from memory; David Campbell, a Denver truck driver, watched the film from the same seat in the same theater every Sunday for three years and then, when the theater closed down, bought the seat. Manila moviegoers almost started a riot in their frenzy to get tickets and did not calm down until police arrived.

What was it about this movie that turned normal, well-adjusted moviegoers into compulsive *Music*-maniacs? What made the movie so popular that, in 1989, 24 years after it opened, the People's Choice Awards voted *The Sound of Music* one of the top three favorite motion pictures of all time?

"Everything in it is nice and homey and bread-and-butter and simple," Richard Haydn told reporter Joan Barthel in an interview for a *New York Times* piece in 1966.

Ernest Lehman explained his theory to Barthel: "It's a fantasy about a world which no longer exists, where everything comes out right in the end. . . . Our astronauts have succeeded in

getting out of this world, but those who haven't go to see *The Sound of Music* one more time."

One longtime fan, who was six years old when the movie came out, explained, "The movie seems to touch every adult emotion. You feel love, fear, parental love, patriotism. It's fifteen movies rolled into one!"

Another fan, who was 17 years old in 1965 and still watches the film with her family every Christmas, states: "For me, more than anything else, the movie is about values. The family takes a stand for what they believe in and measures everything against their own principles."

For years, Robert Wise has received fan mail from all over the world. His eclectic following ranges from film students writing theses on the movie to nuns seeking autographs.

There has never been a movie that has garnered such repeat business as *Music*. A Los Angeles woman went to see *Music* 58 times; a sailor in Puerto Rico, 77 times; and in 1988 Myra Franklin, a 47-year-old widow from Wales, was listed in the *Guinness Book of World Records* for having seen *The Sound of Music* 940 times!

According to a *Variety* survey, in 1965 *Music* became the number-one box-office hit of the year. Then, by Christmas 1965, it edged past *Gone With the Wind* (by slightly less than $1 million) to become the number-one film of all time. *Music* kept that title until 1970, when a rerelease of *Gone With the Wind* made that film reigning champ once again. *Music* then held out at number two until

1972, when *The Godfather* won the number-one spot, *GWTW* came in second, and *Music* was listed as the third most popular box-office attraction. In the following year, when *Music* was rereleased in the theaters, the movie moved up to number two (*The Godfather* still held the number-one title). In 1975, Steven Spielberg took over Hollywood, and *Jaws* became the number-one box-office film, and each succeeding year, it seemed another Steven Spielberg/George Lucas film would be released, and *Music* would be pushed down a little farther. Still, it had been a good run, and if the numbers had been adjusted for inflation, who knows? *Music* might have held on to its title even longer.

In 1976 *Music* aired on ABC-TV. The network paid $15 million for the rights to show the movie one time only, and its airing rated number one in the Nielsens despite the film's having been shortened by 31 minutes. It also placed eighth among the 10 top-rated films ever shown on TV. That opened the door for NBC, which in 1978 bought the rights to show the film 22 times over a 20-year period. It is now shown annually at Christmas.

Even the videotape of the movie is breaking records.

According to *Billboard* magazine, *Music* has had the longest run as a bestseller in video history! The video has been on *Billboard*'s Top 40 Video Sales chart for more than 250 weeks, longer than *Jane Fonda's Workout* and *The Wizard of Oz*. It has never come in lower than number three on the Fox video lists since it was released in 1979. *Music* was also transferred to laser disc, one of the first movies to be available in this new form. It was also one of the first movies released under the THX laser disc program, which ensures higher quality of picture and sound.

"The movie was a combina-

Cutting the cake at a celebration of the first anniversary of the film's release.

tion of efficiency, creativity, and luck," said Pia Arnold.

That may be true. Many studios tried to copy the *Music* formula after the movie became a hit, and they all failed. Warner Brothers came out with the $15 million *Camelot* and the $6 million *Finian's Rainbow*. MGM offered Peter O'Toole in *Goodbye, Mr. Chips*; Paramount coerced Clint Eastwood to sing in *Paint Your Wagon*, and Julie Andrews starred in *Darling Lili* for the same studio. The list goes on. Fox tried to work magic again with *Doctor Dolittle* and *Star!* But nothing had the power of *The Sound of Music*.

Charles Champlin described his view of the movie's popularity in his *Los Angeles Times* review in March 1973, when the film was first rereleased in the theaters. He wrote that the movie "works because we still, more often than not, ask the movies to give shape to our dreams rather than our nightmares, to spell out our wishes and fancies instead of our fears, and 'The Sound of Music' says with a towering clarity that there is still innocence in the world, that love conquers all and right will prevail."

People can speculate as to why *The Sound of Music* was such a success. Each viewer has his or her own personal, subjective answer. But perhaps there are no logical reasons for what we feel in our hearts. Maybe Wise summed it up way back in 1966 when he told Joan Barthel of the *New York Times*: "I wasn't trying to say a damn thing in *Sound of Music*. . . People just feel good when they see it."

CAST AND CREW LIST

CAST OF CHARACTERS

Maria	Julie Andrews
Captain von Trapp	Christopher Plummer
The Baroness (Elsa Schraeder)	Eleanor Parker
Max Detweiler	Richard Haydn
Mother Abbess	Peggy Wood
Liesl	Charmian Carr
Louisa	Heather Menzies
Friedrich	Nicholas Hammond
Kurt	Duane Chase
Brigitta	Angela Cartwright
Marta	Debbie Turner
Gretl	Kym Karath
Sister Margaretta	Anna Lee
Sister Berthe	Portia Nelson
Herr Zeller	Ben Wright
Rolf	Daniel Truhitte
Frau Schmidt	Norma Varden
Franz	Gil Stuart
Sister Sophia	Marni Nixon
Sister Bernice	Evadne Baker
Baroness Elberfeld	Doris Lloyd

CREW

Director/Producer:	Robert Wise
Associate Producer:	Saul Chaplin
Screenwriter:	Ernest Lehman
Unit Production Manager:	Saul Wurtzel
Assistant Director:	Ridgeway Callow
Second Assistant Director:	Richard Lang
Casting:	Owen McLean
	Lee Wallace
Script Supervisor:	Betty Levin
Art Director:	Boris Leven
Assistant Art Director:	Harry Kemm
Sketch Artist/Second Unit Supervisor:	Maurice Zuberano
Second Unit Photographer:	Paul Beeson

CAST AND CREW LIST
(CONTINUED)

Special Visual Effects:	L. B. Abbott, A.S.C.
	Emil Kosa, Jr.
Set Decorator:	Ruby Levitt
	Walter M. Scott
Director of Photography:	Ted McCord, A.S.C.
Camera Operator:	Paul Lockwood
Camera Technician:	Roger Shearman
Still-Man:	James Mitchell
Sound:	Murray Spivack
Sound Mixer:	Bernard Freericks
Sound Recorder:	Bill Buffinger
Supervisors:	Fred Hynes
	James Corcoran
Boom Man:	Orrick Barrett
Cable Man:	Jesse Long
Key Grip:	Walter Fitchman
Best Boy:	Fred Richter/Jack Dimmack
Gaffer:	Jack Brown
Property Master:	Eddie Jones
Assistant Prop Master:	Glen "Skippy" Delfino
Second Assistant Prop Master:	Benny Greenberg
Makeup Man:	Bill Buell
	Ben Nye
Hairdressers:	Ray Foreman
	Margaret Donovan
Costume Designer:	Dorothy Jeakins
Costumer (Men):	Dick James
Costumer (Women):	Josephine Brown
Film Editor:	William Reynolds, A.C.E.
Assistant Film Editor:	Larry Allen
Schoolteachers:	Frances Klamt
	Jean Seaman
Choreographers:	Marc Breaux
	Dee Dee Wood
Music Supervisor:	Irwin Kostal
Vocal Coach:	Robert Tucker
Rehearsal Pianist:	Harper MacKay
Music Editor:	Robert Mayer
Technical Advisor:	Lynn McKee
Publicity:	Mike Kaplan
Assistant Publicity:	Carol Shapiro
Dialogue Coach:	Pamela Danova
Puppeteers:	Bil and Cora Baird

BIBLIOGRAPHY

Andrews, Julie. Interviewed by author, September 10, 1992.

Arnold, Pia. Interviewed by author, July 7, 1992.

Barthel, Joan. "The Biggest Money-Making Movie of All Time—How Come?" *New York Times Magazine* (November 20, 1966).

Behlmer, Rudy. "Oral History with Ridgeway Callow." *The American Film Institute Film History Program*, 1976.

Bernhard, Lisa. "From Lost in Space to Her Own Enterprise." *Us* (November 14, 1988).

Breaux, Marc. Interviewed by author, April 30, 1992.

Brown, David. Interviewed by author, June 2, 1992.

Byrne, Bridget. "Never Less than a Nice Girl—Even in the Nude." *Los Angeles Herald-Examiner* (July 22, 1973).

Carmack, Michael. "Hammond—Building a Career." *Los Angeles Herald-Examiner* (December 8, 1974).

Champlin, Charles. " 'Sound of Music'—Hills Are Alive Again." *Los Angeles Times* (March 14, 1973).

Chaplin, Betty Levin. Interviewed by author, July 22, 1992.

Chaplin, Saul. Interviewed by author, July 22, 1992.

Chase, Duane. Interviewed by author, April 28, 1992.

Crist, Judith. *New York Herald Tribune* (March 3, 1965).

Crowther, Bosley. " 'The Sound of Music' Opens at Rivoli." *New York Times* (March 3, 1965).

Degn Films. *And Edelweiss Is Also Just a Flower—Myth and Reality of the Trapp Family*. (January 1992).

Fordin, Hugh. *Oscar Hammerstein II: Getting to Know Him*. New York: Ungar Publishing Company, 1977.

Hoaglins, Jess. "Norma Varden—Character Actress." *Hollywood Studio Magazine* (October 1981).

Hopper, Hedda. "Singing Charmian Carr Never Had a Lesson." *Los Angeles Times Calendar* (March 7, 1965).

Houston, Orella. Interviewed by author, June 5, 1992.

Jeakins, Dorothy. Interviewed by author, June 11, 1992.

Jordan, Richard Tyler. "The Tinsel Town." *Los Angeles Magazine* (July 1989).

Kafka, John. "Munich (Hitler's Hotbed) Slashes 20th's 'Music,' Eliminating Nazis As Heavies." *Weekly Variety* (June 1, 1966).

Kaplan, Mike. Interviewed by author, May 26, 1992.

Karath, Kym. Interviewed by author, April 3, 1988, and April 10, 1992.

Kostal, Irwin. Interviewed by author, July 1, 1992.

La Rue, Francie. Interviewed by author, June 5, 1992.

Lee, Anna. Interviewed by author, June 10, 1992.

Lehman, Ernest. *The Sound of Music*. Twentieth Century Fox, January 1964.

Lehman, Ernest. Interviewed by author, October 1987 and June 17, 1992.

MacKay, Harper. Interviewed by author, August 5, 1992.

Martin, Mary. *My Heart Belongs*. New York: William Morrow and Company, Inc., 1976.

McCord, Ted. "The Sound of Music." *American Cinematographer* (April 1965).

Miller, Tony, and Patricia George Miller. *Cut Print*. Los Angeles: Ohara Publications, 1972.

Morgan, Tracey. "Musical Heirs." *Us* (March 5, 1990).

"Movie Debut, Wet But Wonderful!" *Hollywood Citizen-News* (January 25, 1965).

Nelson, Portia. Interviewed by author, May 18, 1992.

Nixon, Marni. Interviewed by author, May 19, 1992.

Plummer, Christopher. Interviewed by author, May 2, 1992.

"Poe Tells 'Sound of Music' Story; Could Be Top Grosser of All Time." *Motion Picture Exhibitor* (January 26, 1966).

Reynolds, William. Interviewed by author, July 6, 1992.

Rodgers, Richard. *Musical Stages—An Autobiography*. New York: Random House, 1975.

Rodgers, Richard, Oscar Hammerstein II, Howard Lindsay, and Russel Crouse. *The Sound of Music*. New York: Random House, 1960.

Rubin, Steven Jay. " 'Sound of Music' Kids—Where Are They Now?" *Los Angeles Times Calendar* (April 26, 1981).

Seaman, Jean. Interviewed by author, June 8, 1992.

Segal, Mort. Interviewed by author, June 8, 1992.

Scheuer, Philip K. " 'Sound of Music' Without the Taste of Saccharine." *Los Angeles Times Calendar* (March 7, 1965).

Shearer, Lloyd. "The Biggest Box Office Draw of All Time." *Parade, Independent Press Telegram and Evening News* (December 18, 1966).

Silverman, Stephen. *The Fox That Got Away*. Secaucus, New Jersey: Lyle Stuart, Inc., 1988.

Slate, Libby. "25th Anniversary for Oscar-Laden 'The Sound of Music.' " *Los Angeles Times* (March 31, 1990).

"The Sound of Music." *Daily Variety* (March 1, 1965).

" 'Sound' of 20th Prod'n Heard; Lehman Inked." *Daily Variety* (December 10, 1962).

"Still One of Our Favorite Things; 'The Sound of Music,' Cast Returns for a 25th Anniversary Von Trapp Reunion." *People* (September 10, 1990).

Teusch, Judith Ann. "A Talk with Maria." *Our Sunday Visitor* (June 11, 1964).

Thomas, Larri. Interviewed by author, May 18, 1992.

Truhitte, Dan. Interviewed by author, May 1, 1992.

"20th To Film R&H's 'Sound of Music'; Pays Million For 15-Year Lease On Hit." *Daily Variety* (June 13, 1960).

Von Trapp, Johannes, Interviewed by author, April 16, 1992, and September 18, 1992.

Von Trapp, Maria Augusta. *The Story of the Trapp Family Singers*. New York: J. B. Lippincott Company, 1949.

Von Trapp, Maria. *Maria—My Own Story*. Carol Stream, Illinois: Creation House, 1972.

Von Trapp, Maria Augusta, with Ruth T. Murdoch. *A Family on Wheels*. New York: J. B. Lippincott Company, 1959.

Williams, Whitney. "Salzburg Snubs 'The Sound of Music,' But Basks in the Bonanza of Tourist Booty Lensing of 20th-Fox Film Brought the Town." *Daily Variety* (June 20, 1969).

Windeler, Robert. *Julie Andrews—A Biography*. New York: St. Martin Press, 1983.

"Wise Hits 'High-Handed' 20th Staffer Who Slashed Nazi Footage from 'Music.' " *Daily Variety* (June 2, 1966).

Wise, Robert. "Why 'The Sound of Music' Sounds Differently." *Los Angeles Times Calendar* (January 24, 1965).

Wise, Robert. Interviewed by author, June 1987; June 1, 1992; and August 20, 1992.

"Wise Helms 'Sound' at 20th." *Variety* (November 5, 1963).

"Wise, Shocked by Munich's Nazi Cuts, Questions 'Power' of Branch Offices." *Variety* (June 8, 1966).

Wood, Dee Dee. Interviewed by author, April 28, 1992.

Wyler, William, and Axel Madsen. *William Wyler—The Authorized Biography*. New York: Thomas Y. Crowell Company, 1973.

Zanuck, Richard. Interviewed by author, July 8, 1992.

Zuberano, Maurice. Interviewed by author, June 1, 1992.

ACKNOWLEDGMENTS

I'D LIKE TO GIVE SPECIAL THANKS TO A FEW PEOPLE WHO PUT AN incredible amount of time and effort into this book; my work could not have continued without their support.

First, of course, is Robert Wise. Over the years Bob has been a kind and generous friend. He was supportive of this book right from the beginning and devoted many hours of his time for interviews, introductions, and editing.

Second is Mike Kaplan, who will probably never volunteer for anything *ever* again. He not only sat with me for hours at Twentieth Century Fox, digging through 30 boxes of photographs, but he put up with my frustrations as my research became more and more complicated. He deserves an Oscar for loyalty and patience. Now, if only he would change that message on his answering machine . . .

Next I'd like to acknowledge Ernest Lehman's contribution to this book. Ernie, who has the best memory in the business, was generous enough to share his stories with me, and I thoroughly enjoyed our hours together.

I'd also like to thank Saul Chaplin for allowing me access to his story; his impact on the film was tremendous, and his anecdotes added a lot of depth and humor to the book.

And finally I must thank my editor, Stacy Prince, whom I now consider a good friend. Stacy was another generous supporter who gave an enormous amount of time and energy to this project. I can't thank her enough for "teaching me the ropes." Thanks as well to the staff at Contemporary Books, who worked so hard to make me look good, and

especially to Christine Benton, who helped me tie up so many loose ends.

I'd also like to thank the following people for their invaluable help and encouragement:

Julie Andrews, Christopher Plummer, Kym Karath, Johannes von Trapp, Richard Zanuck, David Brown, Betty Levin Chaplin, Portia Nelson, Anna Lee, Marni Nixon, Dan Truhitte, Marc Breaux, Dee Dee Wood, Maurice Zuberano, William Reynolds, Aurelia Houston, Francie La Rue, Irwin Kostal, Larri Thomas, Pia Arnold, Harper MacKay, Dorothy Jeakins, Frances Klamt, Jane Weaver, Charlotte Sutterlin, Bert Fink of the Rodgers & Hammerstein Organization and Vince Scuderi at Williamson Music, Ned Comstock at the University of Southern California, Dr. Charles Bell at University of Texas in Austin, University of Wyoming, Twentieth Century Fox, the Margaret Herrick Library at the Academy of Motion Picture Arts and Sciences, the Austrian Tourist Bureau in Salzburg, Jimmy Hawkins, my publicist Ed Goldman . . . and my agent, Jim Pinkston.

CREDITS

I interviewed many of the film's principals extensively when doing the research for this book; when no source for a quote is mentioned, the words come from a recent interview with the speaker.

Every effort has been made to find the correct rights holder for each photograph and illustration. If there are any discrepancies, please contact the author care of the publisher.

The following photographs and illustrations are reproduced through the courtesy of Twentieth Century Fox:

Cover photos, title spread, chapter 1 spread, pages 19, 20, 21, chapter 2 spread, 26, 27, 31, 43, 45, 47, chapter 3 spread, 51, 55, 57-61, 63, 65-68, chapter 4 spread, 80, 82, 83, 87, 89-104, 107, 112, chapter 5 spread, 116-19, 121-28, 131, 132, 134-40, 143-56, 158, 159, 164-71, chapter 6 spread, 176-79, 184, 189, chapter 7 spread, chapter 8 spread, 209.

All photos in color inserts are reproduced through the courtesy of Twentieth Century Fox unless stated otherwise.

The following are photographs and illustrations reproduced through the courtesy of the University of Southern California Cinema-Television Library:

INDEX

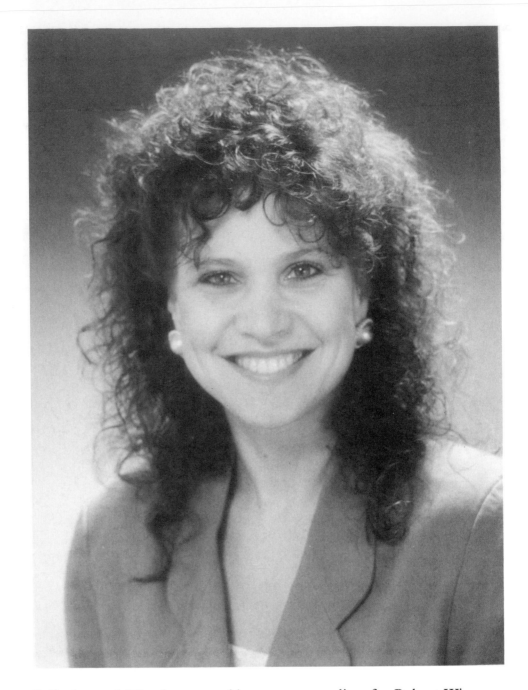

Julia Antopol Hirsch was working as a story editor for Robert Wise Productions when she became aware that the director/producer was still receiving mail from fans of *The Sound of Music*, and she came up with the idea of writing the definitive book on the making of the picture. Hirsch has worked as a screenwriter for the past 10 years and has recently completed a screenplay that will be produced by Robert Wise. She lives in Orange County, California, with her husband and two children.